Folklife

ANNUAL 1985

A Publication of the American Folklife Center
at the Library of Congress

Edited by Alan Jabbour and James Hardin

Library of Congress · Washington · 1985

Folklife Annual presents a yearly collection of articles on the traditional expressive life and culture of the United States. The articles are written by specialists in folklife and related fields, but the annual is intended for a wide audience. A publication of the American Folklife Center at the Library of Congress, *Folklife Annual* seeks to promote the documentation and study of American folklife, share the traditions, values, and activities of American folk culture, and serve as a national forum for the discussion of ideas and issues in folklore and folklife.

The editors will consider for publication articles on all areas of folklife and are particularly interested in the folklife of the United States. Manuscripts should be typewritten, double-spaced, and in accord with the *Chicago Manual of Style*. Submit to: The Editors, *Folklife Annual*, Publishing Office, Library of Congress, Washington, D. C. 20540.

ISBN 0-8444-0462-4

ISSN 0747-5322

Designed by James Wageman

For sale by the Superintendent of Documents, U.S. Government Printing Office
Washington, D.C. 20402

Cover: Harvesting cranberries at the Birches, Tabernacle, New Jersey, 1982.
Photograph by Carl Fleischhauer

CONTENTS

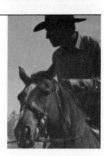

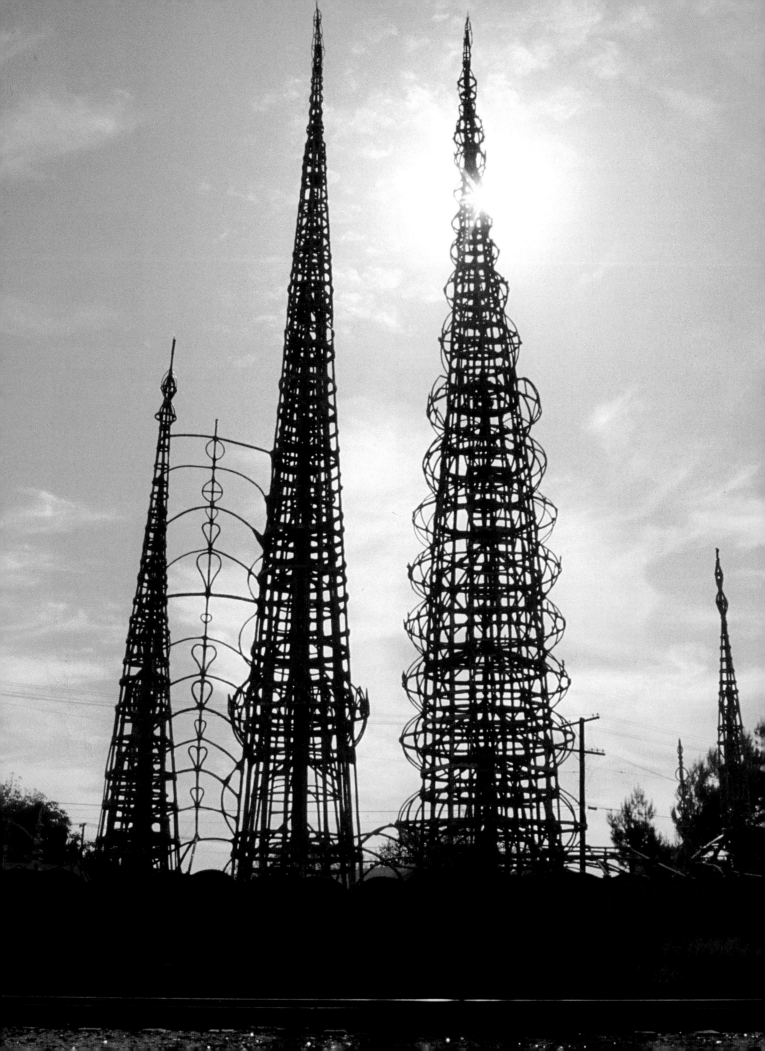

PREFACE

Folklife Annual grew out of the long-standing desire of the American Folklife Center and the members of its Board of Trustees (especially former trustee and distinguished folklorist Wayland D. Hand) for some sort of national serial publication on American folklife. Most often the proposed publication was called a journal—but the frequency of a journal, the extent of the editorial work required to produce it regularly, and the many other practical considerations of such an enterprise seemed daunting. And there was concern too that a journal would compete for manuscripts with publications from other institutions, several with long and distinguished traditions.

When the Library's Publishing Office came to the Folklife Center with the idea of an annual, a publication aimed at a wide audience and one that would allow for a full use of illustrative material, the new idea seemed to fulfill the old desire. The proposal was workable, it responded to a need of the community of folklorists for publishing their work, and it seemed to fulfill as well one mandate of the center, to present to the American people evidence of a rich heritage of expressive life.

From the beginning we agreed that our annual should neither focus on a single topic each year nor be limited to center activities and contributions of the center's staff. Rather it should seek contributions from all parts of the United States and from all those engaged in the study of American folklife. We set out to find articles that were well-researched, thoughtful, and carefully written—that sought to interpret as well as document the results of field work and study. We hope the articles presented here succeed in achieving those goals, and we invite the participation of our readers as we assemble articles for future volumes.

In beginning this new series, we gratefully acknowledge the support of the Library's Office of the Associate Librarian for National Programs. The Library of Congress is home for the American Folklife Center and the Archive of Folk Culture and is, throughout its many divisions, an unparalleled resource for the study of American folklife.

Opposite: Watts Towers, Los Angeles. *Photograph by Seymour Rosen*
Following pages: New Jersey farm produce, October 1983.
Photograph by Joseph Czarnecki

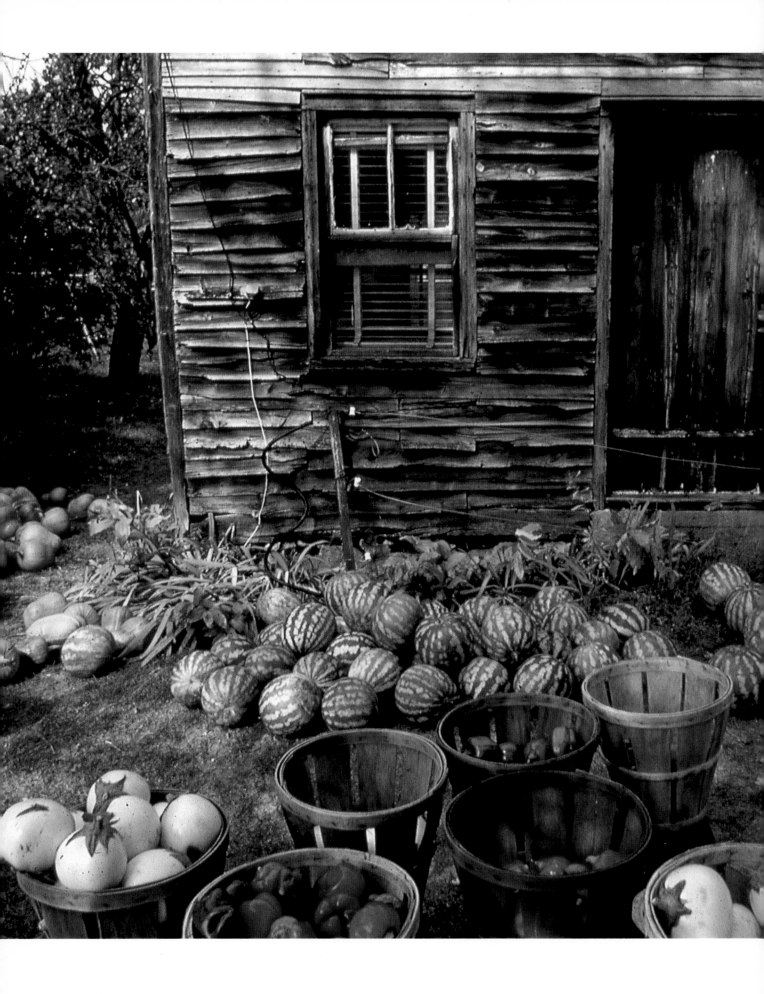

6

INTRODUCTION: Coming to Terms

We had not planned it that way, but this first volume of *Folklife Annual* aptly reflects the activities and preoccupations of the American Folklife Center during the year of the volume's gestation. Our major field effort of 1984 was the Pinelands Folklife Project, undertaken in a swath of New Jersey that is sometimes referred to loosely as the Pine Barrens and that has been designated more recently as the Pinelands National Reserve. Through this project, and several which had preceded it, the center considered the related subjects of folklife and preservation, conservation, land management, and sense of place. The study has been a meditation on the intertwining of nature and culture—two words that in their various etymological manifestations have served our civilization since ancient times as we struggle to define our relationship with the world around us. Mary Hufford's essay, with which the volume begins, tackles this nature-culture dichotomy head-on by recounting the experiences of our fieldworkers in New Jersey's Pinelands and the thoughts of the people they visited. It moves from cranberry bogs to cedar stands, salt-hay fields, and oyster beds, showing that much of what we think of as "natural" is in fact the product of long-standing traditional cultivation, that "cultivation" in turn establishes a sort of ground-base for "culture," that culture is deeply influenced by the natural habitat in which it flourishes, and that the rhythm of this interaction creates what we think of as a cultural region.

One sign of the existence of a cultural region is the use of a term to designate its inhabitants. Such terms sometimes emerge from the inhabitants themselves as a means of self-identification; sometimes the terms are imposed by outsiders or by one class of insiders upon another, which greatly complicates their connotations and propriety. In the New Jersey Pine Barrens the term *Piney* is today the subject of debate about its meaning, to whom it applies, and whether it should be embraced as an emblem of regional pride (epitomized currently by "Piney Power" buttons) or shunned as an outsider's stereotypic epithet. David Cohen's essay shows how the development and perpetuation of the term *Piney*, accompanied by a sort of legend about origins that defines the term, owe much to local historians who have written about the region. Pondering this historical backdrop, one may conjecture that if the term is ever generally adopted for regional self-identification (like "Tarheel"), it will have to distance itself from its legendary definition.

To the extent that we are unable to divine every signifi-

cance embedded in our Pinelands fieldwork, perhaps the resultant archive will prove wiser in the long run than its creators. The center's attention in the past year has focused to a large extent upon archiving. We hosted a national conference on automation and folklife archives, and one of the special goals of the Pinelands Folklife Project was to experiment with a system that, through automation, allows fieldworkers to "archive as they go." The Pinelands Commission can have access to the computerized data base, and thus the archive can help answer not only our own questions but other questions we have not dreamed of.

Perhaps the central mystery of an archive—or, for that matter, of a library or museum—is that it must preserve the past, reserve from the present, and serve the future. Since, in principle as well as in practice, it helps our civilization remember and understand what we had forgotten or previously ignored, it must select for the future things the full significance of which it cannot divine at present. Thus an archive with a national mission must grow and adapt, not only in its procedures but in its central vision. The alternative is a treadmill of pigeonholing and formularizing that inevitably leads to institutional atrophy. Archie Green's essay "The Archive's Shores" evokes an image of the Archive of Folk Culture as a living, developing institution that differs from the static image of an archive implied in the catch-phrase "dusty archives." The essay, first offered in briefer form in 1978 as a lecture during the symposium with which we celebrated the fiftieth anniversary of the archive's creation, ties the archive's development to important strands in the history of ideas in twentieth-century America. The ideas, in turn, are made manifest in the thoughts and actions of three men—Robert W. Gordon, John A. Lomax, and Horace Kallen—all of whom were students of Harvard professor Barrett Wendell in the early years of this century. This essay will serve as the inaugural contribution of *Folklife Annual* to a process of reflection regarding the historical development of the ideas and ideals embedded in the terms *folklore* and *folklife*. Such essays are always welcome, but they are particularly appropriate in preparation for the observance of the American Folklore Society's centennial later in this decade.

The mission of the founders of the Library's Archive of Folk Culture was to document American folksong ("folk song" or "folk-song," as they would have written it). Leaving aside their larger purposes, along with the broader mission that subsequently evolved for the archive, it is possible to observe that much of their early effort was invested in differentiating folksong from other forms of song. The very existence of that qualifier *folk,* of course, reflects a desire to differentiate, to bring certain qualitative distinctions to the foreground, to set aside a special corpus from the larger mass of human expressions subsumed under the word *song.* Yet folksongs are, after all, songs; and there are times when it is important to think afresh about the essential unity of all art in the manner of its creation. Edward D. Ives's essay "The Teamster in Jack MacDonald's Crew" takes its theme and inspiration from a single folksong recorded by him from a single singer. A copy of the recording is in the Archive of Folk Culture and has been published on one of our documentary LP anthologies (Library of Congress LBC 8, *Songs of Labor & Livelihood*). Here the burden of his essay is to contemplate that song, its maker, and the context of its creation along with the poetry and art-song of the likes of Matthew Arnold and Samuel Barber. Thus it is that, though the items in the archive remain the same, time lends us fresh lenses through which to view them.

Two essays in this volume echo and amplify the Folklife Center's "year of the cowboy" in 1983, during which we mounted a major exhibition entitled *The American Cowboy* and organized concerts and symposia to match. John Erickson's is a literary contribution, immersed in direct personal experiences and reflections arising from them. John Bennett offers an essay more analytical in its approach, extracting generalizations from both personal observation and mountains of additional research data. The exhibition dealt extensively with American myth-making about the cowboy. Both these essays address the reality of cowboys as an occupational group in the twentieth-century West. It is revealing that, for both writers, explaining the reality of cowboy life required accounting for ideals. A cowboy, stripped of the romance of our national fantasies, may be nothing more than an agricultural laborer (perhaps, especially in the old days, a migrant agricultural laborer). But the point is that you cannot just strip him of dreams, ideals, and values. Economics must be conjoined with cultural values to explain the cowboy to the rest of us, and finally the myths we sought to disentangle from the reality of cowboy life prove inextricably intertwined.

The cowboy theme raises forcefully another issue we have never quite come to terms with in the field of folklore and folklife. Our field of study has always been subject to two

contrary impulses: to take the cultural traditions of small, relatively homogeneous groups as our focus or to broaden the arena of inquiry to larger regions, nations, even civilizations. Is folklore, or folklife, a traditional expression of community values? Or is it an expression of national character? Or does it express international cultural connections among the people of the world? To judge from the publications of folklorists over the past century, the answer is—all of the above, sometimes, depending. The study of folklore is both intensive and comparative, and rightly so, for the things being studied express many layers of cultural significance simultaneously. An Appalachian fiddle tune is simultaneously a personal expression, a community tradition, an emblem of regional style, and (in expanding circles of connection) an artifact of America, the English-speaking world, and fiddling worldwide. Similarly, a cowboy's lariat twines together many strands of cultural meaning and value, from craftsmanship and techniques of use through symbolic significance to the larger civilization.

Folk art, which provides the final subject for essays in this volume, presents a similar problem of definition. Are we to think of folk art in terms of traditions carefully nurtured and passed along from generation to generation within a homogeneous community? If so, the artistry and craftsmanship of the Italian stone carvers working on Washington's National Cathedral certainly seem to fit the bill beautifully. Marjorie Hunt has shared with us, through the carvers' words and images of their work, a sense of the personal and communal discipline that sustains this grand stone-carving tradition. It is worth noting, however, that the carvers at the National Cathedral are from more than one region; both northern and southern Italy are represented, as are other European countries. There is a sense in which stone carvers are an international fraternity or guild, thrust together in the places where their work takes them and bound together by the grand tradition of their craft.

Howard Finster, by way of contrast, seems to some people to be an artist without a clear tradition, a self-taught visionary whose art can be called "great" more comfortably than "folk." Yet his biography reveals many other arts

we would unquestionably call folk arts—banjo and harmonica playing, singing in the traditional style of the Upland South, extemporaneous preaching in the traditional style. Further, he has crafted things with his hands (and imagination) since childhood. Finally, though they have no contact with one another, many other grassroots artists have come to our attention in recent years, and there are haunting similarities in some of their artistic techniques and subjects. The similarities go well beyond what can be explained away by coincidence; one must assume shared experience, vision, and values at some level—some profounder cultural connection at the spiritual grassroots.

These perplexities, and others, were the subject of the Washington Meeting on Folk Art here at the Library of Congress in late 1984. In the course of that meeting Sheldon Posen, discussing the Brooklyn *giglio* celebrations as an example of folk art, chanced to allude to the possible parallel between the *giglios* and Watts Towers in Los Angeles. Since Sam Rodia's towers have become famous as an example of "folk art environments"—celebrated for their unique, visionary artistry—the idea seemed particularly intriguing to explore. Daniel Ward and Posen have now shared expertise to explore the parallel more closely, and in the process to pose a number of serious questions about the nature of folk art. Certainly the *giglio* in Italy and Brooklyn is a kind of folk art. Are Rodia's Watts Towers and Reverend Finster's backyard Garden of Paradise another?

Thus there hovers around all the thematic groups of essays in this first volume of *Folklife Annual* a cluster of larger questions about folklore and folklife—its relationship to the land (the Pine Barrens), the development of its archives, its relationship to the larger popular values and ideas of our civilization (the cowboy), and the nature of folk art vis-à-vis art (not only for Watts Towers, Reverend Finster, and the stonecarvers, but also for the creator of "The Teamster in Jack MacDonald's Crew"). Like the American Folklife Center itself, its first annual is neither single in form nor totally miscellaneous, but plumbs a cluster of issues, all of which seem important to consider as we reflect upon American folklife today.

CULTURE AND THE CULTIVATION OF NATURE:
The Pinelands National Reserve

By Mary Hufford

In 1978 Congress created the country's first National Reserve in the Pine Barrens of New Jersey. The Pinelands National Reserve differs in concept from National Parks, Forests, or Monuments by virtue of its effort to safeguard natural and cultural resources while maintaining patterns of compatible human use and development. A fifteen-member Pinelands Commission is managing the million-acre tract by coordinating the actions and resources of local, state, and federal governments and the private sector.

Most nationally significant landscapes are so designated because of their unique natural or cultural resources. Cultural resources are often defined as things that give us access to the human past—historic and archeological resources—rather than as clues to understanding contemporary life. If a contemporary culture is honored, the group itself is often regarded as an anachronism, having carried the past forward in an unusually intact form. People fall outside the frame of a natural preserve, except as visitors who do not change anything.

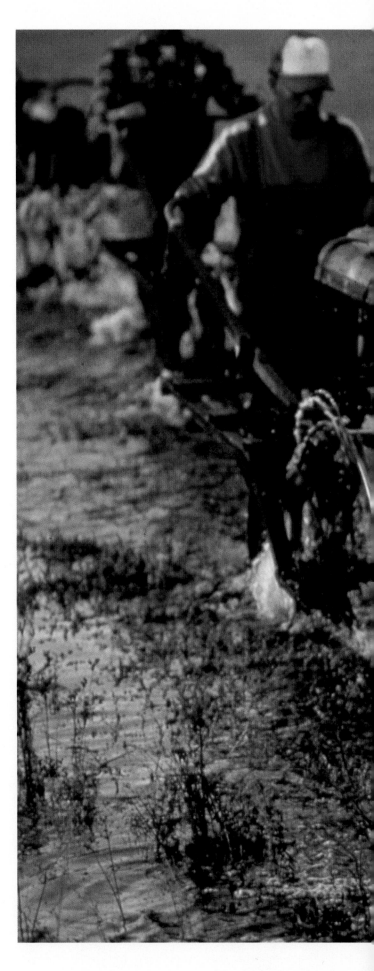

Harvesting cranberries at Haines's bogs in Chatsworth, New Jersey.
Preceding pages: Misty aerial view of the Pinelands
Photographs by Joseph Czarnecki

People are encouraged to remain in the Pinelands National Reserve, however, and to maintain their traditional patterns of land and resource use. The goal is a "living landscape," protected in part by its "traditional guardians," who could be regarded as cultural resources themselves. Such a national reserve cannot be maintained simply as a wilderness area with its cultural resources confined in restored villages. Whereas there are guidelines for evaluating natural and historic resources, there are none for evaluating living cultural resources. In an effort to help develop a model for fostering a living landscape, the American Folklife Center launched the Pinelands Folklife Project. The field survey, conducted during the fall of 1983, paid special attention to the interplay of folk culture and natural resources and to the region's sense of place.

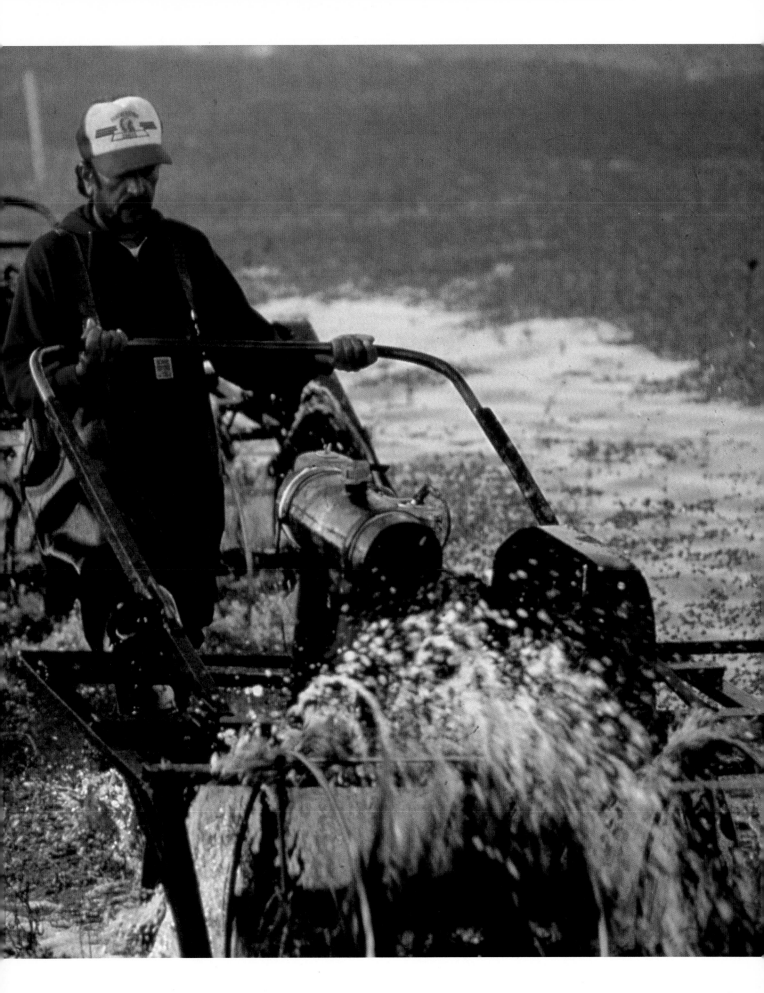

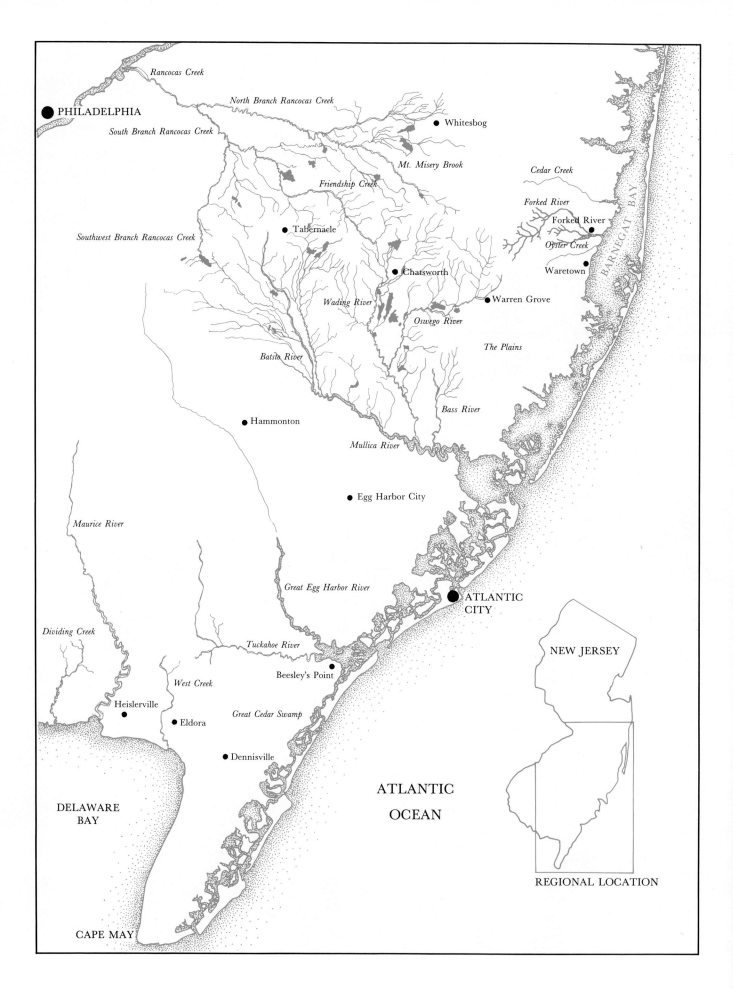

PHILADELPHIA

Rancocas Creek

North Branch Rancocas Creek

Whitesbog

South Branch Rancocas Creek

Mt. Misery Brook

Cedar Creek

Friendship Creek

Forked River

Forked River

Southwest Branch Rancocas Creek

Tabernacle

Oyster Creek

Chatsworth

Waretown

Wading River

Warren Grove

Oswego River

The Plains

Batsto River

Bass River

Hammonton

Mullica River

Egg Harbor City

Maurice River

Great Egg Harbor River

ATLANTIC
CITY

NEW JERSEY

Dividing Creek

Tuckahoe River

Beesley's Point

West Creek

Heislerville

Great Cedar Swamp

Eldora

Dennisville

ATLANTIC

OCEAN

DELAWARE
BAY

REGIONAL LOCATION

CAPE MAY

BARNEGAT BAY

Pine Barrens tree frog (Hyla Andersoni), one of South Jersey's rare amphibians. *Photograph by Robert Noonan*

The creation of the Pinelands National Reserve has deeply affected the lives and the culture of the region's inhabitants. Suddenly people whose forebears struggled to tame the elements in South Jersey discover that because they live in the only wilderness in Eastern Megalopolis, the value of their land has plummeted, and they can no longer plan to retire on the proceeds from its sale. They are solemnly informed by environmental scholars that they live on a very large aquifer. The place, which has crawled with botanists since the eighteenth century, has begun hopping with dirt bikers, hikers, and canoeists on weekends. Journalists, their curiosity piqued by John McPhee's writings, comb the area, hoping to interview "real" Pineys like Fred Brown. Bill Wasiowich, also mentioned by John McPhee, is pictured in *Life* magazine. And those who are not living subsistence lifestyles find that they do not fit the image of the Pinelands held by outsiders.

Rumors fly about what people can and cannot do with their own property. People begin to assume that permits are required to prune trees in their yards and that the nonindigenous plants edging their foundations will have to be uprooted. A man applies to the Pinelands Commission for permission to build another structure on his land. He is told he lives just outside the Pinelands Reserve and feels like he has won the lottery.

Everything gets inventoried and classified: the watersheds, the soil types, the fire-prone areas, the pingoes, and the Indian shell mounds. Pine Barrens tree frogs and curly grass ferns are carefully itemized. Forges and sawmills are checked off. The carrying capacities of woodlands areas for white-tailed deer are duly noted. In 1980 a comprehensive management plan is drafted, and municipalities set about the arduous task of bringing their zoning regulations into conformance with the regional plan.

Then one day in September 1983 a gas station attendant living in Egg Harbor notices that yet another survey is under way. The headlines in the *Atlantic City Press* read, "Federal Scientists Study Pinelands Culture." He is skeptical, but that afternoon a blond, bearded man named Jens Lund drives into the station, fills up his tank, and hands the attendant a government credit card.

"Oh," says the attendant, "you must be one of those folklorists with the Pinelands Folklife Project."

"Why, yes, I am," replies Dr. Lund in surprise.

The attendant scratches his head.

"Say, tell me something," he says. "Do you really think there's any *culture* around here?"

The attendant's question is a fair one. Although the term *culture,* meaning "a whole way of life, material, intellectual, and spiritual," has been with us for more than a century now, not everyone understands that all human communities possess it. Culture as a medium for the improvement of human beings is so often thought of in opposition to nature that its semantic roots are obscured. In the seventeenth century, when European settlers were first arriving in the Pinelands, it meant "the tending of natural growth." Later it came to mean, by analogy, "a process of human training."[1] Culture in its most literal sense refers to the improvement of what occurs naturally, as in "silviculture," "agriculture," and "cranberry culture." Human beings occur naturally, too.

If approached as an organic whole, the culture of the Pinelands National Reserve cannot be separated from its natural resources. Nor can the natural history of the region be told apart from the history of its human inhabitants. Human ecologists John Sinton and Jonathon Berger note that nature and culture in the Pinelands converge around three active ingredients: water, earth, and fire.[2] The people and the environment have been mutually cultivated through centuries of learning to capture, curb, and redistribute these three elements. Valuable information about the land and its people, the legacy of generations of observation and use, is stored not only in archaic tools and technologies but in the minds of

those traditional guardians who continue to study and conserve their environments. The traditional guardians of the landscape are also the guardians of the culture. Their story begins with the Ice Age, a watershed event of some magnitude that happened ten thousand years ago.

The Ice Age is the culprit.

"South Jersey is a result of the last Ice Age," said George Brewer to folklorist Jens Lund. "Before that, South Jersey was just a bunch of little islands. The runoff from the last Ice Age filled it in."

They were discussing the cultural chasm that divides North and South Jersey. As a result of this chasm, a characteristic of states that are taller than they are wide, South Jerseyans threatened to form a separate state several years ago. They broadcast their intention on bumper stickers that read, "South Jersey: the Secret State." There is some truth to the statement. The "Joisey" accent and the smokestacks that fume into orange and gray skies belong to only a small portion of North Jersey. While South Jersey has spewed forth its share of ashes, the smoke is of a different sort. The ice age with its series of melting glaciers had something to do with that.

We do not know whether the islands mentioned by Brewer bore names before they were glaciated. We do know that every time a glacier shrank it unleashed torrents of water, each with its own blend of silt, gravel, sand, and clay, like islands stacked on top of one another and named retroactively by geologists: Cape May, Bridgeton, Pennsauken, Beacon Hill, and Kirkwood formations, and the topmost Cohansey Sand. The glaciers gouged out basins and upheaved ridges, none of them very pronounced and all of them linked by the sand they contained.

"Everything south of Trenton is mostly sand," George Brewer observed. He was providing Lund with the deep background on his logging operation in Great Cedar Swamp.

That sand is the famous Cohansey Aquifer, a deposition of sand that holds 17 trillion gallons of pristine water. The aquifer, replenished entirely by precipitation, feeds all the ground water in South Jersey and, because of its permeability, is highly susceptible to pollution.

For centuries following the Ice Age, there was mutual influence between people and the landscape. Almost as if they took their cues from the Ice Age, human beings used small-scale processes of deposition and erosion to cultivate indigenous crops like salt hay, cedar, cranberries, and clams. What they contributed was geometry, history, and a rich vocabulary of discernment. In that vocabulary a landscape that has been accused of an undulating sameness begins to throb with its own nuances. Perhaps the most profound source of unity for the diversified landscapes lies hidden underground in the water table.

In the uplands of South Jersey the water table is seldom more than five feet from the surface. In the lowlands it peeps through. It does not burst or gush, it seeps and trickles through dendritic depressions in the land, spring-fed sloughs, that give rise to barely perceptible islands. Differences in elevation, sometimes of only a few inches, make for marked differences in vegetation and soil types. In many parts of the Pinelands, the ground is not solid, and people know where they can walk by reading the vegetation. The soil types and the various kinds of "bottom" that exist in the wetlands have been thoroughly annotated by the people who have lived there over the past three hundred years.

George Brewer described the varieties of bottom that lay in close proximity to one another. The sweet gum tree in his

The Cohansey Aquifer, its top dusted with fine, white sand and inlaid with the trails of deer and people, underlies much of the Pine Barrens. As large and culturally diverse as the region is, its residents are all connected by the sand and water. Those who have grown up there have a saying: "You can go away from the Pines, but you can't get the sand out of your shoes." *Photograph by Joseph Czarnecki*

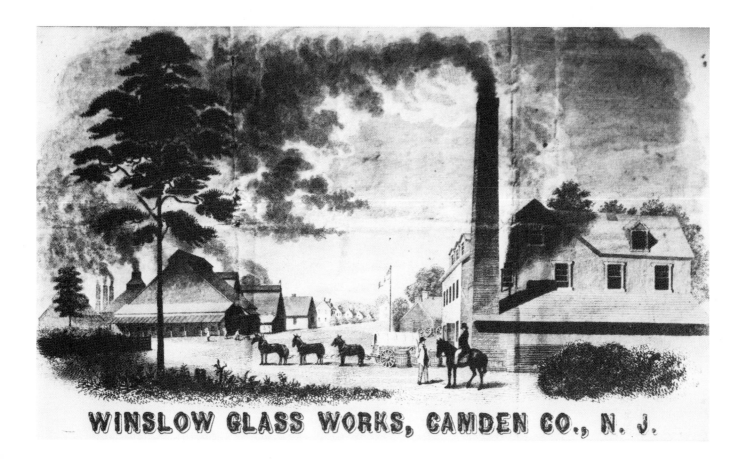

WINSLOW GLASS WORKS, CAMDEN CO., N. J.

yard, he observed, indicates a boggy bottom. The yard behind his mother's house, on the other hand, is sandy enough "to sink a garden tractor."

Her front yard is so gravelly you can hardly dig a hole, and down by the school there's a field full of buckshot sand. Behind it is a sand-wash—good enough for road gravel. [Interview, Jens Lund, October 15, 1983]

Jack Cervetto, who logs cedar in the Oswego Swamp, observed that in the South Plains each hill, as small as it is, is composed differently.

Every hill has a different material to it. One is a gravel hill, another has sugar sand, another is ordinary sand, and there's some that are solid rock.

The names of those hills are more pronounced than the hills themselves: Hogback Hill, Skunk Hill, and Bacon's Ridge. [Interview, Mary Hufford, April 5, 1984]

When the European settlers arrived, they found an area that was, as it is today, very wet, very sandy, and very fire-prone. For centuries fire had been wielded by the Delaware Indians, both to procure food and to control the naturally occurring wildfires. In the drier uplands especially, the vegetation responded by becoming both more volatile and more resilient. On the Plains, an upland tract which many regard as the Pine Barrens proper, the pitch pine and scrub oak sprout leaves within one season after a fire has ravaged the area.

In the eighteenth and nineteenth centuries, as the industrial revolution progressed, the smoke hovering over South Jersey was patterned differently. Pine trees that had been exploded by wildfires were now smoldered into charcoal. The charcoal was used as fuel in the houses where sand was fused into glass and in the forges where bog iron—from tea-colored swamp streams—was smelted. Water-powered saw-mills sprang up along the streams, converting the Atlantic white cedar into shingles for houses and planking for ships.

Many of the towns that existed in this period were company towns—iron plantations—and their ruins bear the company names: Hanover Furnace, Martha Furnace, Mary Ann Forge, and Harrisville. Harrisville was actually a town surrounding a papermill. The paper, made from salt hay grown in the meadowlands fringing the Pine Barrens, was crude and tea-colored, some say, because of bog iron in the water.

By the mid-nineteenth century the furnaces had converted their last minerals and were shut down by circumstances beyond their pale, including the discovery of the anthracite fields in Pennsylvania. They subsided into ruins, to await their own conversion into historic sites or other industries. Around them the landscape bore witness to the manipulation of water and fire—in sloughs and streams that were bridged and dammed and in the black remains of charcoal pits that peppered the uplands. The swamps were riddled with crossways—pole roads constructed to aid the removal of cedar from the swamplands. The crossways, some of them more than two hundred years old, have been used several times. Jack Cervetto, a woodsman in his seventies, claims to be the third white man to harvest the Oswego Swamp. "They used to say that all the crossways lead to Candlewood," said

Cranberry bogs currently in operation. Fred Mahn, Division of Soil Conservation, State Department of Agriculture, provided current information about location of the bogs. *Map by Donald Shomette*

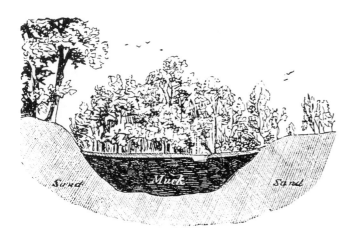

A swamp, favorably situated for cranberry cultivation. J. J. White wrote: "The soil best adapted to the production of cranberries is an equal mixture of coarse sand and muck. . . . Could a soil of this composition be found in a state of nature, rightly situated as regards moisture, much expense of sanding might be saved." In cranberry culture, the muck is covered with sand, inverting the natural arrangement so that in several years the two are thoroughly mixed, producing the ideal mixture of black sand. (Joseph J. White, *Cranberry Culture*, New York: O. Judd Co., 1885, 29 and 32)

The swamp reformulated. "Water is essential," wrote White, "but it must be under control." Turf walls, six feet thick, support and protect the true dam of sand, which also serves as a road. (Joseph J. White, *Cranberry Culture*)

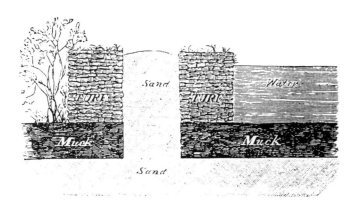

Cervetto. "That's where the first sawmill was." Where turf had been removed for insulating charcoal pits, habitats favorable for today's rare and celebrated plant species were produced. Nineteenth-century journalists took notice, declaring in amazement that here, in the shadows of New York City and Philadelphia, was a wilderness:

> It is a region aboriginal in savagery, grand in the aspects of untrammelled nature; where forests extend in uninterrupted lines over scores of miles; where we may wander a good day's journey without meeting half-a-dozen human faces; where stately deer will bound across our path, and bears dispute our passage through the cedar brakes; where, in a word, we may enjoy the undiluted essence, the perfect wildness of woodland life.[3]

By the time these words were being published, the cranberry craze was well under way: putting the logged-over cedar swamps and stopped-up streams to work toward improving the naturally occurring fruit. One account credits Peg Leg John Webb of Cassville with the discovery that flooding the bogs in winter would protect the evergreen cranberry vines from both frost and insects. He set his first vines in holes punched with his peg leg. He is also credited in local tradition with the accidental discovery that cranberries can be sorted by bouncing them. According to the story, he tripped on his way up the stairs with a bushel of cranberries. The bad, mushy berries only made it partway down the stairs. The good, firm berries bounced all the way to the bottom. Today every cranberry on the market has been bounced at least seven times. While the sorting devices are now sophisticated machines, the ghost of Webb's stairway hovers above them.

All that was needed was a good water supply and a method for controlling the levels. In what is now known as Whitesbog, Col. James Fenwick founded a cranberry plantation, harnessing both the water supply and the work force that formerly had been tapped by Hanover Furnace. Although "cranberry fever" abated with the panic of 1873, cranberrying prospers today as one of the region's more famous traditional, indigenous practices.[4]

Cranberry bogs are essentially remodeled cedar swamps—large basins in which the stumps have been removed and the turf cut away and mounded into embankments and dams, which also serve as roads. The native cedar is incorporated into the landscapes of cranberry culture in the form of cedar packing-houses, workers' cottages, crates, and gates.[5]

In 1870 J. J. White, Fenwick's son-in-law, published a book

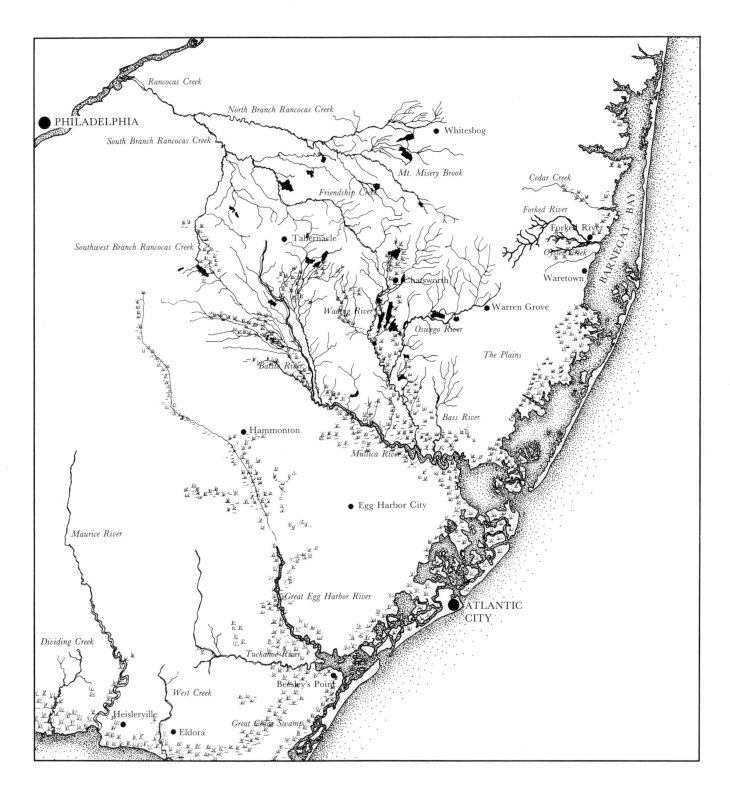

on how to cultivate cranberries. His illustrations provide information on the anatomy of different bottoms—the most essential being the muck found in ponds, swamps, and savannahs. The technical definition for muck is "decomposing vegetable and animal matter together with alluvial mud under water." [6]

For every acre of land set out in bogs there has to be seven to ten acres of reservoir. Thus each complex of bogs—and, by extension, each cranberry family—perches on its own branch of a major waterway. The Birches, in Tabernacle, owned and operated by Earl Thompson, is on the Roberts Branch of the Batsto River; Whitesbogs, in Pemberton, operated by Tom Darlington (J. J. White's grandson), draws from Pole Branch, Cranberry Run, Indian Run, Antrim's Branch, and Gaunt's Branch; Friendship Bogs, in Friendship, is on the Batsto River; Sharpless Bogs is at the headwaters of Medford Lakes; Sim Place, on the edge of the Pygmy Forest, is on the East Branch of the Wading River; Retreat Bogs, run by

the Budd family, is on the South Branch of the Rancocas River. At the heart of the Pine Barrens, the Haineses, DeMarcos, and Lees coordinate their water use for harvesting, irrigation, and frost protection, tapping the Shoal Branch of the Wading River.

The landscapes are so cleverly embedded that canoeists and hikers may not see them as working landscapes but as wilderness playgrounds. "This is a high ridge here!" said fieldworker Nora Rubinstein to Jack Cervetto, who was guiding her through a section of his woods. "This is a dam," Cervetto corrected her. "This is man-made. This is built." Shortly thereafter they came to a sluice. "This is the North Branch of the Wading River," Cervetto told her, sharing his awareness of hidden connections. "This is all concrete and water flows underneath it. It's on a standstill right now, because over at Sim Place they're holding the water to put on the cranberries in case of frost." Stories of trespass vandalism are common, as fieldworker Christine Cartwright learned from Elizabeth Carpenter:

> One grower found a bunch of people sitting in a drainage ditch in his cranberry bogs—they'd opened one of his floodgates so they could sit under the resultant waterfall and enjoy it, regardless of the immense damage that resulted. They were actually insulted that he was upset. They figured they had a right to do what they were doing. [Interview, Christine Cartwright, September 28, 1983]

The cultivation of indigenous crops has an undeserved reputation for being easy, linked perhaps with romantic notions in general about things that are indigenous. "Bogs require no cultivation, harrowing, or manuring," we are told by one misguided reporter. "The planter only waits in serene contentment, confident that the harvest is sure to come." [7]

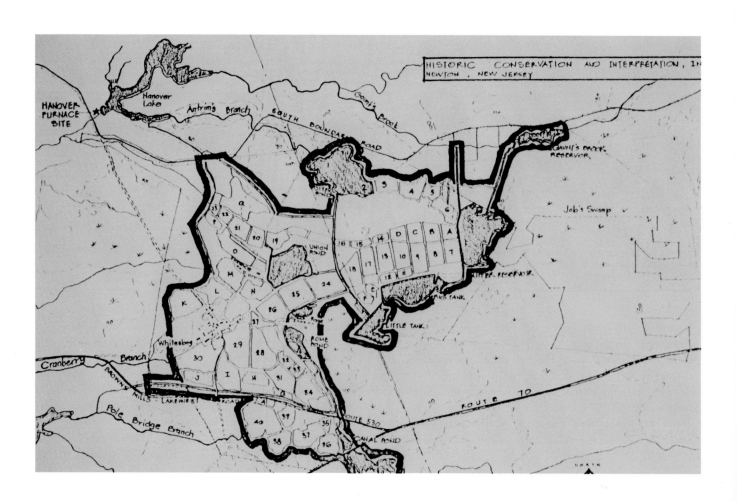

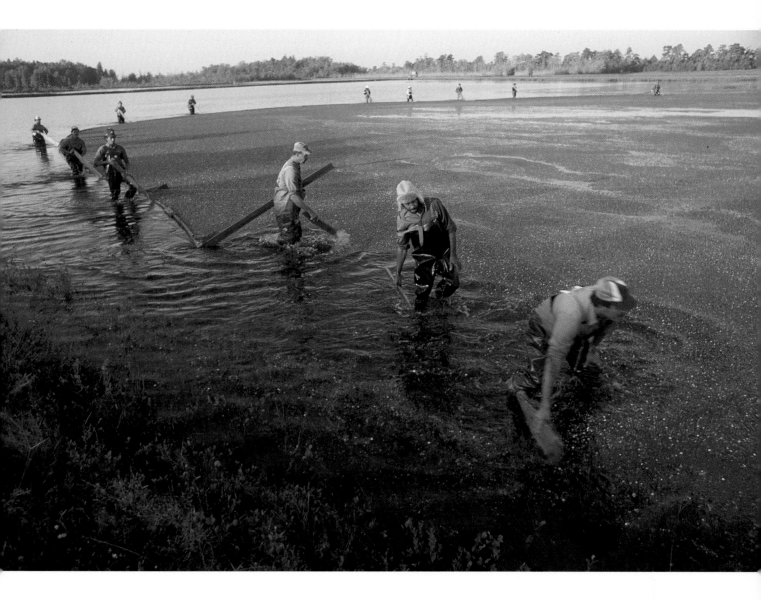

Bog-building in fact represents a staggering amount of human energy and time. Henry Mick and Abbott Lee outlined the basic steps for fieldworkers Christine Cartwright and Mal O'Connor:

1. Pick a spot near a stream.

2. Survey the property for elevations, to facilitate conservation of water.

3. Locate the reservoir at the top of the property.

4. Plan the bogs.

5. Ditch the first bog, using the sand to make the dikes, which also serve as roads for machinery.

6. Push the trees out with large machinery. Salvage the cedar and pine.

7. Burn off useless vegetation.

8. Eliminate competitive root systems by inverting turf. Use turf to line the dikes.

9. Grade the bog. A bog should be within a half-inch of level for conservation of water.

10. Put in underground pipes for irrigation.

11. Plant the vines, forty to seventy thousand per acre. [Combined from interviews, Christine Cartwright, September 29, 1983, and Mal O'Connor, November 12, 1983]

Bog building may take three years, and maturation of the plants requires at least two or three more. Most people in cranberry agriculture today are in at least the third generation of growers. Many are fifth generation growers, whose family histories are also the history of cranberry culture in the region.

The end result is something of a work of art—"a mosaic of dams, canals, and bogs," as grower Mary-Ann Thompson described it. The bogs range in size from one to twenty-five acres. Bogs are places in their own right, with names like Ragmop, Old Bog, Pole Bridge Bog, and Buffin's Meadows. The names are active in local parlance because some of the work force for the bogs is in its third or fourth generation.

Cranberry culture may not be a performing art, but it generates a lot of audience. Since the advent of wet-harvesting in the early 1960s, the harvest has provided a colorful spectacle of bobbing red berries herded toward a conveyor belt

While the ditch in a bog gone wild may hold more aesthetic appeal for visitors (opposite, above), the cranberry grower applies a different set of canons when reading the landscape. The new bogs at Buffins Meadows regarded as state-of-the-art bogs (opposite, below), are streamlined for maximum efficiency. The central ditch has been replaced by sprinkler systems on the dams, which are all exactly two hundred feet apart. *Photographs by Joseph Czarnecki*

through water reflecting a deep blue sky, ringed with amber sand and bright evergreens. It attracts busloads of schoolchildren and a spate of reporters each fall.

Machines for wet-harvesting are essentially large horizontal eggbeaters that knock the berries off the submerged vines. There are two kinds of wet harvesters: "ride-ons" and "walk-behinds." The berries shoot to the surface, where they are shepherded ("hogged") over to the conveyor belt that raises them onto a truck. The hogging method was developed by Eduardo Torres, one of the farm hands at the Haines bogs in Hog Wallow.

Technological advances in the industry are rooted within a local pool of human talent and interest, and each generation contributes something new. Cranberry technology is in constant flux, and last century's tools have evolved into sophisticated machinery within the lifetimes of those in the grandparent generation. Because the industry is so small, and because bogs tend to be idiosyncratic, growers modify existing machines and invent new ones to suit their needs.

Each generation of cranberry growers has its inventors. J. J. White, in addition to writing the accepted manual on cranberry culture, patented a number of devices for processing cranberries at Whitesbog. Tom Darlington, his grandson, invented the Darlington Dry Picker. Abbott Lee, of Speedwell, patented one of the wet harvesters in use in the region. The Lees and the Darlingtons are now in the process of developing floating pickers—essentially a new kind of work boat. Central to this free-flowing exchange of ideas is a local machinist who gives the ideas form. "It's a very tight-knit industry in terms of all the locals," said Mark Darlington.

We can borrow equipment back and forth, and Dave Thompson, the local machinist, is fantastic at coming up with the stuff that my dad can conceive of. My dad will work out something and Dave will make it, and what'll happen is somebody'll hear about it and want to try it out. We'll loan it to 'em and they'll come back and say, "Well, we need these changes on it." Pretty soon some grower can go to Thompson and say, "Hey, look, I need thus-and-such," and he'll say, "Okay, I made it this way for so-and-so, and you probably want the bigger wheels," and he can just make it up for 'em. And every year we change it, and he ends up doing the changes on it, and so he sort of keeps up on that and he doesn't even need drawings or anything. [Interview, Mary Hufford and Mal O'Connor, November 18, 1983]

Disparate notions of perfection and of what's beautiful are

cast into relief here. A number of the old bogs in Whitesbog were purchased by Lebanon State Forest nearly twenty years ago. They are not currently harvested and could be regarded as feral bogs—cultivated bogs that have gone wild. To a visitor, their deep and random ditches are beautiful. To a cranberry grower, they represent something else. "There's one twenty-five-acre bog that was just unmanageable," said Mark Darlington.

It had this ditch that goes over the top of your head. It just wanders—it's got oxbows in it! You can't pick it, it's just a mess over there. . . . It's four feet out of level—that means the top end's got to be five feet deep before the lower end even sees any water. And that's a staggering amount of millions of gallons. And over there we don't have a closed water system; you have to open the gate at the bottom and let it go downstream and that's it.

What's beautiful, on the other hand, is a solution to a problem in cranberry management, imaginatively wrought. The bogs that the Darlingtons developed across the highway from Whitesbog, in Buffin's Meadows, are widely acknowledged to be state-of-the-art bogs. What's beautiful is their precision, economy, and efficiency. The ditches have been eliminated, as Mark explained:

These bogs over here, Dad sat down from the very beginning to try to make as efficient as he possibly could, so it's as level as we could make it. It's all two hundred feet, center to center, on the dams, exactly. The bogs change length, but they're all exactly the same width, so we're able to spray 'em from one dam with a sprayer that goes out a hundred feet, then you go around the other side and do the other part. Then you don't need any ditches down the middle for water.

The same principles apply to machinery: "The beauty of my dad's engineering is that it doesn't look great—it looks rather strange most of the time. No frills on it at all. It's elegant from an engineering standpoint, because it's as simple and easy to build as a machine can be and get the job done."

Many local grown-ups drew some income as children working in cranberry and blueberry fields. Child labor laws did not apply to the children of cranberry growers, and working in the fields was part of growing up. Stephen Lee III and his brother Abbott recalled playing in the blueberry fields when quite young, building their own miniature bogs. At eight or nine they began driving tractors, nailing cedar blueberry flats together, and counting tickets. Local children

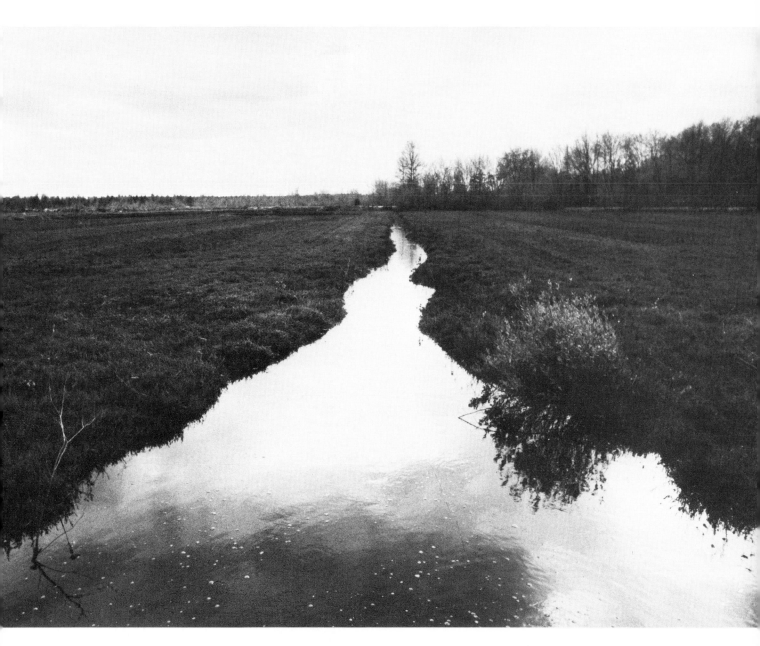

still earn some pocket money in the cranberry and blueberry
fields. Several growers suggested that teen-age vandalism
would diminish if newcomers understood the landscapes the
way those who work and play on them from childhood do.
"Children who move here are frustrated by the lack of things
to do," commented Mary-Ann Thompson, "and part of it is
that they're not trained to live in the area." [Meeting with
fieldwork team, September 16, 1983]

The local work force was supplemented earlier in the
century by Italian laborers from South Philadelphia. They
were hired through an Italian boss or padrone who super-
vised hundreds of families during the harvest each fall. In
Whitesbog a padrone named Donato always hired a number
of musicians and a well-known storyteller. They lived in
houses that have since burned to the ground. Where the
foundations are still marked by the flora of civilization, the
spots are still called "Rome" and "Florence."

These days the bogs are glossed in Spanish by Puerto Rican
farmhands, in Creole by men from Haiti, and in Khmer by
Cambodians. Fieldworker Bonnie Blair spent a morning at
the Birches in hip-waders, learning to walk in a flooded bog:

One of the Haitian men told me that I had to be sure to
walk carefully, and that the way to learn what the land
was like under the water was to "watch out" (in the sense
of "see") with your feet. Orlando Torres told me that this
was a good bog to work, in terms of depth of the water,
since it didn't have too many holes, and even the ditches
weren't too deep. [Fieldnotes, Bonnie Blair, October 14,
1983]

The position of water watcher (or water foreman or water
checker) falls to the man who knows the water and the range
of its interactions with the land. He has to patrol the bogs,
watching for damage by beavers and swans, leaks in gates and
sluices, and any other irregularities. Jack Cervetto used to
watch the water around Abe Gerber's bogs in exchange for
the privilege of gathering sphagnum moss on the property.
Cervetto knows the water intimately—every slough, island,
and bottom. He is able to distinguish gradations in what is to
newcomers an undifferentiated wilderness. He knows where
the water comes from and where it is going.

"All right," said Jack Cervetto to fieldworker Nora Rubin-
stein on a tour of his swamp near Plain Branch, "now see that
water we just went through? That separates that island from
this island. Now this is another island surrounded by water."

"How can you tell that it's a slough and not just a wet spot?"
Nora asked him.

"Well, it's low all the way around it. Altogether different

bottom. See that rain we had the other day. . . . Last week this
was perfectly dry. The rain we had the other day has put some
water in here."

"Does this island have a name?"

"No, no, but it's my island, and I'm pretty well attached to
it."

"How deep is this?"

"It isn't too deep. You know on the bottom, all this bottom
here is stone as white as milk. Gravel, stone, white sand, as
white as chalk or milk." [Interview, Nora Rubinstein, October
28, 1983]

He spoke of other kinds of bottom. Savannah bottom is low
bottom on the upland, with solid clay from the top down. No
trees grow there because of the clay, only savannah grass. In
wet weather one has to be careful because the clay gets soft.
Oak bottom is "loomy" (loamy) ground, good for farming.
Oak mulch is sweet, pine mulch is sour. "The type of vegeta-
tion gives you the type of soil," Cervetto told her.

Cervetto, a veteran fire fighter, checks the condition of the
vegetation and soil frequently to obtain what he calls the fire
index. When the ground is very dry, the fire index is high, and
he doesn't go too far from home. The old-timers always knew
to check the fire index. "Young people don't seem to check
for it as much," Cervetto observed.

The foreman of the entire operation is often a local per-
son, who exercises a natural leadership in the community.
"Old-timers with the proper authority make the best fore-
men," said Mark Darlington. Old-timers, who probably
worked in the bogs as children, are valued for their knowl-
edge of the water and, in several instances, were never retired.
"Retiring an old-timer is a tricky business," said one grower.
"First of all, you can't replace them, because they know so
much, and secondly, without something like this to keep them
going, they're likely to die within six months after they retire."
As long as they are willing and able to work, their services are
valued. The cultivation of water foremen is not formalized—it
occurs within families whenever a child seems interested.
Bobby Hopkins, the water foreman at Whitesbog, frequently
brings his grandson Matthew, a preschooler, to the bogs.
"That means," observed Mark Darlington, "that someone in
that generation is starting to learn about the water." [Field-
notes, Mary Hufford, November 18, 1983]

Cranberry bogs and cedar swamps are intertwined, in
their histories, and in the experience of those who work
in both. Logging operations, however, do not draw the
appreciative audiences that cranberry harvests do. Cervetto
and Brewer spoke of their critics, who protest the seemingly

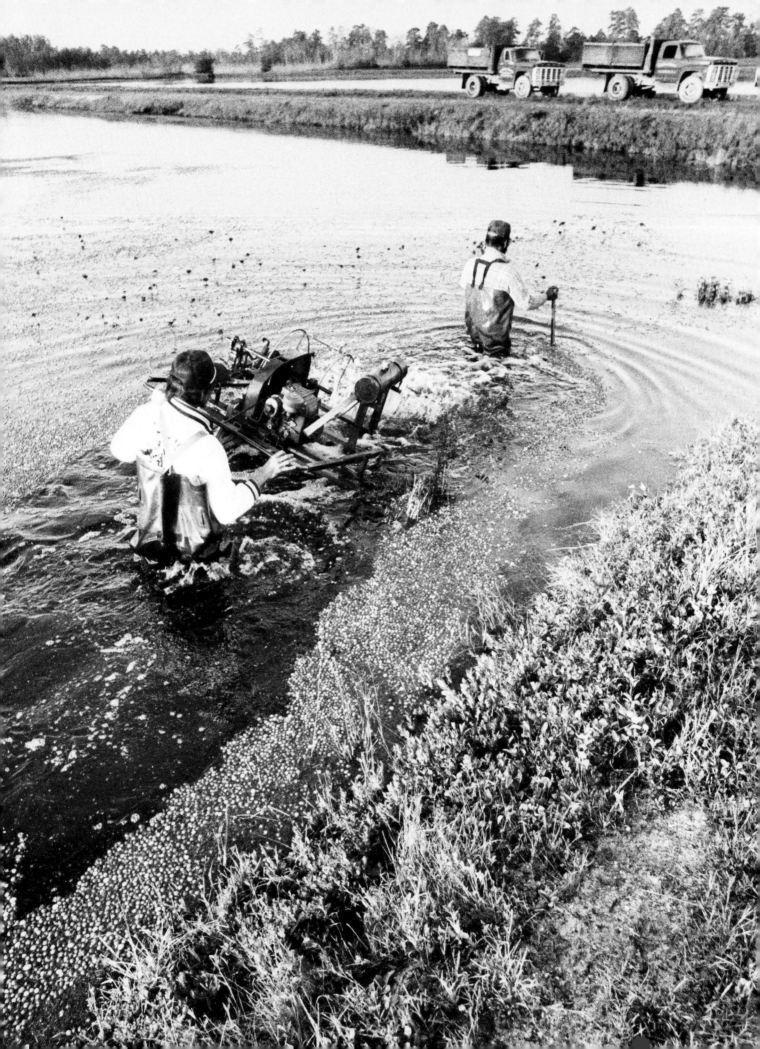

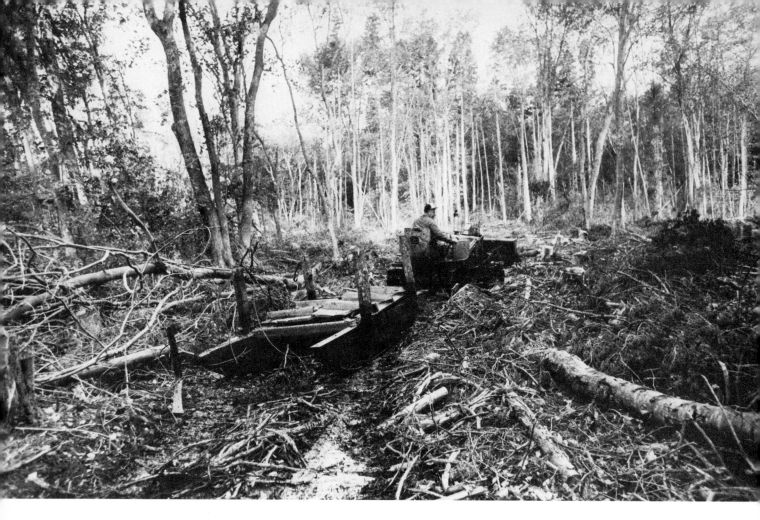

wanton destruction of trees. Cedar sawyers, however, view the trees as living organisms, to be stewarded within the larger unit of life that is the swamp. Like bogs, swamps can be coaxed toward perfection by human standards, though on a much larger scale. Swamps have to be weeded with chain saws to eliminate the maple and gum. "That's nature, competition," said Clifford Frazee.

We want the cedar, but nature wants the maple. So what I'm trying to do is get the cedar to grow there, and I'm cutting all the maple and gum out because if I left it the cedar wouldn't come back, because there would be too much shade for the cedar to grow. [Interview, Mal O'Connor and Mary Hufford, October 7, 1983]

Each cedar swamp presents a variation on basic cedar swamp anatomy, the ideal form of a swamp that exists most firmly in the minds of cedar sawyers. As Cervetto says:

Some swamps are only a hundred feet wide, some six hundred feet wide. Oswego Swamp, where I am, is a thousand feet wide. It starts up at Coffin Board Hollow, in the Forked River Mountains. Along the edge of every swamp is a variety of species of plants—magnolia, gum, maple, huckleberry—a hundred of them before it gets into the wet part. There are hard-bottom swamps and dry-bottom swamps. Each cedar has a hassock around it, about eight to twelve inches wide—it's a natural entanglement of roots around the cedar, and it's where you

George Brewer of Dennisville wends his way through Great Cedar Swamp with his bulldozer and sled. He passes through places uncharted and unseen by motorists, such as Laurel City, Buzzard's Clump, and A Horse Hung Himself. *Photograph by Joseph Czarnecki*

can hang sphagnum moss to dry when you're pulling it in the swamp. If the water gets above the hassock it kills the cedar. Of course, in dry-bottom swamps, the cedar grows without the hassocks. [Interview, Mary Hufford, April 10, 1984]

George Brewer works in Great Cedar Swamp near Heislerville. It takes him two hours to get from a major road back to the site he is lumbering. (It takes a motorist an hour to travel from Philadelphia to Atlantic City.) He drives as far as he can in a large truck and goes the rest of the way by tractor over the crossway, passing through places with names like Laurel City, Buzzard's Clump, and A Horse Hung Himself. The felling operation is only the most visible part of a management process that is taking generations to test and develop.

Clifford Frazee's logging operation is on the North Branch of the Forked River, roughly six miles northeast of Jack Cervetto's stand on the North Branch of the Wading River. Though it might not appear so to the casual visitor, the place is steeped in history. For Frazee that history is everywhere in evidence—in barely discernible remains of charcoal pits, some of them containing "butts" indented with hundred-year-

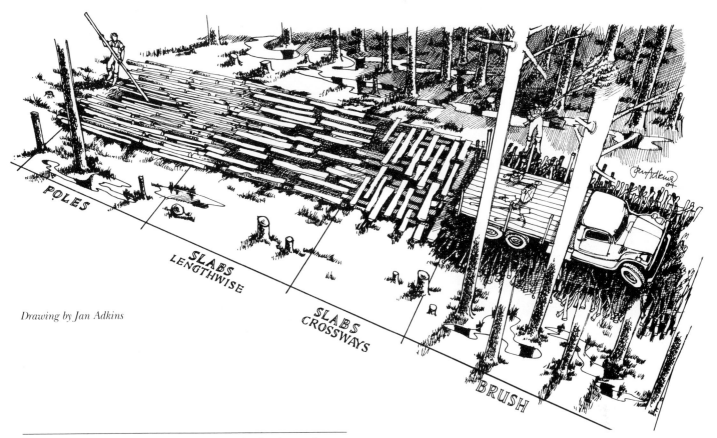

POLES

SLABS LENGTHWISE

SLABS CROSSWAYS

BRUSH

Drawing by Jan Adkins

Clifford Frazee of Forked River standing on the first layer of a corduroy road on the North Branch of the Forked River. *Photograph by Joseph Czarnecki*

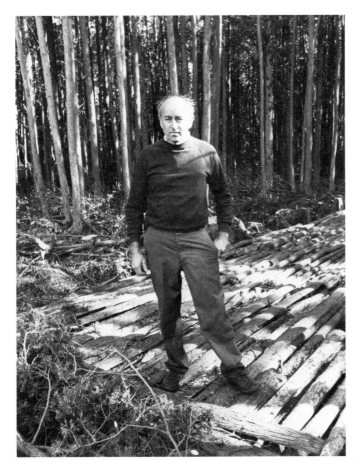

old axe kerfs, and in other structures that subside into the landscapes, like the ubiquitous crossways.

Crossways, also known as causeways, corduroy roads, or pole roads, are roads built by cedar loggers in order to haul tons of cedar over mucky swampland. The term *causeway* is also applied to bridges, many of which were built in connection with the woodland industries. Most of them are not named on maps, though woodsmen know their names and whereabouts intimately. Frankie's Crossway, the oldest in the area, according to Frazee, was built around the end of the eighteenth century, about the time when nature reporter Peter Kalm predicted the imminent extinction of Atlantic white cedar. One of the more recent, Collins' Crossway, is a bridge built by Frazee out of creosoted lumber capable of supporting fifty tons. It is so named because "Collins was a predominant name for woodspeople."

The construction of a corduroy road is a time-consuming process, executed by Cliff Frazee and his son Steve with great craftsmanship, as fieldworker Mal O'Connor observed:

Roadwork must be done on each of the two days per week spent in the woods in order to get the truck back to where the logs are, and to take advantage of the low water table during dry season. First, Steve carved out the road by marking the borders with his chain saw. Then Cliff and Steve leveled the roadbed, removing all stumps within the borders by running the chainsaw, first hori-

George Brewer of Dennisville.
Photograph by Joseph Czarnecki

zontally along the desired level (the bottom of the stumps), and then slicing pieces perpendicular to the initial cut. Roots are then discarded and the moss and dirt is forced into the mushy, level floor that remains. The thinnest cedar logs (less than four inches at the butt), together with maple and gum logs (swamp hardwoods called "junk trees" by Frazee), are positioned longitudinally along the road. The thinnest logs are placed in the middle, flanked by thicker logs where the wheels of the truck will need the most support.

The next step on the road is to bring a load of slabs from the mill on the next trip to the woods and place them in between the logs to level that section of the road. Then limbs that had been trimmed from cedar trees are placed on the top. Two sets of limbs meet in the center, mirroring each other, crotch ends out, brush ends in. Again, everything is used. [Fieldnotes, Mal O'Connor, October 14, 1983]

Everything is not only used but used to its maximum capacity. Frazee pointed out that by placing slash on the road to improve its passability he also improves the growing conditions for the miniscule saplings struggling to come up beneath the brush. The road itself becomes a strategy for managing cedar.

The old-timers did it that way. We put the brush on the crossway, and that holds the slabs in position. We leave the slabs right there and the cedar won't reseed in the road, and the trees'll grow up on both sides and meet at the top. I can show you a couple of places where it was cut off like that a hundred years ago. It's rotted out, but the trees don't grow up in it. The advantage is that it gives a tree five extra feet for growth. You should thin out cedar, but if you thin it too much the wind'll blow it over. We fall 'em all toward the crossway, and most of 'em fall right on it. You have to notch 'em just right to

have 'em fall. [Interview, Mary Hufford, September 23, 1983]

George Brewer noted that the older roads were built by men who were paid two cents a rod. They had to be very tightly constructed to accommodate horses and oxen. "That was an art in itself, building a crossway," he said. The first logs to be put into the muck were called "dead men."

Atlantic white cedar, one of the most valuable timbers on the East Coast, takes from eighty to one hundred years to mature. It could grow faster if it were not so crowded. One hastens the harvest at the expense of the product, however. Cedars, which compete with one another for sunlight, also support each other against windthrow. "Clear" cedar, free from knots, is the product of many years of crowding that subdues and naturally eliminates most of the branches beneath a canopy that towers sixty feet overhead.

Given the years it takes cedar to mature, experiments with cedar and evaluations of those experiments are spread out over several generations. The chances of one man raising and harvesting the same stand of trees are slim. Despite the lengthy time frame, cedar sawyers chronicle human influences on the upcoming crops. George Brewer told Jens Lund of his father's experiments with thinning cedar. In the late 1940s he decided to eliminate the weaker pole-sized cedar in a stand of sixty-year-old trees. The method worked until a fierce snowstorm blew the standing trees to the ground. Eventually they righted themselves, creating what is known as "boxy" timber—dense wood that closes up on the saw. Several decades later, when the stand was cut, all the trees had a streak of boxy wood. "Shook" timber results when scattered trees are twisted by the wind to the point that they crack.

Brewer speculates that certain kinds of fire produce good cedar. He logged a stand of cedar that grew in Burnt Causeway after a fire swept through in 1887. "There's a beautiful piece of cedar coming up where they had that fire in 1944," he observed. Under certain conditions, fire eliminates competition between cedar trees and junk wood. But the turf

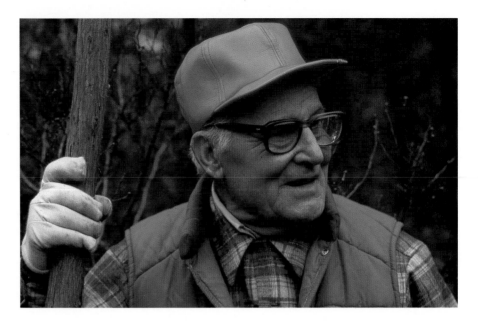

Jack Cervetto of Warren Grove.
Photograph by Joseph Czarnecki

containing the cedar seedlings must be wet enough to protect them from burning. Cedar sawyers monitor young cedar from its most miniscule state. It comes up, George Brewer said, like hair on a dog's back.

"See that young cedar in there?" said Jack Cervetto to Nora Rubinstein. "Beautiful crop of young cedar! This was cut off about forty years ago—I cut this off. Look at the nice young crop come in. Beautiful."

For Cliff Frazee the crucial agent in the regeneration of cedar is water. He compares cedar, with its acute sensitivity to environmental changes, to oysters. Conditions have to be right or the swamp will come back in maple or gum. He is continually working on new solutions to old problems of cedar management. One solution he espouses involves plugging up the stream in the harvested area with brush so that the water will flow throughout the flood plain to the rest of the cedar. His theory is that the water should be halfway up on the cut stumps (which are about three inches) to allow for reseeding. Balance is critical—whole stands of cedar have been drowned by beaver dams, and cedar that grows in too much water is too hard. The old-timers called such wood "brazil," and Frazee says, "You could get killed trying to saw it."

Cedar does not rot out in swamp water. In the early part of the nineteenth century, mining cedar logs was a lucrative activity centering around Dennisville. Logs that were estimated to be more than a thousand years old were dredged up in perfect condition where they had fallen and been covered over with muck and peat. How entire swamps came to be buried is something to marvel over. Cervetto attributes the phenomenon to hurricanes. Brewer wondered whether a comet could have punched a whole swamp into the ground. Trees that had fallen over with their roots attached were called *windfalls*. Trees that had broken off were known as *breakdowns*. Wilson reports that breakdowns were more easily mined, and a log digger would first secure a chip from any log he discovered, determining by the smell of the chip whether the tree was a windfall or a breakdown.[8]

People use all their senses in making sense of the woods. Jim Stasz, a naturalist and avid bird-watcher who spent much of his boyhood in the Pine Barrens, says you can close your eyes and, just by smelling the plants, predict what birds are in the vicinity. Conversely, you can tell by the bird songs what plants are there. Sphagnum smells like iodine, according to Cervetto, and mosquitoes can't stand it. Therefore there are few mosquitoes in the swamp. Brown creepers are found where there is cedar, seeming to prefer the flaking bark. [Interview, Eugene Hunn with Jim Stasz, December 19, 1983] That bark is also favored by pole beans. "I have in my garden almost five hundred poles of pole lima beans," said George Heinrichs to Elaine Thatcher.

> Those are cedar poles. You could use the regular two-by-two's from the lumber yard, but the cedar has a rough bark that makes it very easy for the beans to climb on. Yeah, like Jack and the Beanstalk, if you had one twenty feet in the air, he'd go clear to the top of it. [Interview, Elaine Thatcher, October 1, 1983]

The acoustics in a cedar swamp have enhanced the music of many a fox chase in the region. According to Jack Cervetto, cedar produces its own music: sixty-foot trees loosely mired often rub against one another in the wind, sounding like a musical instrument:

> In freezing weather when the wind blows and the dead trees lean over against the green ones, it's just like an accordion. And every one sounds different. [Interview, Mary Hufford, April 4, 1984]

Like water from the aquifer, cedar emerges everywhere. It is one of the most celebrated timbers for boatbuilding. Cedar sawyers know the needs of their customers and walk through swamps identifying clam stakes, setting poles, fence posts, and trees destined for boats. "The long ones there with a green

top onto it," said Jack Cervetto, again addressing what appeared to be a stand of trees,

> they're clam stakes. When the state rents out an area in the bay to store their clams, then they buy those clam stakes and mark out their clam grounds. And this stuff here is snow-fence posts for municipalities like Brant Beach and Surf City. They put these posts down and a snow fence around it to keep the sand from blowing away. There's bean poles, and a lot of this short stuff is used for fencing and dog pens and things like that. [Interview, Nora Rubinstein, October 28, 1983]

Slabs are returned to the corduroy road, and scraps are saved for decoy carvers. The sawyer's knowledge of wood plays an important part in the production of cultural artifacts. Harry Shourds, a well-known decoy carver from Seaville, obtains his cedar from George Brewer. "Brewer really knows his wood," said Shourds. "He knows what's good for carving, for boats, and for shingles."

In its transformed state, the wood follows the watershed into the bay. Sometimes, unfortunately, the flow is reversed. Salt intrusion is bad for living cedar, and George Brewer notes the presence of brackish-water cattails in a swamp with alarm. Mutatis mutandis, however, cedar is superior to any other wood for use in salt water.

George Brewer provides the planking for repairing oyster boats on Delaware Bay, and Clifford Frazee's lumber ends up on Barnegat Bay, via the workshops of boatbuilders Joe Reid and Sam Hunt. Reid is acknowledged locally as a master builder of Jersey garveys, and Sam Hunt produces the Barnegat Bay sneakbox—both indigenous boat types that evolved along with the landscapes of the region.

Garveys, blunt-ended boats used by clammers and oystermen, are not beautiful. One of Reid's customers told Tom Carroll, "A garvey's just about the ugliest thing in the world, but it makes a dynamite work boat. It's a flat-bottom boat. It's actually a working platform." [Interview, Tom Carroll, October 8, 1983]

Joe Reid, who for many years worked the bay clamming and fishing, now builds and repairs boats in his workshop behind his house in Waretown, assisted by his son James. Like the management of cedar in swamps, the transformation of cedar into salt-water vessels is underwritten by generations of trial and error and critical observation, some of it occurring in the context of the family enterprise.

"It's a beautiful wood, cedar," said Joe Reid to Tom Carroll, "the best wood that grows, for boats." Reid has experimented with various kinds of wood and spoke of the merits and shortcomings of each. Oak is too heavy and prone to rot. White oak can be used for sprung timbers in a round-bottomed boat, such as the sneakbox. For cut timbers, Douglas fir is best, because it holds a nail better than cedar. Pine soaks up a lot of water and would weigh twice as much as a cedar boat.

> Some of the old boats were built out of pine around here, and when you'd pull them up on the bank, their seams would open up three-eighths of an inch—the wood would shrink, then the seams would go back together again when you put it in the water, but sometimes they'd get gravel in them, and you couldn't get it to go tight again. [Interview, Tom Carroll, November 16, 1983]

Spruce? They use that for boats farther north, but it doesn't hold up well in warm water and won't hold a nail the way cedar will. Southern cedar, that is, Atlantic white cedar that grows in a southern state like North Carolina, makes big boards and is tough. However, it is no good on the bottom of a boat. It is short-grained and breaks off—perhaps, the sawyers speculate, because the winters are not as harsh down south. At any rate, Jersey cedar is the best wood for Jersey waters.

> Our cedar has a long grain, and you can steam it. Every night we'd steam a board up in the bow, clamp it, and leave it overnight, next morning it'd be shaped. If we did that with Southern cedar, next day it'd be broke right in two. We didn't know that until we started using it. Fiberglass doesn't handle itself in water the way that cedar does—cedar takes in just the right amount of water. When it's first put there, it tends to sit right on top of the water. In a couple of weeks it soaks up the right amount of water and settles down. Then it handles really well. You can't beat cedar for a boat. [Interview, Tom Carroll, November 16, 1983]

Like bog-building and cedar management, garvey construction is not strictly prescribed. "Every boat is different," said James Reid, Joe's son and apprentice. "My father hasn't built two boats exactly alike." There are certain strictures, however, for the boat must be able to navigate in less than three feet of water. "You can't beat a garvey for the bay," said James.

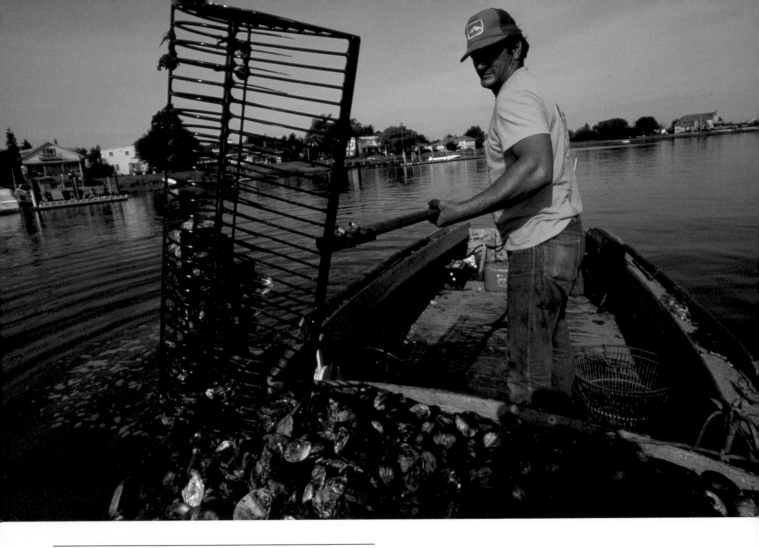

Charles DeStefano of Pleasantville loads clams with a shinnecock rake into his Jersey garvey. *Photograph by Joseph Czarnecki*

Of course, there were a few different places where any boat could get through, and everybody local knew it. Of course, if they had garveys they could just go wherever they felt like, and if people would try to follow 'em they'd run aground. That was before the State started dredging and maintaining channels too much." [Interview, Tom Carroll, October 8, 1983]

The bay bottom has changed in other respects during Joe Reid's lifetime. There were numerous channels, most of them small and unmarked but all of them named. There was Horsefoot Slough, near Sedge Island, and Buck's Slough, named for Old Man Buck Ridgway, Fishing Slough, Cooper Slough, and Sammy's Slough. Sammy's Slough was named for Sammy Birdsall, and a bayman knew he was on it in the flats (a portion of the bay two feet deep) when from his view Sammy Birdsall's house on the shore was aligned with the tree behind it. Reid remembers three islands in the Bay that were washed away, though he used to have to watch out for them in his boat.

There are three methods of clamming: treading, raking, and tonging. One treads for clams by feeling for them with one's toes in shallow water. Good treaders can manipulate the clam by foot up the opposite leg, bringing it within arm's reach. Teeth take the place of toes on scratch rakes, known locally as shinnecocks. Tongs, also toothed, are plied from the side of a garvey. Features on individual garveys are related to the preferred work techniques of their owners. Pleasure boat builders can indulge in more flare, since no one needs to lean against the side when working out of them. Work boats have wider decks for holding more clams. If a clammer uses a shinnecock, he might have a small cabin on his garvey, since raking is done off the back. Joe Reid, who always tonged, had no room for a cabin, because he manipulated the long handles around the boat from one side to another. [Interview, Tom Carroll, October 8, 1983]

Rakes and tongs were developed for clamming in different bottoms. Rakes can only be used where clams are close to the surface. A clammer can distinguish a clam from a rock by the feel transmitted through the handles. Tongs comprise han-

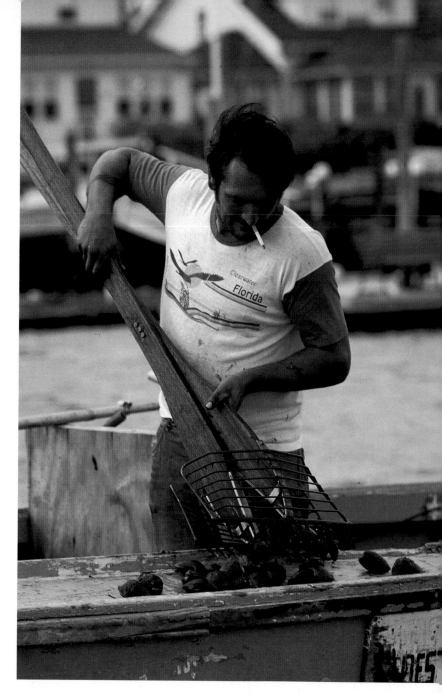

Right: Tonging on Barnegat Bay with keyport heads.
Photograph by Joseph Czarnecki
Below: Barrel, keyport, and wooden heads.
Drawing by Jan Adkins

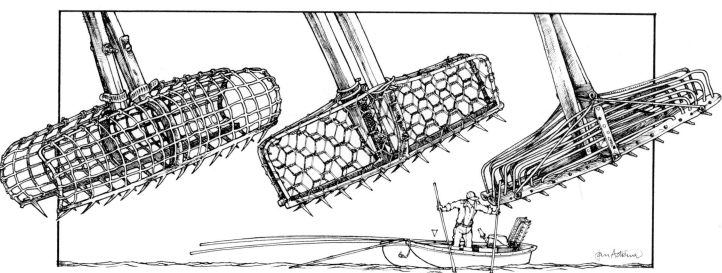

dles, known locally as stales, and heads. Louis Peterson, a Delaware Bay oysterman, keeps three kinds of heads on hand: wooden heads, barrel heads, and keyport heads. On keyport heads the stales go all the way to the teeth; on barrel heads the stales go only to the beginning of the basket. Wooden heads are made of seasoned oak, with teeth of sawed-off steel pounded through. Wooden heads are best for soft bottom. "You can catch oysters with wooden heads when you can't catch anything but mud with the other ones," said Lou Peterson to Jens Lund. He uses his barrel heads for shallow, hard-bottom tonging. The critical factor is the setting of the teeth. Hard bottom requires more of an angle. Heads are set to catch on the top for oysters. For clams, the teeth are shorter, closer together, and set to dig deeper into the mud. [Interview, Jens Lund, October 22, 1983]

The mud on the bottom of the Maurice River is so loose that seed oysters there can only be caught with wooden heads. "You have to feel your tongs, and hold up on them,

and you can pretty near feel the oysters goin' in," said Peterson. He learned to be a bayman from his father and grandfather. His grandparents, he recalled, sometimes lived on their oyster boat—one of the "mosquito fleet" that used to come out of Dividing Creek and tong the high beds between Egg Island and the mouth of the Maurice River. Some of Peterson's growing-up happened on their boat.

I'd be back in the wheel house with Grandpop and he'd be tellin' me tales. Actually, he was teachin' me. He couldn't read nor write, but he could count and he knew what he was doin', and he had poems that was his way of rememberin' your nautical terms for if your boat was dead ahead or goin' away from you or whatever it would be. . . . I can't really remember them, but it would be combinations of lights, such as, "If a red and green and white you see, then on your left he'll be." [Interview, Jens Lund, October 22, 1983]

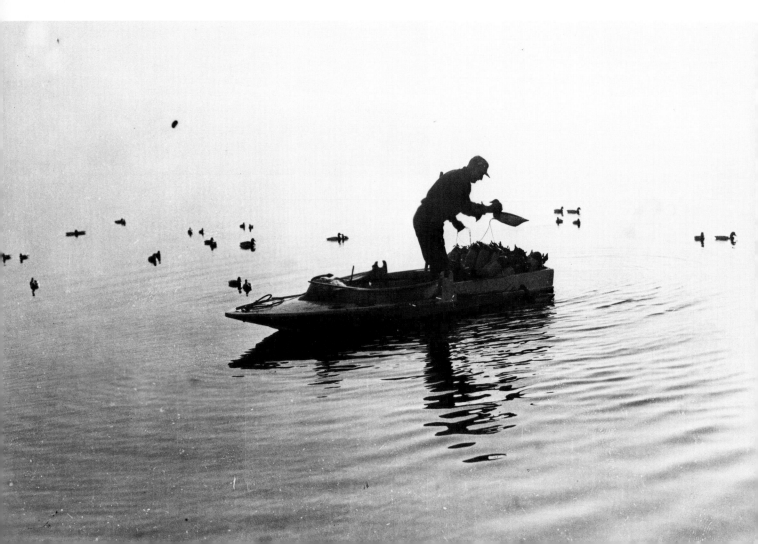

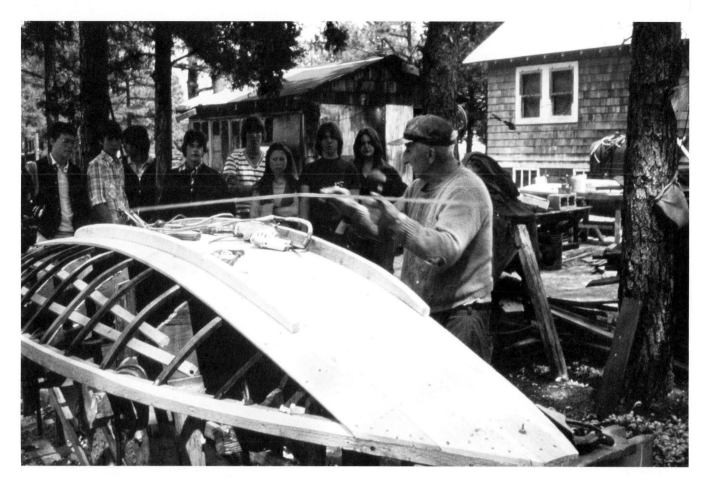

"I don't think that you consciously know anything," he reflected later. "I think living around this area and growin' up around it, your senses become used to it … you take my father-in-law—he moved down here in 1950, and he couldn't get over the fact that every native down here, when the wind changed, noticed it." [Interview, Jens Lund]

Between the woodlands and bays are the meadows, home territory for one of the most elegant duck-hunting skiffs in the country. The Barnegat Bay sneakbox, also built of Atlantic white cedar, is an ingenious example of a form born of and intended for use in a particular environment, in this case the brackish estuaries of South Jersey.

The craft came of age in 1836, in the workshop of Hazelton Seaman. Seaman was, according to Nathaniel Bishop,

a boatbuilder and expert shooter of wild-fowl [who] conceived the idea of constructing for his own use a low-decked boat, or gunning punt, in which when its deck was covered with sedge, he could secrete himself from the wild-fowl while gunning on Barnegat and Little Egg Harbor Bays. . . . While secreted in his boat . . . hidden by a covering of grass or sedge, the gunner could approach within shooting distance of a flock of unsuspecting ducks: and this being done in a sneaking manner, the baymen gave her the sobriquet of sneakbox.[9]

The craft is small—twelve feet long by four feet amidships. It generally accommodates one man, or, as Heinrichs

pointed out, a man and his boy. It is light enough that one man may pull it over land between channels. It is equipped with a mast-hole, centerboard well, and detachable rudder for sailing; oarlocks that fold down and a removable decoy rack to promote absence of profile; runners for traveling on ice; and accessory ice hooks for breaking up porridge (slushy) and pane (hard) ice. Its spoon-shaped hull enables it to glide through areas marked as land on coastal maps, and its draft is shallow enough, as the saying goes, "to follow a mule as it sweats up a dusty road." Its sloping transom allows a hunter to row backwards in channels that are too narrow to turn around in. It is linked in tradition with the Barnegat Bay duck stool—a decoy renowned for its dugout body; the bodies are carved hollow to lighten the burden on the tiny sneakbox.

In the sneakbox the shapes of men and meadows are fused. The planked-over deck, which keeps the gunners' legs warm, was often custom-made. "They used to build a sneakbox special for a man," Sam Hunt once said. "He used to lay down on the ground and they'd draw a circle around him and build a hatch so his belly could stick out."[10]

Plywood cannot be used in sneakboxes, because it will not accept the requisite compound curves the way cedar will. Each plank is curved in two different directions, and no two planks are curved in exactly the same places. Gus Heinrichs, George's father, made a separate pattern for each plank, which he numbered. When his father was dying, George vowed he would never let the patterns out of the family. "I

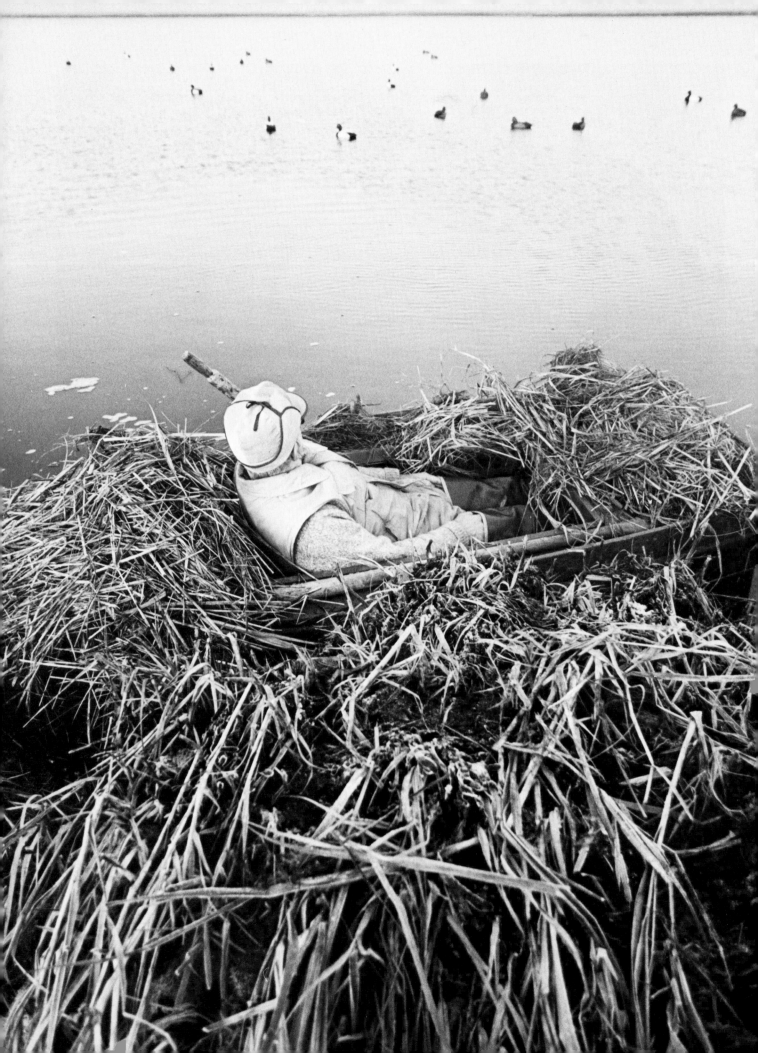

made a promise to my father that if I didn't build boats and my brother didn't, that I'd cut up the patterns and destroy them, because it's his pattern and no one has ever copied it. The Heinrichs sneakbox will die if I don't continue." [Interview, Mary Hufford, September, 1979]

Like cranberry bogs, sneakboxes belong to branches of families. "I'm a third generation sneakbox builder," said George Heinrichs to Elaine Thatcher. "I've been in the boat business all my life—it's in the blood. My father and all of his family were boatbuilders. We're just completely a boat family. That's the way we was born and raised." [Interview, Elaine Thatcher, October 1, 1983]

The meadows that shaped the Barnegat sneakbox are themselves shaped in connection with another traditional land-use pattern: salt-hay farming. Like cranberry bogs, salt-hay fields are banked and ditched for irrigation and drainage. They have treacherous and unpredictable bottoms, and levelness is an ideal seldom realized for long. Each spring, Joe Reid recalled, smoke could be seen over meadows from Forked River to New Gretna when salt-hay farmers burned their fields off. The fires allowed air to circulate through the root systems and provided some insurance against rotten marsh by strengthening the surface mat. The mat comprises a network of decomposed plant fibers and roots strong enough to support horses and heavy machinery when the hay was cut in the fall. If firm enough, the entire marsh may undulate, but a man will not fall through. "A lot of marsh," said salt-hay farmer George Campbell,

> you'll go over it, and it will wave, but then there's some marsh you don't wave, you just go 'poonk!' and that's what we call rotten marsh. It's interesting. You're a hundred yards off and you feel the meadow vibrating. [Interview, Jens Lund, November 7, 1983]

In the nineteenth century the hay was cut with horses, scythes, and pitchforks. The horses wore special wide shoes—some of them with leather uppers and giant buckles—to keep them on the surface. Boats known as hay scows were used to transport horses and hay. Now that work is done with tractor-drawn windrowers with balloon tires.

Salt hay is much finer than what George Campbell calls fresh hay. It still grows along Barnegat Bay, though it is not harvested. "Up Jersey, goin' up the Parkway, one place I cross there's a beautiful salt marsh, and I'd love to get a blade into it 'cause it has beautiful salt hay."

There are four kinds of salt hay: rosemary, yellow, sedge, and black. Each one flourishes at different elevations that vary only by inches. The meadows are fertilized once a month at spring tide when the ocean washes over the banks and spreads throughout the meadows. Salt hay is used for mulch around flowers, as packing material for bricks and ceramics, as insulation for concrete, as animal feed, and in caskets. "When you're laid out," predicted Lou Peterson, "it'll be on a bed of salt hay."

George Campbell's father harvested salt hay in Dividing Creek, as did his grandfather. The meadows bear names like the Cabin Marsh (where his father built a cabin), Hand Meadow, Turkey Point, and Owl's Nest. Winter is a good time for harvesting salt hay in particularly wet areas, because the frozen bottom can then support heavy machinery. Freezing in the marshes produces what George Heinrichs calls "cut-outs"—clams that are forced upward out of the muck. They can be picked up soon after the thaw. Heinrichs used to fill a sneakbox with cut-outs.

"You have to know the meadow bottom," Campbell told Lund. "When you've worked in it as long as I have you just learn it, and you know your meadow and you know places that you don't go." Once when he had to travel he left his sons in charge of haying down in Cabin Marsh.

They seen a big piece of marsh that I hadn't cut and they said, "I wonder why dad hadn't cut this." Well, I got a phone call. They had all three of my tractors down. They shouldn't've been out there, and they didn't realize that piece was that soft until they got out and got into it. The Mosquito Commission come down with one of their rigs with a big winch on it and winched them out. [Interview, Jens Lund, November 7, 1983]

Maintaining the banks is half the battle. These days salt-hay farmers struggle for survival on two fronts. One battle is with the ocean. Owl's Nest and Turkey Point were reclaimed by the ocean. "The tides break the banks and the tides just keep comin' in and it changes the whole vegetation structure and you lose all your salt hay. It turns into unmarketable stuff and gets so soft and wet that you can't get out there with machinery."

The other battle is against sterilization of the marshes by pesticides, notably DDT used against mosquitoes.

It infuriated me a few years ago. They was sayin' I was raisin' all the mosquitoes in the salt meadows, and I said, "Well, you come in and you wiped out all the natural

enemies of the mosquito and then you claim I'm raisin' 'em," because they wiped out the fiddler crabs. The whole meadows was sterile. The fiddler crabs was gone, the mussels was gone, the fish in the ditches was gone, the crabs in the ditches was gone. . . . I was pleasantly surprised how quick the meadows has come back since they quit using it. The fiddler crabs is back strong now. The meadows just came back to life again. The dragonflies is back, and it's good to see 'em. [Interview, Jens Lund, November 7, 1983]

The meadows have regenerated on that front, but, as Campbell says, the same Mother Nature that bounced back is eventually going to prevail against him:

Salt haying has always been a hard, dirty job, and a lot of people don't care to do it and a few of us is crazy and we love it and you do develop a love for it — I'm not ashamed to admit it. Last year I was down on my bay shore down here, my bank had broke, you know. I stood there and cried 'cause I seen a way of life leavin', you know, that I'd loved, and you can only fight Mother Nature for so long and she's gonna win. I know she's gonna win. [Interview, Jens Lund, November 7, 1983]

The meadows could be seen as a kind of buffer zone between the woodlands and bay. For men who later in their lives worked in the bay or woodlands, it provided a training ground in adolescence. Clifford Frazee trapped muskrats

George Campbell, a salt-hay farmer in Eldora, keeping the meadows in order. Since the 1950 hurricane he has had to create artificial banks with his bulldozer. "We're not going to be able to do it much longer," he predicted. "It's going fast. I just keep running from one hole to another now on my cranes." *Photograph by Joseph Czarnecki*

there as a teenager, as adolescent boys still do. The meadows he trapped are now laid out in tract housing. He skinned the muskrats (locally called "marsh rabbits") by nailing their tails to the steps behind the house. He was seven when he started to trap, and as he grew taller the nail holes ascended the steps. They are still there.

When Lou Peterson was seven he worked for salt-hay farmers, running baling wire for two dollars a day. It is one of the opportunities he had that equipped him for living in the area. He remembers digging up an old abandoned boat from the meadow, and, with a friend bailing, he poled it along. They hauled seine for money that way. Today it would be illegal, he said, echoing a concern expressed by cranberry growers: "What they've done is they've just destroyed the youth just by passing laws, as far as I'm concerned."

Joe Reid got some of his first practice as a boatbuilder working on a sneakbox he retrieved from the meadows — an interesting archeological resource. "My father knew it wasn't any good, but he let me work on it anyway. I never did get it afloat, but it was good practice for me." In the subterranean muck the larger cycles enveloping the culture are concealed and revealed. There are oyster shells 360 feet below the surface of Campbell's meadows. "A thousand years ago," he said, "this was all under water. There's a larger cycle going on, and our lifetimes don't mean that much to it." Beneath another meadow, over by Port Norris, he discovered the remains of a cedar swamp. Along the Delaware Bay the meadow banks are shored up by abandoned oyster schooners, a temporary safeguard against habitats that ebb and flow.

Those who act upon the region reflect upon it as well, and it reflects back something of them. They may experience its variety in a way that is denied to visitors who come in search of wilderness alone. A visitor, contemplating a pristine swamp in the middle of a state park, does not have at his fingertips the concordance that accumulates among residents who have traded observations season after season, year after year. However he may read the swamp through his own experiences, his understanding is unlikely to embrace the connections with Joe Reid's garveys or George Campbell's salt-hay meadows or the cranberries harvested with its water or the gifts placed at Christmas under cedar Christmas trees. He will not see the myriad interior spaces where the swamp is fixed in peoples' memories. He cannot follow its tangled course through the minds of those who can tell by the vegetation how the bottoms are composed and how the water flows through the sand beneath. He may not be able to tell that the sand itself is always moving.

"Living in the pines," Joanne Van Istendal, of Marlton, New Jersey, wrote in a letter after the survey, "is a little like living on a ship at sea. The movement of the seasons, the water, and the sand becomes a part of you, and you don't realize it until you go out of the place. . . . The sand is like the sea too, it keeps moving and filtering, trying to purify itself. If you learn to live with its vastness, it gives you a sense of security, of something greater than yourself."

Notes

1. Raymond Williams, *Culture and Society* (London: Chatto and Windus, 1975), 16.
2. John Sinton and Jonathon Berger, *Water, Earth, and Fire: Voices from the New Jersey Pine Barrens* (Baltimore: Johns Hopkins Press), forthcoming.
3. W. F. Mayer, "In the Pines," *Atlantic Monthly* 3 (1859): 560–69.
4. William Bolger, Herbert J. Githens, and Edward S. Rutsch, *Historic Architectural Survey and Preservation Planning Project: Village of Whitesbog.* Report to Pinelands Commission (Historic Conservation And Interpretation, Inc., Box 111, RD 3, Newton, New Jersey 07860), September 1982.
5. Mary-Ann Thompson, "The Landscapes of Cranberry Culture," in *History, Culture and Archaeology of the Pine Barrens: Essays from the Third Pine Barrens Conference,* ed. John Sinton (Pomona, New Jersey: Stockton State College, Center for Environmental Research, 1982), 193–211.
6. Bolger, 23. See also Joseph J. White, *Cranberry Culture* (New York: Orange Judd and Company, 1870).
7. *Camden Daily Post,* August 20, 1879, cited in Harold F. Wilson, *The Jersey Shore: A Social and Economic History of the Counties of Atlantic, Cape May, Monmouth and Ocean* (New York: Lewis Historical Publishing Company, 1953), 737.
8. Wilson, 724.
9. Nathaniel Bishop, *Four Months in a Sneak-Box* (Boston: Lee and Shepard, 1879), 9–10.
10. Interview with Christopher Hoare, April 1978. Cited by David Cohen, in *The Folklore and Folklife of New Jersey* (New Brunswick: Rutgers University Press, 1983), 122.

THE ORIGIN OF THE PINEYS: Local Historians and the Legend

By David Steven Cohen

Despite its great size — about a million acres or one-fifth of the state's land area — there has always been something elusive about the New Jersey Pine Barrens. Named for its dominant tree specie, the pitch pine (*Pinus rigida*), the region is a mosaic of swamps, bogs, marshes, and forests of oak, cedar, and pine. Below its sandy, porous soil is the Cohansey Aquifer, an underground reservoir of fresh water. The region has been called a "barrens," because until recently it was not thought suitable for farming. Today some people prefer the term Pinelands, or simply "the Pines."

The stereotype of the Pineys. "Piney Funeral."
Photograph by Harry Dorer, about 1940. Courtesy of the Newark Public Library and the New Jersey State Museum

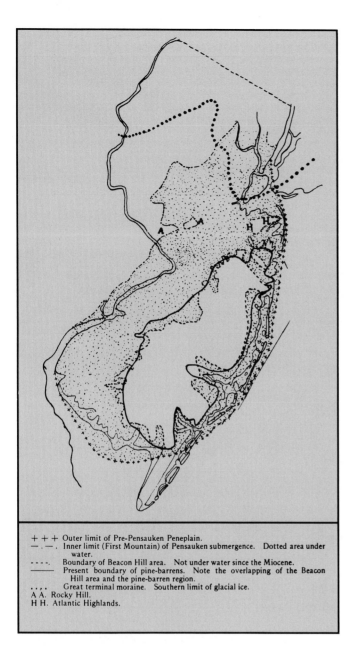

Boundaries of the Pine Barrens. From John W. Harshberger, *The Vegetation of the New Jersey Pine-Barrens* (Philadelphia: Christopher Sower Company, 1916)

+ + + Outer limit of Pre-Pensauken Peneplain.
— . — . Inner limit (First Mountain) of Pensauken submergence. Dotted area under water.
- - - -. Boundary of Beacon Hill area. Not under water since the Miocene.
———— Present boundary of pine-barrens. Note the overlapping of the Beacon Hill area and the pine-barren region.
. . , . Great terminal moraine. Southern limit of glacial ice.
A A. Rocky Hill.
H H. Atlantic Highlands.

as far west as the Maurice River. On the northeast it excludes a large part of Monmouth County included by Harshberger. Harshberger's map followed natural boundaries, while the Pinelands Commission's map used highways as boundaries in some places.[3]

When folklorist Herbert Halpert collected folktales and folksongs in the Pines between 1936 and 1941, he divided the region into two subregions. He confined his fieldwork to the subregion north of the Mullica River, that is, in Ocean County and the eastern part of Burlington County. His rationale was that the subregion north of the Mullica River was not suited for ordinary agriculture.[4] The American Folklife Center of the Library of Congress, which conducted fieldwork in the region in the fall of 1983, used the boundaries mapped by the Pinelands Commission and surveyed the folk cultural resources found within those boundaries. The point is not that one approach is wrong and the other is right; it is that regions are perceived differently by different people.

As elusive as the region are the people known as the "Pineys." Janice Sherwood of Forked River, one of the founding members of the Pinelands Cultural Society, says: "We just figure if you gotta ask what a Piney is, then you haven't been there long enough to figure it out. But I think a Piney is just a little bit deeper in the woods than you are."[5] Social distinctions are implied in the current folk terminology: the "Pineys" are those who live in the interior, the "Clam Diggers" are the baymen along the coast, and the "Rock Jumpers" are the farmers of South Jersey.[6] When Herbert Halpert asked in the late 1930s and early 1940s who the Pineys were, he was told regularly that the Pineys lived further south, until he reached a point in his travels where he was told that the Pineys lived further north. Then no one admitted to being a Piney; today people from all over South Jersey call themselves Pineys. There are even "Piney Power" bumper stickers and buttons.

This confusion is caused by the fact that the name has had a shifting referent. Some families that have lived only one or two generations in South Jersey have adopted a "Piney" identity. For example, Joe and George Albert, two brothers from Sayreville in north central New Jersey, frequently visited South Jersey on hunting and fishing expeditions. In 1939 Joe Albert moved to Waretown to live in a cabin he built in 1933. In the late 1950s George Albert retired and moved in with his brother. Their cabin became the location of a weekly musical gathering known as the "Saturday Night Jamboree" at the "Old Home Place." From this informal musical gathering evolved in 1975 the Pinelands Cultural Society and two string bands, the Pine-Hawkers and the Pineconers.[7] Gladys Eayre

The very boundaries of the region are vague, in part because vegetation regions, soil zones, and culture areas do not have exact boundary lines. The region has been delimited differently at different times.[1] In 1916 botanist John W. Harshberger mapped the region according to its vegetation. On the east he drew the boundary line just west of Barnegat Bay, on the southwest well north of Delaware Bay, and on the northeast well into Monmouth County.[2] The Pinelands Commission, created in 1979 by the New Jersey Legislature after the United States Congress established the Pinelands National Reserve in 1978, mapped the Pinelands Planning Area, whose boundaries differ significantly from Harshberger's Pine Barrens. The Pinelands Planning Area includes parts of Barnegat Bay and even some of the barrier islands on the east. On the south it reaches to the shore of Delaware Bay but only

and Merce Ridgway, two founding members of the Pinelands Cultural Society, are descendants of old South Jersey families.[8] Sam Hunt, the banjo player in the Pineconers, was Joe and George Albert's hunting guide, but he was not born in the Pine Barrens; he moved to the Barnegat Bay vicinity as a boy.

Furthermore, there has been some turnover in the population of the Pine Barrens. John Sinton has shown that the population of Washington Township, Burlington County, in the heart of the Pine Barrens, increased from 1,315 to 2,010 between 1830 and 1850 but decreased to 612 from 1850 to 1890. He attributes the depopulation in the late nineteenth century to the decline of the glass and paper industries.[9] Such a dramatic decline indicated a migration out of the region.

Not only the referent but the connotation of the name "Piney" changed. Throughout the nineteenth and well into the twentieth century the name was used in a negative way. It was in use as early as 1866, when G. T. Le Boutillier, a student at Princeton who was sent to the village of Shamong as a missionary, wrote to Rev. Allen H. Brown of the Presbyterian Church at May's Landing:

> The people who inhabit this region are the original, who have long resided here and new comers who are rapidly establishing towns and villages here and there throughout it. The former, commonly called "Pinies" are a sparse population living and obtaining a livelihood by making charcoal, gathering cranberries and huckleberries for the markets. They are sadly ignorant, and superstitious, and degraded.[10]

A few years earlier, in 1859, W. F. Mayer writing in the *Atlantic Monthly* used the term "Pine Rats" to refer to them. He described them in the most derogatory terms:

> Completely besotted and brutish in their ignorance, they are incapable of obtaining an honest living, and have supported themselves, from a time which may be called immemorial, by practising petty larceny on an organized plan. The Pine Rat steals wood, steals game, steals cranberries, steals anything, in fact, that his hand can be laid upon; and woe to the property of the man who dares attempt to restrain him![11]

These residents of South Jersey's interior did not fit neatly into Mayer's Jeffersonian vision of idyllic farmsteads, and he predicted their ultimate extinction:

> We shall not suffer his company much longer in this world,—poor, neglected, pitiable, darkened soul that he is, this fellow-citizen of ours. He must move on; for civili-

zation, like a stern, prosaic policeman, will have no idlers in the path. There must be no vagrants, not even in the forest, the once free and merry greenwood, our policeman-civilization says; nay, the forest, even must keep-a-moving! We must have farms here, and happy homesteads, and orchards heavy with promise of cider and wheat golden as hope, instead of silent aisles and avenues of mournful pine-trees, sheltering such forlorn miscreations as our poor cranberry-stealing friends! . . . There is no room for a gypsy in all our wide America! The Rat must follow the Indian,— must fade like breath from a windowpane in winter![12]

Other terms were less offensive, such as "Pine-hawker" and "Piner." In 1891 a Burlington County newspaper referred to "Pine-hawkers" in an article about applejack:

> In Southampton, where applejack is plenty and pine-hawkers numerous, it is invariably prescribed for chills

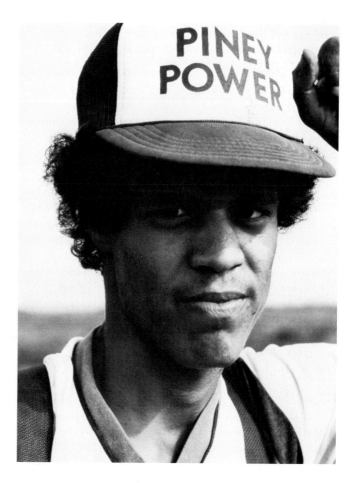

and fever, grippe, coughs, colds and nervous prostration. Owley Lemon, king of the pine-hawkers, who is now 76 years of age, has been drinking applejack regularly ever since the Civil War broke out, and even now can drink a quart per day without the slightest inconvenience. . . . Despite his years, he can kick higher, dance longer and stand more exposure than any man in Southampton.[13]

In an 1893 article on "Jerseyisms" in *Dialect Notes*, Francis B. Lee included the term "piners," which he defined as "those who live in the Jersey pines,—the 'ridge' sections (eastern and southern) of the state."[14] According to an 1894 article in *Harper's New Monthly Magazine*, "the term 'piners' is synonymous with the term 'poor whites' in the South."[15]

Elizabeth S. Kite, a staff member of the Vineland Training School, made reference both to "Pineys" and "Pine Rats" in an article she wrote in 1913.

They are known as the 'Pineys' or 'Pine Rats' and are recognized as a distinct people by the normal communities living on the borders of their forests, although their manner of living arouses neither surprise nor interest, having always been taken quite as a matter of course.[16]

Kite was a fieldworker on the 1913 Kallikak study of "the heredity of feeblemindedness," in the tradition of the Jukes study of the 1870s.[17] While the Kallikak family (a pseudonym) was not from the Pine Barrens, Kite used a similar approach in her work on the Pineys:

But the real Piney has no inclination to labor, submitting to every privation in order to avoid it. Lazy, lustful and cunning, he is a degenerate creature who has learned to provide for himself the bare necessities of life without entering into life's stimulating struggle. Like the degenerate relative of the crab that ages ago gave up a free roving life and, gluing its head to a rock, built a wall of defence around itself, spending the rest of its life kicking food into its mouth and enjoying the functionings of reproduction, the Piney and all the rest of his type have become barnacles upon our civilization, all the higher functions of whose manhood have been atrophied through disuse.[18]

In later years Kite attempted to modify the harshness of her stereotype of the Piney. In 1940 she told Herbert Halpert:

Nothing would give me greater pleasure than to correct the idea that has unfortunately been given by the newspapers regarding the Pines. Anybody who lived in the Pines was a Piney. I think it a most terrible calamity that the newspaper publicity took the term and gave it the degenerate sting.[19]

Halpert did not confront Kite with her own words written twenty-seven years earlier.

Associated with the name "Piney" is a legend about the origin of the inhabitants of the Pine Barrens. The development of the legend can be traced through written sources. In fact, there is no evidence that the legend either originated or went into oral tradition. It was created and sustained by local historians and popular writers. Thus, it should be considered a local-history legend, not a folk legend. I define a local-history legend as a narrative that is set in the past, that is loosely, or not at all, tied to historical documentation, and that is elaborated in a chain of written communication by local historians. A folk legend, on the other hand, results from a chain of oral communication.

The earliest mention of this local-history legend is in the 1859 *Atlantic Monthly* article mentioned above.

This extraordinary race of beings are lineal descendants of the New Jersey Tories, who, during the Revolution, made the Pines their refuge, whence they sallied in perpetual forays against the farms and dwellings of the partisans of the opposite cause. Several hundreds of these fanatical desperadoes made the forest their home, and laid waste the surrounding townships by their sudden raids.[20]

The 1894 article in *Harper's New Monthly Magazine* distinguished between the "Tory Refugees" and the so-called "Pine Robbers."

The Jersey Pines were first brought to the notice of the great world beyond them as a place of hiding of many Tory refugees during the war for our independence. These were British loyalists who helped to give Monmouth County the character it earned as the chief sufferer, in that bloody contention, of the horrors that always attend civil war.[21]

The author noted that some of the Refugees were New Jersey militiamen who became Loyalists, others were renegades who were nominally Loyalists paid by Tories in New York but who hid in the woods and plundered the countryside, and others were marauders who escaped from British vessels to form "picarooning" bands. They were known as the "Jersey

Greens" in distinction to the New Jersey soldiers in the Continental Army who were called the "Jersey Blues."

> These precious opponents of liberty did not pause at trifles like murdering sleeping men, but they were charming fellows when compared with the Pine robbers. So desperately bad were these robbers that they preyed upon both sides, and the names and deeds of their leaders are kept in mind to-day through the legends of old neighborhoods and the traditions of old families. They lived in caves burrowed in the side of the sandhills. They covered these dens with brushwood when they were in them, or when they issued from the forest to ravage the country.[22]

By the time of Elizabeth Kite's 1913 article, the legend had grown to include not only Tories and Pine Robbers, but also many others. The subtitle of her article says it all: "The Pineys: Today Morons; Yesterday Colonial Outcasts, 'Disowned' Friends, Land Pirates, Hessians, Tory Refugees, Revellers from Joseph Bonaparte's Court at Bordentown, and Other Sowers of Wild Oats." According to Kite: "In the Province of New Jersey, it is certain that 'disowned' youths, cast out by the society [of Friends] did in some cases betake themselves to the loose lives of the dwellers of the Pines."[23] In addition, she wrote: "After the battle of Trenton, certain Hessian soldiers and other deserters from the British army found safety in the seclusion of the Pines, and added still another element to its already mixed population."[24] And finally, she contended:

> In the gay days when Prince Joseph Bonaparte held his miniature court at Bordentown, many were the revels and hunting parties in the Pines which were indulged in by the members of his suite. All these revelers came back, leaving a train of nameless offspring to complicate still further the mixed social problem of the Pines, so that today, in tracing the ancestry of any particular group, one runs up continually against the impossibility of proving exact ancestry.[25]

In 1936 local historian Henry Charlton Beck defined the Pineys as those "who lonely in lack of education, have lived back in the Jersey pine woods, on hidden trails and beside dismal swamps."[26] He wrote that they are "the descendants of first settlers, bog ore miners, lumber-cutters, glassmakers, sailors and soldiers of Washington's time, Hessians who preferred to go amok in the woods to returning home, [and] slaves who sought strange ways to celebrate their new-found liberty."[27] He was evidently influenced by the stereotype of the Pineys fostered by Elizabeth Kite and others in his reference to the Pineys as "the children and grandchildren of those to whom several wives for one man was an accepted code."[28] He mentioned a specific legend:

> One story, perhaps the most persistent in this regard, is well known. A British soldier of good parentage but with uncertain ideas of living, became enamored of a barmaid in a wayside tavern and without the trouble of a wedding they became joint proprietors of the place. There came a family of eight children all of whom were later found to have mental deficiencies or criminal inclinations. The soldier, tiring of this mode of life, went back to England, married in his rightful class and began anew. At home, a family of three normal children resulted.[29]

The story is suspiciously similar to the genealogy of the Kallikak family, which according to Henry H. Goddard descended from Martin Kallikak, Sr.

> When Martin Sr., of the good family, was a boy of fifteen, his father died, leaving him without parental care or oversight. Just before attaining his majority, the young

man joined one of the numerous military companies that were formed to protect the country at the beginning of the Revolution. At one of the taverns frequented by the militia he met a feeble-minded girl by whom he became the father of a feeble-minded son. This child was given, by its mother, the name of the father in full, and thus has been handed down to posterity the father's name and the mother's mental capacity.[30]

Probably the most widely read version of the legend is found in John McPhee's 1967 book *The Pine Barrens,* which originally appeared in the *New Yorker Magazine.* He mentioned the Tories who "fled to the pines during the American Revolution. People with names like Britton and Brower, loyal to the King, and sometimes covered with feather and tar, left their homes in Colonial cities and took refuge in the Pine Barrens."[31] He also mentioned the Hessians. "After the British defeats at Trenton and Princeton," McPhee wrote, "Hessian soldiers deserted the British Army in considerable numbers, and some of them went into the Pine Barrens."[32] He claimed, for example, that "Sooy is a German name more common in the pines than Smith."[33] McPhee also repeated the part of the legend about the Quakers. "Also during the eighteenth century," he wrote, "when the farmlands of western New Jersey were heavily populated with Quakers, the Pine Barrens served as a catch basin for Quakers who could not live up to the standards of the Quaker code."[34] He cited the Ridgway family as an example. In addition, he mentioned English, Welsh, and Scots who came primarily by way of New England, including the Cranmer family, said to be descended from Thomas Cranmer, the archbishop of Canterbury, and French Huguenots who settled at Mt. Misery, including the Bozarth family.[35] Some blacks "fled from slavery into the pines," including Dr. James Still, the so-called "Doctor of the Pines."[36] There were also descendants of Lenape Indians from the Brotherton Reservation in the Pine Barrens. "Numerous people in the Pine Barrens today are descended, in part, from Indians who remained. George Crummel, a charcoal-maker who lived in Jenkins Neck and who died there in 1964, was the great-grandson of Isaac Cromo, a chief of the Leni Lenape. On the site of the Brotherton reservation is a hamlet called Indian Mills."[37] Finally, he mentioned pirates, privateers, smugglers, and Pine Robbers, including Joseph Mulliner, a leader of a band of outlaws, who "became a legend in the pines."[38]

To determine the historical truth of the legend it is necessary to determine who the Pineys are. John Sinton tried to refute the stereotype of the Pineys as being illiterate, isolated, and degenerate by carefully studying the manuscript census of Washington Township from 1850 to 1900. He came to the conclusion that there was a relatively homogeneous Anglo-Scottish-Irish culture, a single religion (Methodism), a relatively high rate of literacy, a strong reliance on the family, and a regional market economy for farm crops and timber.[39] Following a geographic definition (that is, all the people living in Washington Township) rather than a genealogical definition, Sinton included watermen and boatmen (Washington Township borders on the Little Egg Harbor River), farmers, fishermen, and glass workers, as well as the woodchoppers and colliers traditionally associated with the name "Piney."

By the same token Elizabeth Marsh studied mostly the Pine Barrens south of the Mullica River and reported the existence of "an ethnic archipelago" consisting of Germans in Egg Harbor City and New Germany (Folsom), Jews in Alliance, Woodbine, and Norma, Yankees and Italians in Hammonton, Ukrainians in Mizpah and Woodbine, White Russians in Mays Landing, black Jews in Elwood, Kalmyks in Freehold, Japanese in Elmer, and Puerto Ricans in Vineland.[40]

Pauline Miller, the county historian of Ocean County, attempted to trace the genealogies of the most common Pinelands surnames. She concluded that they are the "third and fourth generation Americans of English stock from New England and second and third generation Americans from Burlington County who settled in the coastal villages and the Pinelands. For the most part, those who settled deep in the Pines were the sons and daughters of the coastal village families along Ocean, Atlantic and Cape May Counties."[41] While this conclusion is essentially correct, Miller slipped into the realm of legend when she wrote about the Clevenger and Bennett families.

> Tradition, that waft of information which has been passed on but cannot be proven, is that William Clevenger, who died in Pasadena in Ocean County in 1872, was a descendant of a Hessian soldier who deserted and fled into the Pinelands after the Battle of Trenton. There are other alleged descendants of Hessian deserters from the Headquarters at Bordentown and Trenton, but further research will have to determine the veracity of these stories.[42]

She also wrote:

> Some of the Bennetts descend from one of the crewmen on Captain Kidd's pirate ship. The crewman was released from Old Bailey in London when he could

prove that he was an apprenticed seaman, not a pirate. He fled to America, changed his name to Bennett and settled south of Barnegat at a place still called Bennett's Neck. There is no record of his English name.[43]

Nevertheless, her genealogical approach is the one that must be used to verify the historical accuracy of the legend.

In my study of history and legend among the "Jackson Whites," today known as the Ramapo Mountain People, a racially mixed people living on the border of northeastern New Jersey and southeastern New York State, I found that the legend about their origins, while based on some accurate historical information, was untrue as a historical account of the group's origins.[44] Yet Gary Mills, a historian who studied the Cane River Creoles, a racially mixed population living in northwestern Louisiana, found that the legend about their origins was substantially true.[45] If we look at the various parts of the legend about the origin of the Pineys in light of genealogical information about common Pinelands surnames, we find that some parts of the legend are true, some parts are untrue, and some parts are elaborations on the truth.

The part of the legend about the Quakers is essentially true. Many of the family names associated with the Pine Barrens are found throughout South Jersey. The Ridgway, Cranmer, and Ong families are the case in point. Richard Ridgway and his wife Elizabeth were Quakers from Welford, England, who came to Bucks County, Pennsylvania, in 1677. His occupation was listed as a tailor. He resided in Pennsylvania until about 1690, when he moved to Burlington County, West New Jersey. He was one of the judges for Burlington County from 1700 to 1720. He died in 1723.[46] Some time prior to 1714 Thomas Ridgway from upper Burlington County settled in Little Egg Harbor. He was listed as a member of the Friends Meeting in Tuckerton.[47] The Cranmer family of New Jersey descends from William Cranmer, who was an early settler at Southold, Long Island. He moved to Forked River and Cedar Creek, New Jersey, around 1748 or 1749.[48] William Cranmer was also listed as a member of the Friends' Meeting at Tuckerton.[49] Ong is a famous surname associated with the Pine Barrens, primarily because of the place name Ong's Hat.[50] Like Thomas Ridgway, Jacob Ong settled in Little Egg Harbor from upper Burlington County. He and his wife Elizabeth were elders in the Friends' Meeting of Egg Harbor. In 1725 he left Egg Harbor to settle in Pennsylvania, returned in 1728, and left again for Pennsylvania in 1735, this time

never to return. Ong's Hat was probably named for Jacob Ong, even though the Ong family did not remain in the Pines.[51]

The part of the legend about the Hessian soldiers, on the other hand, is essentially untrue. Herbert Halpert collected a cycle of legends about Jerry Munyhun, whom he called the "wizard of the Pines." Munyhun was said to be a trickster and a magician. One of Halpert's informants, Charles Grant, called Munyhun an "old Hanover Hessian," but others said he was either Irish or black. The stories about him were associated with the Hanover Furnace in the Pines.[52] However, there is no evidence that Jerry Munyhun was a real person. Furthermore, no Pinelands surnames appear in the lists of Hessian soldiers who fought in the American Revolution.[53] And those Pinelands surnames thought to be Hessian are not German names. The Clevenger family, said to be Hessian by Miller, has been traced to England. The first known Clevenger in America was George Clevenger, who resided in

Map of Chestnut Neck in 1777, showing the houses of Joseph Sooy and James Giberson. *Delineated in 1950 by Paul C. Burgess. Courtesy of Paul C. Burgess*

The Village of
CHESTNUT NECK
Egg Harbor Township
Gloucester County N.J.
1777
Delineated in 1950
By Paul C. Burgess.

1 The Fort
2 Store Houses
3 John Mathis House
4 Paynes Tavern
5 Henry Davis House
6 John Adams Landing
7 Joseph Sooy House
8 John Smith
9 Micajah Smith
10 Jeremiah Adams
11 Joseph Johnson
12 Edward Bowen
13 Robert Smith
14 Jeremiah Higbee
15 James Giberson

Yonkers, New York, before 1682. His son, John Clevenger, born 1678, moved to Monmouth County, New Jersey, in 1699. In 1757 John Clevenger was living in New Hanover Township, Burlington County.[54] The Sooy family, said to be German by McPhee, descends from Joost Sooy, who was born in Holland in 1685 and immigrated to America about 1705. He was a mariner-merchant who was listed in the records of the Old Dutch Reformed Church in New York. He and his family migrated from New York to Cheesequake Creek in Monmouth County, and from there to Lower Bank on the Mullica River in Burlington County. He and his sons purchased thousands of acres of land in Washington Township. He died in 1767 and was buried at Lower Bank.[55] The Bozarth family appears to be German in ancestry (not French Huguenot, as McPhee stated), but they are not descended from Hessian soldiers. Simon Bozoth of Evesham bought land in Burlington as early as 1715, well before the Revolutionary War.[56] He died in Burlington County in 1753, according to family records.[57] The family name (variously spelled Bosserdt, Boshart, and Bussart) is common among the Pennsylvania Germans.[58]

John McPhee's statement that French Huguenots settled Mt. Misery is partially true. The land on which Mt. Misery was later founded was owned by Peter Bard, the son of Bennet Bard from Montpelier, France. He was a French Huguenot who came to America about 1700 with his wife Dinah and settled in Burlington, West New Jersey. He was a merchant and a justice of the peace in Burlington from 1717 until 1721. In 1723 he moved to the tract of land he owned in the Pine Barrens.[59] While Joseph Bonaparte, Napoleon's brother and former king of Naples and Spain, lived in exile in Bordentown from 1817 to 1839, there is no historical evidence that members of his entourage left offspring in the Pine Barrens.

The part of the legend about the colliers and charcoal burners in the bog iron industry is also partially true. Some of the names on the payroll lists and street directories of Martha and Batsto are the surnames associated with the Pinelands. For example, Jesse Evans was the manager of Martha Furnace from 1805 until about 1842. The Evanses were Quakers. John King was a carter at Martha and owner of the Half Moon Tavern at Flyatt. He died in 1813. George Cramer was listed as a supplier of the furnace in 1809, and Stephen Cramer as a supplier of teams and horses in 1810. Thomas Estil was a teamster who went to work at the Weymouth furnace in 1813.[60] Among the residents of Batsto between 1853 and 1856 were H. Birdsall, George Reeves, J. Mickel, Daniel Brown, and D. Southard.[61] However, to explain the origins of the Pineys in terms of one of the traditional occupations associated with the Pineys is a circular argument.

The parts of the legend about Tories, Refugees, Pine Robbers, and pirates are related. As J. Franklin Jameson noted in *Privateering and Piracy in the Colonial Period*, the difference between privateering and piracy was not always clear. By law a privateer was a privately owned armed vessel which was granted a letter of marque authorizing it to commit acts of warfare against the enemy. But it is difficult to deter-

mine what acts were legitimate privateering and what were piracy. As Jameson noted, William Kidd, the famous pirate who lived for a while in New York City, had a letter of marque from Lord Bellomont, the governor of New York. Yet he was tried for piracy and hanged in England in 1701.[62] William Kidd's privateering/piracy activities were confined to the coast of Africa and Madagascar, during the height of the Madagascar slave trade and King William's War. Perhaps because he resided for a time in New York City, stories were created about his alleged activities along the Jersey Shore. These stories tended to follow the genre of the buried treasure legend, which in itself is a stereotype of piracy. Often the buried treasure was to be protected by the ghost of a crewman who was killed for this purpose and buried with the treasure. Such stories were written by local historians about Brigantine and Barnegat, as well as other places along the Jersey Shore.[63]

Legends about pirates on the fringe of the Pine Barrens trace back at least to mid-nineteenth century. In 1868 Barber and Howe wrote about the so-called Pirate Tree in the town of Burlington, along the Delaware River.

> Superstition held it famous, as the place of deposit for gold and silver, by Blackbeard and his associate pirates. It is said that they landed one stormy, terrific night loaded with an unusual quantity of plunder, which they buried in silence at the root of this tree, which took its name from this circumstance. . . . Some one, however, must be interred with the gold to protect it from depredation; and at last one of the most reckless outlaws, a Spaniard, who had long merited the honors of the neighboring Gallows Hill, stepped forward and offered himself as their victim. He was shot through the brain by Blackbeard, with a charmed bullet, which penetrated without occasioning a wound, thus leaving him as well prepared as ever for mortal combat, except for the trifling circumstance of his being stone dead. He was buried in an erect position; and so well has he performed his trust, that, for any evidence we possess to the contrary, the treasure remains there to the present day.[64]

William Teach, alias Blackbeard, was a historical person whose activities were confined primarily to the Caribbean and the coast of North Carolina. As with William Kidd, there is no historical evidence that Teach ever came to New Jersey, let alone buried treasure here.

The pirate-treasure legends about Captain Kidd and Blackbeard seem to be based on a blurring of the distinction between piracy and privateering. There were indeed smug-

gling and privateering along the Jersey shore. According to Arthur Pierce, New Jersey had only three legal ports of entry during the 1760s, Perth Amboy, Cohansey, and Burlington. But the Mullica River Basin, especially in the vicinity of Little Egg Harbor, became a center for smuggling. Charles Read, collector of customs at Burlington, wrote in a 1763 report that "many vessels trading to Plantations not belonging to the

King of Great Britain, returning with cargoes of Rum, Sugar, and Molasses, have found means to smuggle the same into his Majesty's Plantations, without paying the King's Duty." [65] This smuggling should be viewed against the backdrop of the British Navigation Laws, which were being circumvented by some of the most respectable citizens of New England, such as John Hancock, and as an assertion of economic independence against the dominance of New York and Philadelphia.

With the outbreak of the American Revolution, many of those who were smugglers became privateers, including Joseph Sooy of Little Egg Harbor. Privateering was so common that in September 1778 the British dispatched an expedition of three hundred British regulars and about a hundred New Jersey Loyalists under Capt. Patrick Ferguson to "clean out the nest of Rebel pirates" at Chestnut Neck and proceed up the Mullica to destroy the iron works at Batsto and the military storehouses at The Forks. Governor Livingston dis-

patched Count Pulaski, but Pulaski got lost and went to Tuckerton instead. Three privateers and an armed pilot boat managed to escape before the British arrived. The British found ten vessels that had been seized by "the rebel cruisers." They destroyed the village, which Ferguson described as "the principal resort of this nest of Pirates." One of the homes that was destroyed was that of Joseph Sooy.[66] While it was piracy from the British point of view, it was patriotism from the point of view of the American Whigs.

According to David J. Fowler, currently a Ph.D. candidate in history at Rutgers University, New Jersey had a disproportionate number of Tories, which resulted in much civil violence along the coast and in the Pine Barrens. Much activity occurred even after the British surrender at Yorktown in 1781. Some Loyalists fought in organized units such as the West Jersey Volunteers and the New Jersey Volunteers. Others, known as the "Refugees," formed less formal bands sometimes numbering as many as one hundred. Monmouth County, both in the Pines and at Sandy Hook, was a center of Refugee activity. The hanging of Capt. Joshua Huddy in 1782 by a band of Refugees became an international incident. And there were also the so-called Pine Robbers or "Pine Banditti," who seemed to be taking advantage of the unstable situation to raid both Tory and Whig sides. However, the distinction between the Refugees and the Pine Robbers was not so clearly drawn at the time.[67] Two Pine Robbers are of special interest in terms of the legend. One was William Giberson; the other was Joseph Mulliner.

Giberson is an old Pine-Barrens family name. Herbert Halpert collected a cycle of stories about Sam "the Fiddler" Giberson. The Giberson family in New Jersey was actually Dutch. The name originally was Gysbertse. In 1634 Lubbert Gijsberts, a wheelwright from Blaricum in the province of North Holland, came to Rensselaerswyck.[68] In 1701 a John Gysbertse of Middletown was mentioned in a land deed. The family had ties to Flatbush on Long Island. By the time of the Revolution there were Gibersons living in Ocean County also.[69] While the Giberson family is found throughout South Jersey, there is no evidence that William Giberson left any direct descendants.

Legends about William Giberson date back to the mid-nineteenth century. In 1845 local historian Isaac Mickle wrote that a septuagenarian informant described Giberson as "a large man of almost incredible strength and activity. It is said that at a running jump he could clear the top of an ordinary Egg Harbor wagon."[70] Mickle provided an account of how in December 1782 William Giberson was captured by some militiamen commanded by Capt. John Davis, who were sent to Egg Harbor to stop the Refugee activity there.

On one occasion his lieutenant, Benjamin Bates, with Richard Powell, a private, called at a house where Davis had been informed, over night, that two Refugee officers were lodging. Bates got to the house before any of the family had risen except two girls who were making a fire in the kitchen.

He inquired if there were any persons in the house besides the family, and was answered, "none, except two men from up in the country." He bade the girls show him where they were, which they did. In passing through the room separating the kitchen from the bedroom, he saw the pistols lying on a table. Knocking at the door, he was at first refused admittance, but finding him determined to enter, the two Refugees finally let him in. They refused to tell their names but were afterwards found to be William Giberson and Henry Lane, Refugee lieutenants, the former a notorious rascal who had committed many outrages, and killed one or two Americans in cold blood. On their way to the quarters of Davis' company, Giberson called Bates' attention to something he pretended to see at a distance. Giberson started in another direction, and being a very fast runner, although Bates fired his musket at him, he made his escape. Davis on being informed of what happened, told Bates to try again the next night. Accordingly, the next night he went to the same house. While in the act of opening the door he heard the click of a musket cock, behind a large tree within a few feet of him, and turning around, saw Giberson just taking aim at him. He dropped on his knees and the ball cut the rim of his hat. Giberson started to run, but before he had got many rods Bates gave him a load of buckshot which broke his leg. He was well guarded until he could be removed with Lane to Burlington gaol.[71]

According to David Fowler, this incident is confirmed by the pension application filed in 1831 by Benjamin Bates. It recounts the same incident.

In the month of April 1782 he entered in the service again in a company commanded by Capt. John Davis in what was called "the Egg Harbour Guard." We were stationed at Chestnut Neck on Little Egg Harbour River in Gloucester county and remained in the Service till the

month of December 1782. Our business was to watch the Reffugees and Traders on both sides of the River and along the Sea Shore. . . . Whilst I was engaged in searching a house in which it was said there were some Reffugees, I found a Man by the name of Giberson, who was a Noted Reffugee. He made his escape from the house, and got into the woods. After searching a long time for him I gave him up and returned to our quarters. When I told Capt. Davis that I had seen Giberson, he sent me back again to look for him. Whilst engaged in searching for him, he suddenly jumped from behind a large Black oak tree presented his gun and fired at me. As he presented, I dropt down upon my knees, and the load passed over me, without hurting me. He then ran, I fired upon him, and wounded him so that he fell, and then went up to him and took him prisoner.[72]

The pension application adds information about how Giberson later escaped from the Burlington County jail by changing clothes with his sister.

He was afterward taken to the Burlington County Gaol, where he affected his Escape, his sister having been permitted to visit him, they exchanged clothes. He went out and she remained in prison and the plot was not discovered until he had got too far to be overtaken.[73]

In the 1920s local historian Alfred M. Heston recounted these incidents in two of his books, *South Jersey: A History* (1924) and *Jersey Waggon Jaunts* (1926).[74] But he added another incident to the legend about William Giberson, which portrayed him more as an outlaw with a heart of gold.

It is related that one day a lad was gunning in Tuckerton Bay, when he was surprised by the appearance of Giberson and his gang in a boat. They made the boy a prisoner and took from him his fowling piece. Then they ordered him to pilot them to Tuckerton landing. Reaching what was called "scow landing," they moored the boat and went to the tavern recently built by Daniel Falkenburg, the first inn keeper in Little Egg Harbor. As soon as the refugees reached the tavern they indulged in a drunken revel. Some of the residents sent a messenger to Manahaukin, where there was a company of militia, and informed them of the presence of the refugees in Tuckerton.

A squad of soldiers marched toward the place to capture or disperse the revelers, but a Tory informed the outlaws of their coming and about the time the militia

reached Tuckerton the refugees fled to the landing. Seizing their guns they took an advantageous position in the boat. The militia marched down Green Street toward the landing, and as they came near the creek, the refugees poured the contents of their heavily charged guns into the ranks of the militia with such fury and precision that the latter were forced to retreat followed by the outlaws, who pursued them to West Creek. Seeing the retreating militia on the opposite side of the creek, Giberson and his victorious band returned to Tuckerton to go aboard their boat.

When they reached the landing the boat was some distance off. In their absence two of their comrades, who were too drunk to join in the pursuit had become sober enough to unmoor the boat and were paddling the craft down the creek, shouting as their companions came in sight, "we are the boys to hold the boat." The returning outlaws mistaking them for their enemies, ran along the creek in pursuit. They fired and killed both of the men before discovering that they were of their own gang. After this the refugees returned to the tavern and finished their debauch. Before leaving Tuckerton, Giberson hunted up the boy from whom he had taken the gun, returned it to him and also presented him with a Spanish dollar.[75]

Thus in the nineteenth century William Giberson was considered a ruthless outlaw, albeit colorful by virtue of his strength, agility, and daring; in the twentieth century he began to be considered more of a Robin Hood character.

The same process occurred with Joseph Mulliner. The Mulliners were an English family that came to Little Egg Harbor before the Revolutionary War. Joseph Mulliner left no progeny, but his brother Moses Mulliner married Mary Holden and their children married into the Shourds, Mathis, and Ridgway families.[76] In 1781 Joseph Mulliner was arrested for treason. He was tried by the Burlington County Court of Oyer and Terminer, convicted, and hanged. In his own day he was considered a rogue by both Whigs and Tories. For example, the *New Jersey Gazette* on August 8, 1781, reported about his trial as follows:

At a special court held in Burlington, a certain Joseph Mulliner, of Egg-Harbour, was convicted of high treason, and is sentenced to be hanged this day. This fellow had become the terror of that part of the country. He had made a practice of burning houses, robbing and plundering *all* who fell in his way, so that when he came to

trial it appeared that the whole country, both whigs and tories, were his enemies.[77]

However, in the twentieth century, stories in local histories about Mulliner became more elaborate. Heston described him as "a young man of good address and attractive personal appearance" who "wore an officer's uniform, with a ponderous sword at his side and a brace of pistols in his belt."[78] Furthermore, Heston wrote, "Mulliner had a dog to whose neck he attached an ingeniously constructed collar, and having trained the dog as a courier, when he wished to communicate with his wife—and through her with some of his absent band—he would write a message, fasten it to the collar and then start the dog across the river."[79] After his execution, Heston states, Mulliner was buried at Pleasant Mills, but in 1860 his bones were exhumed and reburied at the Batsto Iron Works. Local historian Henry Charlton Beck noted in 1947 that it was claimed that Mulliner was "hanged in three places and buried in two."[80]

In the hands of Henry Charlton Beck, Joseph Mulliner became a handsome rogue who would show up unannounced at parties at country inns and dance with the prettiest girls.

It was a stormy night and dark when Joe suddenly appeared, his countenance radiant with rain and his smile revealing two rows of perfect teeth. As someone gasped, "Joe Mulliner," the fiddler stopped and the dancers, moving in the dim-lit parlor of the inn, shuffled uncertainly. Mulliner instantly made a demand that the music go on and that the best-looking girl step out to dance with him.

It was an old demand and dancers of all the old towns and their stage-stop hotels were used to it. But though buxom damsels afterward boasted a dance with Mulliner they never willingly answered his invitations. On this occasion there was considerable reluctance. Swains held their girls tight and then Mulliner, whipping out his shooting-iron, gave the men a minute to disappear.

It is a story that has been worn with much handling but not yet has it been called a fable. A timid dancer, a chap perhaps who had been trying for many years to get up the nerve to dance, stayed in the room and defied the gang leader.

"My, my," laughed Mulliner, surprised, "And have all the bold fellows vanished, have all the hawks fled to cover, leaving this chicken-hearted fool among the wenches?"

He of the alleged chicken heart dropped the hand of his partner and swung his own flatly across the face of the intruder. Instead of firing, Mulliner laughed long and loud. Then he shook hands, declaring that so fearless "a little bantam" must have the best girl present. And taking the slapper's partner, he danced a round or two and vanished into the night.[81]

According to Beck, Mulliner was captured while dancing with a girl at one of these taverns.

The most famous incident associated with Joseph Mulliner was the burning of the Widow Bates's house. It was cited by Beck, but even before him it was mentioned in a local history of Pleasant Mills, as follows:

A widow named Bates owned a small farm near the Forks. She was a large, masculine appearing woman, of fearless disposition and an ardent patriot. She had eight sons, four of whom were serving in the American army; the others, being too young for military duty, assisted her in tilling the little farm which yielded them a comfortable livelihood. Among her household goods were some pieces of rare old furniture and a service of silver plate which was highly prized as a family heirloom. Mrs. Bates was a faithful church member and regularly attended services at the log meeting house. Returning from meeting one Sunday afternoon she found her home in possession of Mulliner's gang, though Mulliner himself was not with them. They had ransacked the house and helped themselves freely to her pigs and poultry and among the plunder made up to be carried away she saw her precious silverware. This was too much and stepping forward the undaunted woman loosed the vials of her wrath and gave the band a terrific tongue lashing.

"Silence madam," said the leader somewhat nettled by her fierce tirade, "silence or we'll lay your d—d house in ashes."

"Twould be an act worthy of cowardly curs like you," snapped the widow, "you may burn my house, but you'll never stop my mouth while there's breath in my body."

One of the refugees entered the house, took a firebrand from the hearth and applied it to the building. With equal promptitude, Mrs. Bates seized a pail of water and dashed it on the rising flame while her boys like sturdy little patriots assailed the enemy with a volley of stones; their pluck however, availed but little, they were speedily seized and held fast while the mother was dragged across the road and bound to a tree. The house

was again fired and the family compelled to look help-lessly on until it was entirely consumed. They were then released and the refugees departed with their booty.

The story of Mrs. Bates' misfortune spread far and wide, a host of friends came to her assistance, and in a few days a roomy log house stood on the site of the burned dwelling. Sympathetic neighbors donated furni-ture sufficient to fit it up snugly and affairs at the little farm went on pretty much as before. A few weeks later Mrs. Bates received the sum of three hundred dollars from some unknown person and it was always her belief that Mulliner had taken this means of atoning in some degree for the misdeeds of his followers.[82]

What is especially interesting about this account is that the incident of the burning of the Widow Bates's house first appears in a 1855 novel titled *Kate Aylesford,* written by Charles J. Peterson of Pleasant Mills. It is subtitled *A Story of the Refugees,* and it contains a character thought to be based on Joseph Mulliner. The character's name, though, was Ned Arrison, which sounds like he might have been based more on William Giberson than Joseph Mulliner. As we have seen, Bates was the name of the man who captured Giberson. Be that as it may, the character of Arrison is anything but a Robin Hood. He is described as "a short, thick-set man . . . with a countenance which had never been pleasing, but was now embruited by intemperance and other vices." He owns a ferocious bloodhound named Lion, and he plots to kidnap

the heroine, Kate Aylesford. She is rescued by the hero of the novel, an American officer named Major Gordon. In the novel the Widow Bates's house was robbed and set afire while she was at meeting, but Ned Arrison does not return to make compensation. As one character says about Arrison, "Nobody but a villain would rob the widow and the orphan. Especially a soldier's widow. It could only have been the refugees." [83]

The fact that Mulliner became known as a dancer at coun-try inns may have been inspired by an incident in the novel. There is a scene set in a "country tavern" in which the clientele were mostly "boisterous tars" from the privateers lying in the bay and several countrymen from the small farms in the interior. A black fiddler played while a storm raged outside. There developed a dance contest between a sailor and a countryman in which they danced the "time honored dance, which is known to the initiated as a 'Jersey Four.' " The countryman outdanced the seaman.[84] Then again, dancing in the country inns of the Pines was common knowledge. In 1889 Gustav Kobbé commented as follows:

In the old days, when the furnaces were in operation, numerous taverns were scattered through the pines. They were called "jug taverns," because their entire stock-in-trade usually consisted of a jug of apple-jack, out of which, however, the proprietor would pour any liquid refreshment called for, ranging from lemonade to brandy, and even mixed potables. . . . The chief amuse-ments in those days were huckleberry parties in summer

and oyster suppers in winter. The latter were held in the taverns and were preceded and followed by dancing. A fiddler enthroned in a chair, which had been elevated on to a table, scraped away at "Hi, Betty Martin," "Camptown Races," and the "Straight Four," dances which were perhaps varied by a "challenge jig" between two experts of the Pines. When the fiddler disappeared under the table, as he invariably did, the girls sang the airs and dancing continued all the same.[85]

It is not unusual for an incident from a novel to become part of legend. Henry Glassie showed the same process in regard to the so-called "rapparees," members of the Irish Brigade during the Williamite War, who took to the hills to rob from the rich and give to the poor. Glassie collected tales about two rapparees, Black Francis and Willy Reilly, which originally appeared in a novel titled *Willy Reilly and His Dear Coleen Bawn,* written by William Carleton about 1855. Glassie's informant Hugh Nolan "reorganized and recomposed the novel."[86] A similar process appears to have been at work with the local historians writing about Joseph Mulliner and William Giberson. Generally considered rogues in the nineteenth century, these men were reshaped as Robin Hood heroes in the twentieth century.

The parts of the legend about Indians and blacks are related. The Indian population of New Jersey was estimated at about ten thousand in the precontact period.[87] The Indians who ended up on the Brotherton Reservation at what is now Indian Mills in Burlington County were primarily from central New Jersey. By the mid-eighteenth century they resided at two locations—at Bethel or Cranbury in Middlesex County and at Crosswicks in Mercer County. In 1746 David Brainerd, a Presbyterian minister to the Indians at Crosswicks, estimated that there were about one hundred fifty Lenape Indians there.[88] The Brotherton Reservation was established in 1758 against the backdrop of the French and Indian War. In 1759 Gov. Francis Bernard wrote that the number of Indians at Brotherton "does not amount to 200 & when We have gathered together all in the province they will not be 300."[89] The implication was that not all the Lenape in New Jersey lived on the Brotherton Reservation. There was, for example, a small group residing "off reservation" at Weepink, about ten miles north of Brotherton near present Vincentown. The population at Brotherton declined rapidly during the existence of the reservation. In 1774 Governor William Franklin reported the population as between fifty and sixty.[90]

In 1802 when the reservation was disbanded, a report to the governor mentioned sixty-three adults had rights to the tract.[91] It is reported that seventy to eighty Lenape moved from Brotherton to New Stockbridge, New York, in that year.[92]

By the time of the creation of the Brotherton Reservation, many of the Lenape had adopted European surnames. The surnames of at least those Indians who were representatives at various treaty conferences are known.[93] Many of these same names appear on the land deeds during the same period.[94]

A number of writers on the subject argue that not all the Lenape left New Jersey with the Brotherton Indians.[95] In the nineteenth century various individuals and groups claiming Indian ancestry began to appear on the fringes of the Pine Barrens. Their surnames were not the same as the known surnames of the Lenape Indians. These individuals and groups were mostly listed in the nineteenth-century manuscript censuses as "black" or "mulatto."

One such person was George Crummel. According to Robert J. Sim and Harry B. Weiss, George H. Crummel was born in the neighborhood of Sykesville and was a collier most of his life. His father, George Henry Crummel, came from the vicinity of Hornerstown and died about 1915. The family was said to be descended from Indians.[96] However, the 1880 manuscript census lists a George H. "Cromwell," age twelve, residing with his parents Charles and Phoebe Cromwell in Eatontown Township in Monmouth County. Their race was listed as "black."[97] The 1830 census lists no Crummels but includes Cromwells as "free Negro heads of families" in Burlington and Monmouth counties.[98] A black named Oliver Cromwell of Burlington County served as a private in the New Jersey Continental Line from 1777 to 1781. He fought at the battles of Trenton, Brandywine, Princeton, Monmouth, and Yorktown.[99]

Another person who claimed to be an Indian was a woman named "Indian Ann." She was a familiar figure in Vincentown and Medford around the turn of the century. She supported herself by making baskets and picking cranberries and blueberries. One account mentions that she was the daughter of Ash Tamar, a Rancocas Indian, and was born on John Woolman's farm on the northern side of the Rancocas Creek.[100] Another source indicates that her father was Chief Elisha Moses Ashatama, who lived at the time of the War of 1812 in Egg Harbor. Her mother was said to be a Quaker named Margaret. Ann Ashatama was married two times. Her first husband was Peter Green, and her second husband was John Roberts, a black.[101] Ann Roberts was listed in the 1880

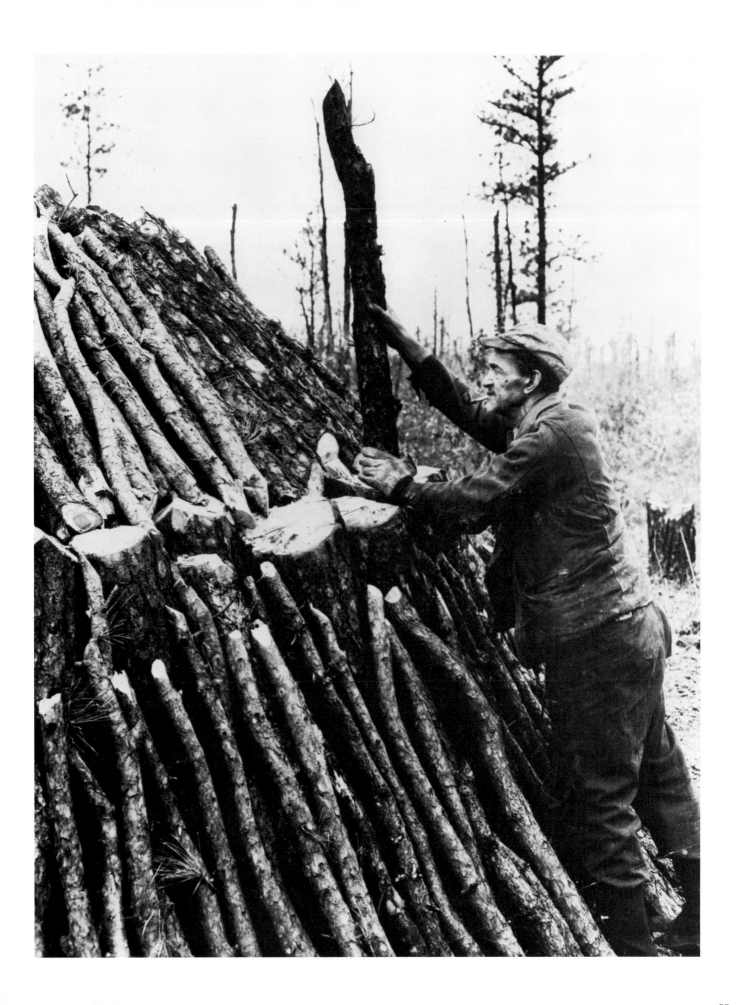

James Still, the "doctor of the Pines," from Medford, New Jersey. From *Early Recollections and Life of Dr. James Still, 1812-1885* (1877; reprint, Medford, N.J.: Medford Historical Society, 1971)

manuscript census as living in Shamong Township. Her race was listed as "Indian" and her age was eighty-seven. But her place of birth was listed as New York, which was also indicated as the place of birth of her father and her mother.[102] Thus, while she was an Indian, it is not clear that she was a Lenape Indian. Her will, dated 1884, mentions three sons, three daughters, and her house and land in Shamong.[103]

The one black family name that shows up on the list of names of known Lenape Indians was that of a family that did not claim Indian ancestry. That name was Still. James Still, who was known as the "Doctor of the Pines" because of his practice of folk medicine in the Medford vicinity, wrote that his mother and father, Charity and Levin Still, were former slaves both born in Maryland. However, Still also wrote: "Our nearest neighbors were an Indian family, the name of whose head was Job Moore. His eldest son was named Job, and he and I were very social. We played together and fished and hunted when opportunity would admit." [104] Furthermore, he wrote, "I was also afraid of Indian Job. He was a tall man, I think six feet and six inches high. He would often get drunk, and go whooping about in Indian fashion, which was a great terror to me."[105]

There were two groups that lived on the fringes of the Pine Barrens that claim Indian ancestry. One group resided in Monmouth County in two locations: at Reevytown in what is today Tinton Falls and at Sand Hill in what is today Neptune. Collectively, they are known as the "Sand Hill Indians." The surnames associated with this group include Reevy, Richardson, and Crummel. The Reevy, Richardson, and Cromwell families were listed in the 1830 census as "free Negro heads of

families." [106] Their descendants claim that the census listed many Indians as black. The other group was the Gouldtown settlement near Bridgeton in Cumberland County. The surnames here include Gould, Pierce, and Murray. These families also were listed in the 1830 census as black.[107] Long considered a free black community, they are now calling themselves Nanticoke Indians. For some time they have had marital and social ties with the Moors and Nanticokes, two racially mixed groups in Delaware. The surnames Harmon and Ridgeway seem to have entered the group through intermarriage with the Moors and Nanticokes.[108]

The Gouldtown settlement is especially interesting because of a legend about its origins. According to a tradition going back to Johnson's *History of Fenwick's Colony,* published in 1839, the community descends from an illicit union between John Fenwick's granddaughter, Elizabeth Adams, and a black named Gould. The following clause in John Fenwick's will was cited as confirmation:

> Item, I do except against Elizabeth Adams of having any ye leaste part of my estate, unless the Lord open her eyes to see her abominable transgression against him, me and her good father by giving her true repentence, and forsaking yt. Black yt. hath been ye ruin of her, and becoming penitent for her sins; upon yt. condition only I do will and require my executors to settle five hundred acres of land upon her.[109]

The Pierce family was said to descend from two mulattoes named Anthony and Richard Pierce who came to New Jersey from the West Indies. According to tradition, they paid the passage from Holland of two Dutch sisters named Marie and Hannah Van Aca, whom they eventually married.[110] The Murray family claimed Indian ancestry. According to Steward and Stewart, "the first Murray of whom there is a trace in the vicinity of the earliest settlement of Gouldtown, was Othniel Murray. He claimed to be a Lenapee or Siconesse Indian, and came from Cape May County. The Lenapees resided in the locality of Cohansey (or Bridgeton) and had quite a settlement at what became known as the Indian Fields, at a run still known as Indian Field Run." [111]

Several black communities in the Pines also had individuals who claimed Indian ancestry. Herbert Halpert collected folklore in three small black settlements: one at Whiting, another near Cookstown, and the third near Toms River. One of his informants, Oliver Minney, said he was half Indian, half Irish. His father, Charles Minney, Sr., was supposedly a full-blooded Indian.[112]

Indian Ann's house at Dingletown in Shamong Township, Burlington County, New Jersey, about 1949. *Photograph by William Augustine. Courtesy of the Donald A. Sinclair Special Collections, Alexander Library, Rutgers University*

The parts of the legend about Quakers, Loyalists, privateers, and Pine Robbers seem to be based on a kernel of truth, the parts about pirates and Hessians seem to be untrue, and the part about the Lenape Indians cannot be proven. More important, however, than whether the legend is true or not is the fact that people believed it to be true. The legend reveals much about the attitudes of outsiders toward the people of the Pine Barrens. These attitudes went through a change from the nineteenth century to the twentieth century.

The negative image of the residents of the New Jersey seacoast and Pine Barrens, according to David J. Fowler, was a reflection of a general stereotype of forest dwellers that can be traced back to the seventeenth century in America and even earlier in Britain and Europe.[113] In the nineteenth century a strong element of Social Darwinism was added. This is seen in the view of the Pineys as socially, mentally, and morally inferior and in the threat in the buried past of inbreeding and miscegenation. Here the legend reflects the racial and social prejudices of the white middle class in nineteenth-century America. In the twentieth century, however, a change occurred. Local historians toned down the sensationalism of the legend and took a more romantic attitude toward the past. We see this in the figure of Joseph Mulliner, who was considered an unpatriotic rogue in the nineteenth century but was made into a colorful Robin Hood hero in the twentieth century. Finally, during the ethnic revival of the 1970s, descendants of the Gouldtown settlement and the "Sand Hill Indians" used the legend as the basis for asserting an ethnic identity as Indians.

Henry Glassie has recently argued that the distinction between history and legend is ethnocentric. "What we call legends in other societies," he writes, "are precisely what we call histories in our own." [114] It is "snide," Glassie argues, to label what other people believe about the past "legend" and what we believe about the past "history." And so he refers to his legend-telling informants in the town of Ballymenone in northern Ireland as "historians."

> There is one past but many histories. We think of one of them—our own—as "history" and others as "folk histories," but they are either all histories or all folk histories. All involve collecting facts about the past and arranging them artfully to explore the problems of the present. Academic historians create a history appropriate to their needs, and no less serious historians of places like Ballymenone do the same; they create one that suits theirs.[115]

The legend about the origin of the Pineys, however, suggests how important it is to maintain the distinction between history and legend. Rather than showing that legend is really history, it suggests that some local history is in fact legend.

Notes

1. Jack McCormick and Richard T. T. Forman, "Introduction: Location and Boundaries of the New Jersey Pine Barrens," in *Pine Barrens: Ecosystem and Landscape*, ed. Richard T. T. Forman (New York, San Francisco, London: Academic Press, 1979), xxxvi.

2. John W. Harshberger, *The Vegetation of the New Jersey Pine-Barrens: An Ecological Investigation* (Philadelphia: Christopher Sower Co., 1916), 15–16.

3. New Jersey Pinelands Commission, *Comprehensive Management Plan for the Pinelands National Reserve (National Parks and Recreation Act, 1978) and Pinelands Area (New Jersey Pinelands Protection Act, 1979)* (New Lisbon, N.J.: The [Pinelands] Commission, 1980), plate 1.

4. Herbert Norman Halpert, "Folktales and Legends from the New Jersey Pines: A Collection and Study" (Ph.D. diss., Indiana University, 1947), 1: 15–16.

5. Quoted in John W. Sinton, ed., *Natural and Cultural Resources of the New Jersey Pine Barrens* (Pomona, N.J.: Stockton State College, 1979), 165.

6. David Steven Cohen, *The Folklore and Folklife of New Jersey* (New Brunswick: Rutgers University Press, 1983), 22.

7. Tom Ayres, "Pinelands Cultural Society: Folk Music Performance and the Rhetoric of Regional Pride," in Sinton, *Natural and Cultural Resources of the Pine Barrens,* 226–27.

8. Ibid., 227; Angus Gillespie, "Folk and Hillbilly Music in the Pines: Gladys Eayre and the Pineconers' Repertoire," in ibid., 236.

9. John W. Sinton and Geraldine Masino, "A Barren Landscape, a Stable Society: People and Resources of the Pine Barrens in the Nineteenth Century," in Sinton, *Natural and Cultural Resources of the New Jersey Pine Barrens,* 171, 175.

10. Quoted in Martin B. Williams, "The Spiritual Needs of Shamong and the Pine Barrens in 1866," *New Jersey Folklore* 2

(1979): 5–6.

11. W. F. Mayer, "In the Pines," *Atlantic Monthly* 3 (1859): 566.

12. Ibid., 568.

13. Quoted in Harry Bischoff Weiss, *The History of Applejack or Apple Brandy in New Jersey from Colonial Times to the Present* (Trenton: New Jersey Agricultural Society, 1954), 122–23.

14. Francis B. Lee, "Jerseyisms," *Dialect Notes* 1 (1893): 332.

15. Julian Ralph, "Old Monmouth," *Harper's New Monthly Magazine* 89 (1894): 337.

16. Elizabeth S. Kite, "The 'Pineys': Today Morons; Yesterday Outcasts, 'Disowned' Friends, Land Pirates, Hessians, Tory Refugees, Revellers from Joseph Bonaparte's Court at Bordentown, and Other Sowers of Wild Oats," from *The Survey*, October 4, 1913, New Jersey State Library, Trenton, N.J. (typescript).

17. Henry H. Goddard, *The Kallikak Family: A Study in the Heredity of Feeblemindedness* (New York: Macmillan, 1913); Robert L. Dugdale, *The Jukes: A Study of Crime, Pauperism, Disease and Heredity* (New York: G. P. Putnam's Sons, 1877).

18. Kite, "The Pineys," 9–10.

19. Quoted in Halpert, "Folktales and Legends from the New Jersey Pines," I: 11–12.

20. Mayer, "In the Pines," 566.

21. Ralph, "Old Monmouth," 337.

22. Ibid.

23. Kite, "The Pineys," 4.

24. Ibid., 7.

25. Ibid., 10–11.

26. Henry Charlton Beck, *Forgotten Towns of Southern New Jersey* (1936; reprint, New Brunswick: Rutgers University Press, 1961), 9.

27. Ibid.

28. Ibid.

29. Ibid., 9–10.

30. Goddard, *The Kallikak Family*, 18.

31. John McPhee, *The Pine Barrens* (1967; reprint, New York: Ballantine Books, 1971), 23–24.

32. Ibid., 24.

33. Ibid.

34. Ibid.

35. Ibid., 24–26.

36. Ibid., 25.

37. Ibid., 26.

38. Ibid., 26–27, 36–38.

39. Sinton and Masino, "A Barren Landscape, a Stable Society," 168–91.

40. Elizabeth Marsh, "The Southern Pine Barrens: An Ethnic Archipelago," in Sinton, *Natural and Cultural Resources of the Pine Barrens*, 192–98.

41. Pauline S. Miller, "Genealogical Research in the Pinelands," in *History, Culture, and Archeology of the New Jersey Pine Barrens*, ed. John W. Sinton (Pomona, N.J.: Stockton State College, n.d.), 174.

42. Ibid., 175.

43. Ibid.

44. David Steven Cohen, *The Ramapo Mountain People* (New Brunswick: Rutgers University Press, 1974).

45. Gary B. Mills, *The Forgotten People: Cane River's Creoles of Color* (Baton Rouge: Louisiana State University Press, 1977).

46. Lelah Ridgway Vought, *Ridgway-Ridgeway Family History* (n.p.: Lelah Ridgway Vought, 1973), 6, 7, 11.

47. Leah Blackman, *History of Little Egg Harbor Township . . .* (Trenton: Trenton Printing Co., 1963), 178, 194–95, 199.

48. Edwin Salter, *A History of Monmouth and Ocean Counties* (Bayonne: E. Gardner and Son, 1890), xxi–xxii.

49. Blackman, *History of Little Egg Harbor*, 199.

50. Beck, *Forgotten Towns of Southern New Jersey*, 19–23.

51. Blackman, *History of Little Egg Harbor*, 178, 194–95, 199, 331.

52. Halpert, "Folktales and Legends from the New Jersey Pines," I: 199.

53. *Hessiche Truppen im Amerikanischen Unabhängigkeitskrieg* (Marburg: Archivschule Marburg Institut Für Archivwissenschaft, 1972), 5 vols.

54. George P. Griffiths, *Clevenger, Pioneers and Descendants* (Baltimore: Gateway Press, 1980), 15, 16–17, 20, 22.

55. Irwin Gladstone Sooy, "Genealogical Records of the Sooy Family," Burlington County Historical Society, Burlington, N.J., 1941 (typescript), 1–2; Sooy Family Data, Division of Archives and Records Management, New Jersey Department of State, Trenton, N.J.

56. West Jersey Deeds, Division of Archives and Records Management, New Jersey Department of State, Trenton, N.J., Liber BBB, 417.

57. Bozarth Family, Burlington County Historical Society Mss., Burlington, N.J.

58. Ralph Beaver Strassburger, *Pennsylvania German Pioneers . . .* (Baltimore: Genealogical Publishing Co., 1966) I: 279; Heinrich Rembe, "Emigration Materials from Lambsheim in the Palatinate," in *Rhineland Emigrants: Lists of German Settlers in Colonial America*, ed. Don Yoder (Baltimore: Genealogical Publishing Co., 1981), 101.

59. *Proceedings . . . of the Surveyor's Association of West New Jersey . . .* (Camden: S. Chew, 1880), 104, 108; Beck, *Forgotten Towns of Southern New Jersey*, 233–34.

60. Henry H. Bisbee and Rebecca Bisbee Colesar, *Martha, 1808–1815: The Complete Martha Furnace Diary and Journal* (Burlington, N.J.: n.p., 1976), 4–5, 7, 93, 94, 95.

61. Arthur Dudley Pierce, *Iron in the Pines* (New Brunswick: Rutgers University Press, 1957), 225–26.

62. John Franklin Jameson, *Privateering and Piracy in the Colonial Period . . .* (New York: Macmillan Co., 1923), ix, xiv, 190–257.

63. William Westerman, "New Jersey Pirate Lore; Captain Kidd," *New Jersey Folklore* 8 (1983): 2–5.

64. John W. Barber and Henry Howe, *Historical Collections of New Jersey . . .* (New Haven: John W. Barber, 1868), 92.

65. Quoted in Arthur D. Pierce, *Smugglers' Woods: Jaunts and Journeys in Colonial and Revolutionary New Jersey* (New Brunswick: Rutgers University Press, 1960), 19; see also James H. Levitt, *For Want of Trade: Shipping in the New Jersey Ports, 1680–1783* (Newark: New Jersey Historical Society, 1981), 18–20.

66. Pierce, *Smugglers' Woods,* 52.

67. David J. Fowler, " 'Nature Stark Naked'; A Social History of the New Jersey Seacoast and Pine Barrens, 1690–1800" (Ph.D. diss. proposal, Rutgers University, 1981), 29–34.

68. Carl Boyer, comp., *Ship Passenger Lists: New York and New Jersey (1600–1825)* (Newhall, Calif.: Published by the Compiler, 1978), 48.

69. Salter, *A History of Monmouth and Ocean Counties,* xxix.

70. Isaac Mickle, *Reminiscenses of Old Gloucester* (Philadelphia: Townsent Ward, 1845), 85.

71. Ibid.

72. United States. National Archives, Revolutionary War Pension and Bounty-Land Warrant Application Files (Microfilm), film 27, reel 173.

73. Ibid.

74. Alfred M. Heston, ed., *South Jersey: A History, 1664–1924* (New York and Chicago: Lewis Historical Publishing Co., 1924); *Jersey Waggon Jaunts: New Stories of New Jersey* (Pleasantville, N.J.: Atlantic County Historical Society, 1926).

75. Heston, *South Jersey,* II: 769n.

76. Blackman, *History of Little Egg Harbor,* 346–47.

77. *New Jersey Gazette,* August 8, 1781, p. 3.

78. Heston, *South Jersey,* II: 770, 771.

79. Ibid.

80. Henry Charlton Beck, "Hanged in Three Places, Buried in Two," *New York Folklore Quarterly* 2 (1947): 242–46.

81. Beck, *Forgotten Towns of Southern New Jersey,* 171.

82. Charles F. Green, *Pleasant Mills and Lake Nescochague—A Place of Olden Days* (n.p.:n.p., n.d.), 14–15.

83. Charles J. Peterson, *Kate Aylesford: A Story of the Refugees* (Philadelphia, Boston, and New York: T. B. Peterson, Phillips, Sampson and Co., J. C. Derby, 1855).

84. Ibid., 50–55.

85. Gustav Kobbé, *The New Jersey Coast and Pines: An Illustrated Guide-Book* (Short Hills, N.J.: G. Kobbé, 1889), 92.

86. Henry Glassie, *Passing the Time in Ballymenone: Culture and History of an Ulster Community* (Philadelphia: University of Pennsylvania Press, 1982), 124.

87. Edward McM. Larrabee, *Recurrent Themes and Sequences in North American Indian-European Culture Contact,* Transactions of the American Philosophical Society, vol. 66 part 7 (Philadelphia: The American Philosophical Society, 1976), 4.

88. Ibid., 5.

89. Quoted in ibid., 13.

90. Ibid., 15.

91. Ibid., 17.

92. Ibid.

93. Samuel Smith, *The History of the Colony of Nova-Caesaria, or New Jersey . . .* (1765; reprint, Spartanburg, S.C.: The Reprint Co., 1966), 442n.

94. Robert Steven Grumet, " 'We Are Not So Great Fools': Changes in Upper Delawaran Socio-Political Life, 1630–1758" (Ph.D. diss., Rutgers University, 1979); Frank H. Stewart, *Indians of Southern New Jersey* (Woodbury, N.J.: Gloucester County Historical Society, 1932), 82–86.

95. C. A. Weslager, *The Delaware Indians: A History* (New Brunswick: Rutgers University Press, 1972), 277; Charles A. Philhower, *Indian Lore of New Jersey* (Trenton: New Jersey Council, Division of Planning and Development, Department of Planning and Development, n.d.), 20–22.

96. Robert J. Sim and Harry B. Weiss, *Charcoal-Burning in New Jersey from Early Times to the Present* (Trenton: New Jersey Agricultural Society, 1955), 17.

97. United States Census. 1880. New Jersey. Monmouth County (manuscript), p. 15.

98. Carter G. Woodson, *Free Negro Heads of Families in the United States in 1830* (Washington, D.C.: The Association for the Study of Negro Life and History, 1925), 75–76, 81.

99. Frances D. Pingeon, *Blacks in the Revolutionary Era.* New Jersey's Revolutionary Experience no. 14 (Trenton: New Jersey Historical Commission, 1975), 20.

100. *Mt. Holly Herald,* April 15, 1932, p. 3.

101. Stewart, *Indians of Southern New Jersey,* 88.

102. United States Census. 1880. New Jersey. Burlington County (manuscript), p. 13.

103. Ann Roberts, Will. August 7, 1894. Division of Archives and Records Management, New Jersey Department of State, Trenton, N.J.

104. [James Still,] *Early Recollections and Life of Dr. James Still, 1812–1885.* (1877; reprint, Medford, N.J.: Medford Historical Society, 1971), 19–20.

105. Ibid., 23.

106. Woodson, *Free Negro Heads of Families,* 81.

107. Ibid., 76–77.

108. C. A. Weslager, *Delaware's Forgotten Folk: The Story of the Moors and Nanticokes* (Philadelphia: University of Pennsylvania Press, 1943).

109. Quoted in Theophilus G. Steward and William Stewart, *Gouldtown: A Very Remarkable Settlement of Ancient Date* (Philadelphia: J. B. Lippincott, 1913), 49.

110. Ibid., 62.

111. Ibid., 62–63.

112. Halpert, "Folk Tales and Legends from the New Jersey Pines," I: 43–44.

113. Fowler, "Nature Stark Naked," 3–6.

114. Glassie, *Passing the Time in Ballymenone,* 746n.

115. Ibid., 650.

THE ARCHIVE'S SHORES

SHORES *By Archie Green*

I n the mind's eye we see an island as bounded by a regular and continuous shoreline, although a careful look often reveals discrete beaches—sandy or rocky, open or mysterious, tranquil or tempestuous. Within American libraries, museums, and universities, archives often appear to be peaceful islands, at a distance from the mainland, figurative retreats for document and disc, manuscript and photograph. As a young sailor during World War II, I prepared for Pacific island hopping at Jamestown, Virginia. Journeying to Washington, D.C., while on leave, for a first visit to the Library of Congress, I saw its Archive of American Folk Song as a cool room within an immense marble building. It took me three decades to connect this room with outside domains of political tension and philosophic discourse.

Working at the Library during 1966, I edited an album of railroad songs from archival field recordings and learned that tie tampers and brave engineers used their chants and ballads variously: to pace work, to commemorate death, to challenge injustice, and to establish consensus. From 1968 to 1976, I was at the archive frequently, at times to study but mainly to prepare myself for visits to Senate and House chambers. There, in office and lobby, I conducted a long folklife "seminar," and, as the American Folklife Preservation Act wound its way to presidential signature in 1976, I had ample time to puzzle over the archive's complexity.

In time, we shall have a full history of the American Folklife Center,

its germinal course and everyday achievements. Here, I want to consider the visions of three widely different individuals whose energies are now integral to the center: Robert Winslow Gordon (1888–1961), John Avery Lomax (1867–1948), and Horace Meyer Kallen (1882–1974). Gordon and Lomax served, respectively, as first and second heads of the archive; whether or not Kallen ever visited it, I do not know.

My choice of a pair of insiders and of an unfamiliar outsider is deliberate, for an island's shores are altered both by wild storm and placid eddy. By invoking images of insularity, I wish to explore the ideas which have shaped the first public-sector unit in the United States devoted to folksong, folklore, and folklife.

We generally trace the origins of the American ballad quest to literary studies by Harvard's Francis James Child and see behind him a line of rhetoricians and antiquarians. Inspiring the trio of Gordon, Lomax, and Kallen was another Harvard professor, Barrett Wendell. Himself uninvolved in folksong study, Wendell was a gentleman, eccentric, patriot, and tory, engaged in ambivalent floundering between orthodoxy and heterodoxy. For him, American literature at its best derived from Mother England, and remote regions beyond the Berkshires produced only inferior writing. Yet this Brahmin, in asking his students to consider literature in relation to their experience, touched in them deep feelings of particularity and pluralism.

Looking back at his own odyssey, John Lomax saw his beginning at the Archive of American Folk Song in the initial encouragement to collect given him by Professors Barrett Wendell and George Lyman Kittredge at Harvard. Lomax dedicated his autobiography, *Adventures of a Ballad Hunter* (1947), to Wendell; previously, this teacher had written a warm introduction for his student's first book, *Cowboy Songs and Other Frontier Ballads* (1910). Over the years, Lomax enjoyed telling, and perhaps embroidering, his calling's opening tale.

As a Texas farm boy in Bosque County, Lomax had heard night-herding cowboys singing. Leaving home for college, he carried secretly a roll of trail songs in his trunk. At the University of Texas, when a distinguished philologist dismissed these as "tawdry, cheap and unworthy," Lomax, in shame, burned the packet. Years later, in advanced work at Harvard, when Wendell encouraged his respect for cowboy song, the Texan felt a phoenix rising from ashes.

Cowboy Songs carried a prefatory message from "Teddy" Roosevelt which closed, "It is ... of real importance to preserve permanently this unwritten ballad literature of the back country and the frontier." In the book's introduction, Wendell

complemented the sentiment, "I commend [cowboy ballads] to all who care for the native poetry of America." The linked phrases "back country," "unwritten literature," and "native poetry" seem commonplace today but were provocative in 1910. At that time, many leaders in academic and governmental circles judged the collecting of folksong as a peripheral activity.

Accordingly, pioneers like Gordon and Lomax engaged in a double mission—asserting that American literature was more than a branch of English letters and asserting as well the vitality of folk literature within American life. In this sense, folklorists, no matter how closely they held to mainstream ideological positions, advocated the merit of expression by neglected people.

In Washington in 1933, John Lomax picked up the tasks of the archive's creator, Robert Gordon. Despite differences in personality, both men were in substantial agreement on matters of then-current ballad theory. An obvious contrast between the pair lay in the ability of Lomax to tell his story dramatically in print and from platform, while Gordon remained largely mute, unable to publish his collectanea in a major book or to pen an autobiographical account.

Gordon's tenure at the Library was brief, running from 1928 to the trough of the Depression, 1932. Unfortunately, the Librarian of Congress, Herbert Putnam, and the chief of the Music Division, Carl Engel, failed to understand their archivist. At first, all three shared a grand vision of a national folksong repository, but Gordon was too much a bobcat to be tamed in a stone cage. He saw himself as a creative scientist; his supervisors needed a bureau-builder. When the private funds that created the position were exhausted, Putnam ended Gordon's appointment. The blow haunted Gordon until his death, and for decades he worked quietly as a technical editor in the Washington area. Only recently has Debora Kodish told the story in an article for the *Quarterly Journal of the Library of Congress* and reported Gordon's unselfish public contribution.

Gordon, born a Maine Yankee, seemed to take to mechanical devices as readily as Lomax had to cowboy song. At Harvard, between 1906 and 1917, Gordon tinkered with cameras, cylinder recorders, and early radio sets, preparing himself for eventual field work while teaching at the University of California, Berkeley. With an *Oakland Tribune* reporter, he sought chanties from the few windjammer crews still sailing through the Golden Gate. Gordon developed rapport with shellbacks and stevedores, no matter whether all their poetry

conformed to canons of ballad scholarship. Waterfront workers remembered him as "the guy with the derby hat and the phonograph."

Many hands hammered out the archive's governing concept, the intrinsic worth of folksong within American letters. Enlightened readers shared the ballad's glamour by reading Bishop Thomas Percy and Sir Walter Scott. At home, authors such as Irving, Cooper, Hawthorne, and Twain decolonized literature by attention to local legend. George Caleb Bingham and William Sidney Mount—steeped in Jacksonian democracy—depicted on canvas homespun fiddlers on flatboats and at barn dances. Joel Chandler Harris popularized Uncle Remus's animal tales; the Fisk Jubilee Singers carried spirituals north; Scott Joplin emblazoned ragtime coast to coast; W. C. Handy placed blues sheet music in many parlors. By the time Gordon arrived at the Library, a wide audience had been prepared to receive the songs of camp meeting and campfire, of hill and range.

Gordon sought machines both to discover and to extend such expression and was eager in his acceptance of technology. For a century collectors have used sound-recording equipment and cameras in the field and have issued their findings in many forms. But the problem inherent within the cylinder or disc machine, the perforated film track, or the magnetic tape and cassette is that all these instruments document tradition and at the same time distort and interfere with it. Hence, by definition, sound apparatus stands like Janus facing antiquity and modernity. Because technology preserves vernacular music in its subtle nuances and also corrodes tradition, robbing the folk of treasures, scholars have been made uneasy by "talking machines" and "canned music." Gordon escaped such anxiety because of faith in science. Not only was he ahead of many peers in his sheer facility with recording equipment—taking to it as an extension of his senses—but he reached out, during the Library years, to acquire commercial discs of folk music from Victor and sister firms.

Barrett Wendell's influence on John Lomax is treated in both their writings; however, I have not found similar references suggesting a dialogue between Gordon and his professors on recording or photographic devices. I am curious to learn whether any early ballad scholars prepared students to collect old lore with new gear, already on the market, or discouraged the use of these tools because they distorted folk material. When did it become proper to teach "the ballad" with a mechanical phonograph or a motion-picture projector

Sound recording truck purchased by the Library of Congress
about 1940

in the classroom? When did school teachers turn to the Library's Archive of Folk Song for field recordings as instructional aids?

I think that Gordon sensed no ambivalence about the "progress" implied by recorder or camera. In his cosmos, folksong represented truth, roots, authenticity. Hence, a device which lengthened an old folksong's life glowed in reflected light. But what if the same device shortened life? Using contemporary judgment, we suggest that Gordon anticipated neither that a phonograph might level traditional walls, nor that it might help enclaved groups in their counter-hegemonic wall-raising. Those folklorists only aware of the homogenizing thrust in mechanical apparatus have not observed that the wide extension of inexpensive recording and playback equipment has given local citizens a bit of control in holding at bay society's robots.

The matter of understanding all facets of the recording process-surfaces presently within the Folklife Center as it reissues Omaha Indian (and other tribal) music "caught" about (and after) 1896. Clearly, these "curiosities" function as

revitalizing factors in present-day Omaha life. Records, thus, advance ongoing campaigns for cultural equity. We feel it necessary, with this enlarged sense of the sound recording's contribution, to follow a single disc as it moves away from field or studio and reenters the resilient community in which listeners alter group identity. Ultimately, we must label early cylinders deposited in the Library not as archaic toys but as survival tools.

The Archive of American Folk Song retained its original name from 1928 through 1955, when it dropped the qualifier *American*. This shift marked response to the fact that, before World War II, the collection had already been broadened to include international material. No one in the Library made a conscious decision to shape an inclusive unit; rather, collectors deposited disc and manuscript from remote lands. Even before these items were accessioned, however, the word *American* had become troublesome to the third head of the archive, Alan Lomax, and to the wartime Librarian of Congress, Archibald MacLeish.

S. B. HILL, ★ 915 CONG. AVE. ★ AUSTIN, TEXAS.

Cheyenne
Aug 28ᵗʰ 1910

Dear Mr. Lomax,

You have done a work emphatically worth doing and one which should appeal to the people of all our country, but particularly to the people of the west and southwest. Your subject is not only exceedingly interesting to the student of literature, but also to the student of the general history of the west. There is something very curious in the reproduction here on this new continent of essentially the conditions of ballad-growth which obtained in mediæval England; including, by the way, sympathy for the outlaw, Jesse James taking the place of Robin Hood. Under modern conditions however, the native ballad is speedily killed by competition with the music hall songs; the cowboys becoming ashamed to sing the crude homespun ballads in view of which Owen Wister calls the "ill-smelling saloon

cleverness" of the far less interesting compositions of the music-hall singers. It is therefore a work of real importance to preserve permanently this unwritten ballad literature of the back country and the frontier.

With all good wishes,
I am
very truly yours
Theodore Roosevelt

From the inception of the American Folklore Society, in 1888, its members agreed that lore in the United States came in a babel: Passamoquoddy, Papagayo, Cajun-French, Pennsylvania-Dutch, to name a few tongues. Neither Gordon nor Lomax remained immune to linguistic reality, but, like most of their peers, they focused on English-language song. I do not mean to paint the archive's pioneers into too narrow a corner. Great in enthusiasm, they saw their public mission as related to Major John Wesley Powell's ground-breaking work — speech, myth, music, custom, artifact — in the Smithsonian Institution's Bureau of American Ethnology. In Gordon's reach to commercial records, he knew that foreign-series discs paralleled then-current "race" and "hillbilly" categories. In early field work for the Library, Lomax recorded the sacred Mexican play "Los Pastores" at San Antonio.

Despite this wide start in collecting, a limiting formula stunted the archive — a nativistic view of Anglo-Saxonism. Some nineteenth-century collectors had used the term primarily in philological reference, but others knew it as a shibboleth for purity of race and imperialistic policy. Some ballad scholars held an imbedded belief that Anglo-Saxon lore (curiously, also tagged *Elizabethan*) was not only quintessentially American but also an antidote to Catholic, Celtic, alien, radi-

cal, or assorted dark-skinned terrors. Many New England jingoists became active in movements to restrict immigration; some opposed the rise of institutions formed by newcomers; others retreated into a state of bitter melancholy, persuaded that their America was doomed.

Within folkloric circles, the term *Anglo-Saxon* was used broadly to touch society and culture. To illustrate, John Lomax opened his "Collector's Note" for *Cowboy Songs:*

> Out in the wild, far-away places of the big and still
> unpeopled west — in the cañons along the Rocky Moun-
> tains, among the mining camps of Nevada and Montana,
> and on the remote cattle ranches of Texas, New Mexico,
> and Arizona — yet survives the Anglo-Saxon ballad spirit
> that was active in secluded districts in England and
> Scotland even after the coming of Tennyson and
> Browning.

Today, we look back at the talismanic phrase "Anglo-Saxon ballad spirit" as part of the conventional baggage of folklorists trained in the past. Lomax may have used it formulaically without implying that other people lacked poetic impulse. We know that he had encountered black cowboys and Mexican vaqueros who were spirited singers with laden songbags. Liking their music, he struggled to accommodate his explanatory phrases to the world about him.

Anglo-Saxonism, when Lomax began to collect, held spatial and temporal significance as it tied to lateral labels. Theodore Roosevelt liked *Cowboy Songs* because the book illustrated the replication on our frontier of "conditions of ballad growth which obtained in mediaeval England." However, Lomax knew in his bones that black and Tejano buckaroos were neither Anglo-Saxon bards nor mediaeval exemplars. Throughout his life the tension implicit in such knowledge proved difficult to contain. While active at the Library, Lomax "discovered" a magnificent black folksinger, Huddie Ledbetter, in a Louisiana prison. The collector published a huge book on "Leadbelly," managed his early concert appearances, and, finally, quarreled with him. Regardless, Lomax could never compress this black singer into a xenophobic mold.

Horace Kallen. *Courtesy of the Harvard University Archives*

drawing upon experience at the Festival of American Folklife, Sen. Ralph Yarborough of Texas introduced a bill to create a folklife unit within the Smithsonian Institution. Time and circumstance altered his plan, for in 1976 the American Folklife Center saw light within the Library of Congress. In 1978 the Archive of Folk Song affiliated with the center, and in 1981 it acquired the name Archive of Folk Culture. (It must be noted here that the archive's staff, in the New Deal years, had already gone well beyond folksong collecting.)

To return to the archive's founding in 1928, I reiterate that it stemmed from the long drive to free our literature from European belletristic antecedents. Barrett Wendell never grasped the genius in Melville's *Moby Dick,* leaving that to others. Yet this teacher inspired Bob Gordon to seek chanties heard on the Pequod. Despite Wendell's pronouncement that American literature was "inexperienced" and "innocent," Gordon helped his fellow citizens see their elusive art in full flower.

We sense folksong's appeal and message by attention to a 1978 archive LP: *Folk-Songs of America: The Robert Winslow Gordon Collection, 1922-1932.* This field album, intrinsically educational, becomes a fitting companion to John Dos Passos's trilogy *U.S.A.* or Vernon Louis Parrington's *Main Currents in American Thought*—contributions in fiction and criticism that, interestingly, came from the pens of two of Wendell's students. I position Gordon's cylinders and discs as illumination for both Parrington and Dos Passos to underscore my view that archival beaches can be washed by Jeffersonian waters.

Had the archive's story ended in 1976, this essay could not have included a commentary on cultural pluralism. Because archive is now joined to center, we may note the voicing of cultural pluralism's meaning in congressional offices while the folklife bill drifted from legislative hopper to White House desk. In his initial bill, Yarborough declared "that the diversity inherent in American folklife has contributed greatly to the cultural richness of the nation and has fostered a sense of individuality and identity among the American people." Upon hearing this declamation by a Texas populist, I knew that we raised our red, white, and blue flag with manila lanyards of black, brown, and yellow.

Senators and Representatives have enjoyed the Library of Congress from its inception as their special reference center. Because of proximity and constant use, they have identified more closely with the Library than with parallel learned institutions in Washington. Hence, during the early 1970s, a majority of these lawmakers saw no problem in extending the

Alan Lomax accompanied his father John on collecting trips in the South and assisted him at the archive. To mark Alan's enthusiasm, I quote a line from a letter dealing with a visit (1935) to the Georgia coast, Florida, and the Bahamas: "This has been the most exciting field trip I have made and, really, its story can only be told in a long, rambling novel." We need this novel, long overdue, as well as a reflective autobiography. It is our loss also that B. A. Botkin left no critical account of his years at the archive (1942-1945). Alan Lomax and Ben Botkin, together with their friend Charles Seeger, carried a heady mix of liberal and radical, populist and Marxist values to the archive during the New Deal period.

In the years from 1950 to 1970, the archive turned inward, reflecting both internal Library policies and an external climate of civic conformity. Further, the activists who came together in the Kennedy years to lobby for the National Endowment for the Arts and the National Endowment for the Humanities were not tuned to folk culture. These partisans of high art and formal learning hardly seemed aware of panoramic folk tradition. Essentially, the builders of the endowments established their agencies initially to distance attention from rurality, artisanship, ethnicity, and regionalism.

The impetus to change in Washington comes from all points of the compass: a chance happening, a planned position paper, a legislative program, a newspaper report. In 1969,

archive's role in documenting folksong (preservation) to novel modes of dissemination (presentation) for folklife. In effect, "passive" archival practices took on an "active" dimension of display for a rainbow of American expression.

Cultural pluralism's bibliography is extensive; its theoreticians are few. Here, I feature only one, Horace Kallen, largely unknown to folklorists. Professor Kallen taught philosophy all his life; versed in esthetics, he wrote extensively about the arts. However, his contribution to folklore was not that of field collection, archival categorization, or popular interpretation. Rather, he articulated a concept which helped resolve the turmoil of many American scholars caught between adherence to the state's dominant ideology and affection for a particular group's expressivity.

Kallen was born in Silesia, Germany, and his Jewish parents brought him as a child to Boston's West End. There, he "grew up among Bostonians neither propertied nor proper." His earliest orthodox doctrines, which came from the Hebrew Bible, were countered by New England teachers who worshipped another set of founding fathers. At Harvard, he was close to many superb teachers, among them William James, George Santayana, and Barrett Wendell. Recalling college days, Kallen reported that he lived not in Cambridge but in an "otherworld," his parents' immigrant home. Additionally, he lived as a social settlement resident in the North End where he met socialists and anarchists, testing his creed against theirs.

Associated with the New School for Social Research in Manhattan from its founding in 1919, Kallen for a period edited *Advance,* the organ of the Amalgamated Clothing Workers. He was also very active in peace, civil liberties, and consumer cooperative movements. Kallen did not subscribe to a separation of scholarship from society, saying dryly that he "never attained that fullness of pedagogical withdrawal which custom and prejudice ordained for the practice of philosophy." We are in his debt for his rejection of campus ethos.

My focus on Kallen's cultural pluralism pulls one thread out of rich cloth but a thread crucial to all folklorists. During his youth he was conscious of fracture between his Jewish and American self. Many immigrant children feel this pain, but not all are able to externalize it creatively. In Wendell's class, Kallen tentatively linked his fate with those Hebrew prophets this Puritan teacher enshrined. Wendell not only brought back from ashes Lomax's packet of cowboy songs but also rekindled Kallen's interest in ancestral past, helping him reconcile seemingly antithetical ideals.

Nationality and the Hyphenated American

By Horace M. Kallen

THE UNITED STATES OF AMERICA are at peace with all the world. Our government is not taking sides in the great war; officially we are the friends of all the embattled powers. And yet—we have but to take up any newspaper, anywhere in America, to find violent praise of one side, violent blame of the other. The sentiment of our country is divided. On all sides, our diverse populations are emphasizing afresh their European origins and background. The German in German-American, the Slav in Slavic-American, the Briton in British-American, have awakened, have become demonstrative and emphatic. The President, observing this, has declared his official and personal boredom with the "hyphenated American," and the conception expressed in this phrase has become an issue in the written and spoken discourse of our country.

Why, in an officially neutral country, has this come to pass? When we look closely to the ground and principle of the division of sentiment in our population, we discover this significant fact: the division is not truly determined by the merits of the European issue; it is determined by the lines of our population's European origin and ancestral allegiance. The Americans of German and Austrian and Magyar ancestry are pro-German; those of French or British or Russian ancestry favor the Allies. Only the Jews seem to be an exception to this rule. Being mainly from Russia, their favor should go to the Russians, but their newspapers, almost without exception, favor the Germans. The case of the Jews, however, is an exception that proves the rule. Although the majority of them came from Russia, they have had no part in the Russian polity; they have been oppressed, persecuted, terrorized, as their brethren still are in Russian territory. As

HORACE MEYER KALLEN (born in Silesia, Germany, in 1882, came to America in 1887), studied at Harvard (A. B., Ph.D.), Princeton, Oxford, and Paris. He has been assistant and lecturer in philosophy at Harvard, instructor in logic at Clark University, and since 1911 of the faculty of philosophy at the University of Wisconsin. At the request of the late William James, he edited his unfinished book on "Some Problems of Modern Philosophy." Besides contributing to philosophical and general periodicals, Dr. Kallen is the author of a recently published book on "William James and Henri Bergson." Dr. Kallen was one of the founders of the Harvard Menorah Society, and has rendered signal service, both by tongue and pen, to the Menorah movement.

79

While Kallen was teaching at the University of Wisconsin, the United States was seized by fears of hyphenated Americans and shrill demands for immigrant-restriction laws. Wisconsin sociologist Edward Ross presented "scientific" arguments for harm inflicted on the body politic by newly arrived foreigners. Drawing on a personal sense of Jewish marginality and public debates by Zionists, Kallen immersed himself in minority issues. He buttressed empathy for beleaguered people by borrowing aspects of the elder Bob La Follette's progressivism. William James's striking image of a pluralistic universe, antithetical to monistic dicta, helped the young philosopher find language then new in the political arena.

At the end of 1914 Kallen prepared an academic paper, "Democracy and the Melting Pot," in response to nativist agitation. This address reached a lay audience in the *Nation* (February 18 and 25, 1915), where the word *versus* displaced *and* in the paper's title. In 1916, he called upon Americans to champion the "perfection and conservation of differences"—language close to that used in the 1970s to advance folklife legislation.

While teaching at the New School and associating with foreign-born needle-trades workers, Kallen drew together several articles on diversity, equality, and comity in *Culture and Democracy in the United States* (1924). Dedicated to Barrett Wendell, the book attacked *Kultur,* countering it with cultural

pluralism (a locution then new in print). In essence, Kallen assailed melting-pot assimilationists and Anglo-Saxon supremacists, while he equated pluralism and democracy.

As early as 1915, Kallen had pointed to Switzerland as a model democracy, a commonwealth of cultures. Patrician critics of his 1924 book spoke derisively of crazy quilts and Balkanization. Returning in 1956 to his cause's wide implications, he suggested that our experience precluded a republic of ethnic or linguistic sub-nations. Reflection on totalitarianism had turned liberals away from dogma of race or geist tied to the state. Accordingly, Kallen stressed the vitality of cultural components within the polity over strange constitutional forms. With Whitmanesque prose, he centered cultural pluralism in expressive rather than political behavior. Contemporary folklorists are wise to turn his formulas into inquiries by asking: What kind of diversity can a sovereignty accept? How does such diversity integrate with our heritage of individual freedom and sectional consciousness? Must we see national sustaining culture always as seamless and absolute?

Rulers of large society have usually treated arts and letters as props for national cohesion, while artists and writers have often seen their work as opposing monolithic rule. In our Viet Nam era of "cultural revolution," black nationalists, white-ethnic revivalists, and counter-culture hedonists became especially strident. Conservatives charged militants, chauvinists, and flower children with subversive divisiveness. Liberals called up varied catchwords to type the changed nation: *mosaic, tapestry, symphony.* Figuratively, folklore collectors became tile setters, weavers, or conductors. Those folklorists who eschewed political envelopment employed their knowledge of traditional language and literature, customary behavior, and the mythic paraphernalia of identity to describe the American cornucopia.

In a 1955 memorial essay to his friend and classmate Alain Locke, Kallen asserted that he had first verbalized the concept of cultural pluralism about 1906, while an assistant to Professor Santayana. Kallen noted, "It has taken these two generations for the term to come into more general use and to figure in philosophic discourse in this country." At his ninetieth birthday (New School, 1972), he expressed oracular satisfaction that his early "upsetting" ideas had been vindicated. Folklorists have assisted in this vindication, not directly as polemicists, but by gathering tribal and ethnic lore and displaying its magnificence.

Metaphorically, folklorists have not upended the melting pot as much as they have sought to treasure its discarded slag.

Folkloric work with "non-Anglo-Saxons" has touched Native Americans, Afro-Americans, and immigrants from all the globe. Some collectors of folklore have paralleled the pioneer documentation of Jacob Riis and Lewis Hine in ghetto and factory, at times absorbing progressive belief in civic reform. More recently, some have been caught up by the Civil Rights movement, which itself contributed to the widening of congressional horizons. Some proclaimed, in the 1970s, that traditional artistry and folk wisdom were integral to American experience; hence, the government's major arts/humanities foundations altered their course.

I shall not gloss Kallen's coinage further but instead shall allude to great differences in this century among black leaders (such as Marcus Garvey, James Weldon Johnson, and W. E. B. Du Bois) caught, like immigrants, between rival goals of assimilation and separatism and lashed by demagogue and eugenicist. The issues long voiced in the struggle against racism still echo in our land. Afro-American lore, serving both as lance and shield, also became an instrument used in the division between integrationist and nationalist. Was Brer Rabbit to be left behind on plantation field or to be recharged as a combative warrior on new battlefields?

We need to probe deeply the interaction between white and black intellectuals who accepted, rejected, or modified theories of cultural pluralism. We can begin with Alain Locke, who identified himself as "a philosophical mid-wife to a generation of younger Negro poets, writers, artists." By urging them to see African art and to hear Afro-American speech and music, he made formal, for many, their link to the discipline of folklore. Literally, he sent them to archive and gallery to immerse themselves in proverb and headdress, ringshout and figurine. Balancing training in ethics and esthetics with reading in anthropology, Locke suggested that the term *value relativism* defined his worldview.

This usage draws us back to Franz Boas, Ruth Benedict, Margaret Mead, Edward Sapir, and their students who generally favored the term *cultural relativism* in their studies. Professor Benedict was influenced by the young critic Randolph Bourne, who, with great flair, championed the organic and creative impulse within immigrant communities. After Benedict's widely read *Patterns of Culture* (1935) appeared, a number of folklorists adopted her exemplifying prose. The path of anthropological language into federal agencies has been better charted than that of philosophical pluralists.

We have yet to describe Kallen's presence in Washington. For example, Sen. Paul Douglas of Illinois had long admired

his friend Jane Addams for her work with immigrants at Chicago's Hull House. In lauding her, he referred to Kallen's seminal "Democracy Versus the Melting Pot." The Douglas reference is unusual; I believe that most Congressmen who subscribed to cultural pluralism learned about it in attenuated form. Some absorbed it out of the politics of ethnicity; others, from religious renewal; still others, from studies about the artistic landscape. Writers as widely scattered as Louis Adamic, Will Herberg, Milton Gordon, Geno Baroni, Michael Novak, Ben Botkin, and Constance Rourke all drew upon or altered Kallen's texts. These individuals, in their separate writings, contributed to legislative dialogue on the widest horizons of American experience.

Until 1967, the Library of Congress's archive remained the federal government's major unit for the transformation of folkloric codes into public actions. After 1967, the Smithsonian's Festival of American Folklife gave high relief on the National Mall to the twined rubric of cultural pluralism, value relativism, and cultural relativism. Festival participants hardly made explicit use of these labels; rather, musicians and dancers performed while craftsmen worked. Auditors and viewers heard a gospel hymn lined out or saw a wood carver fashion an ox yoke. The private ceremonies of groups set apart from America's common culture became public enactments in a colorful "outdoor museum." Perhaps a few visitors on the Mall connected their pleasure to Kallen, Locke, or Benedict. Significantly, a handful of Senators and Representatives made the connection.

The Smithsonian's annual event cemented the word *folklife* to a congressional policy of cultural diversity. Previously, Prof. Don Yoder at the University of Pennsylvania had bridged the teaching of folklore in the United States to European folklife studies (regional ethnology, cultural geography, material culture). A report by Yoder on his extension of the keyword *folklife* to American usage, as well as a report by Ralph Rinzler, the festival director, on the Smithsonian experience would help identify the core ideas now built into the term.

By focusing this essay upon three students of Barrett Wendell, I have tried to reveal one archive's formative concepts. Gordon, Lomax, and Kallen wrought their designs out of mundane and, at times, painful experience. Like other Crusoes, they gathered sticks and stones from the tidal pools about them to construct the platforms upon which they exhorted and prayed. Only from today's juncture can we distinguish sharply their guiding constructs: American litera-

ture's coming of age, folksong's worth, power in recording device and process, diversity as a federal agency norm.

Professor Wendell's Washington apprentices served Americans well by eclipsing their New England teacher's narrow views about literature. Gordon and Lomax, trained in arcane debates about the ballad's origin, helped enfranchise vernacular culture. They enlarged the Library of Congress holdings to include discs with magic power of recall. Sir Patrick Spens and Mary Hamilton, Stackolee and Pearl Bryan, John Henry and Mother Jones now live in a marble mansion.

The achievement of Gordon and Lomax, great enough, led after half a century to the archive's affiliation with the Folklife Center, itself born out of legislative attention to ethnic identity, race tension, cultural accessibility, historic preservation, and resource conservation. In these pages I have touched, but not spelled out, matters of ethnicity and the access to art and letters by rank-and-file citizens. However, I have neglected entirely matters of preservation and ecology. Perhaps a personal note, here, will hint at the center's labyrinthine mandate.

In urging Congressmen, before 1976, to vote for the folklife bill, I learned how differently each member defined the word *folk*. Concretely, it meant string-band tune, good-luck amulet, blessing of the fishing fleet, yarn swapping, corn dance, covered bridge. Abstractly, it meant language retention, Negritude, pleasure in hand skill, savoring dry wit in colloquial humor, respect for Indian belief. I felt complimented when folklorists were likened to Rachel Carson and John Muir, and when I was asked whether we had a Sierra Club or Audubon Society. Finding it necessary to explain folklife to legislators tuned to Cambodia and Watergate, I could not go beyond their common-sense notions that some culture was endangered and that federal dollars for arts and letters, in a democratic society, had to be spent equitably. On Capitol Hill, I suggested that a mountain ballad resembled a redwood tree, snail darter, colonial farmstead, or Amish buggy.

Clearly, as Senators and Representatives considered the folklife bill, they reshaped the concept of cultural pluralism pragmatically by welding it to preservational strategy for human artifact and natural environment. Without knowing in detail the history of their own folksong archive, they tempered the ballad passion of Gordon and Lomax with queries embodied in Kallen's blueprints: How is power shared within a society divided by race, class, language, and creed? Where does expressive culture intersect with political and economic force? Does diversity enhance or negate our social compact?

This cartoon by Dick Peeples appeared in the *Cleveland Press* a few days after the May 8, 1974, hearings on the proposed bill to create the American Folklife Center. Although not present at the hearings, Peeples read a reporter's account of performances by Elizabeth Cotten and Glenn Ohrlin before Senators Howard W. Cannon, Marlow W. Cook, and Mark O. Hatfield.

These provocative questions switch past to present. The folklorists who now choose to work at the Library of Congress and, by extension, at sister agencies cannot escape the burden of reformulating statements of national purpose. We try to complement the netting of a blues lament or the framing of a patterned quilt with attention to studies in normative theory and reports of ideological conflict. Public-sector folklorists should read the historians who have detailed the ambiguities within cultural pluralism. Beyond such insight, it is useful to consider the work of political economists and sociologists on the right who find pluralistic creeds wanting and, as well, of critics on the left who scorn pluralism's utility either as analytic tool or social template.

Armed with the findings of fellow scholars, folklorists can help unravel American complexity. We are sensitive to that array of elements which defines polity and principle: region, religion, language, ethnicity, race, occupation, class, gender, age. We know songs and stories in English, our common language; we know the jokelore of mestizo and creole; we know rituals of migrants, castaways, and refugees. Many contemporary followers of Gordon and Lomax continue to choose documentary projects; others, touched by Kallen's teaching, choose advocacy for creative group or expressive cluster. Archivists, who daily intertwine preservational and presentational modes, of necessity mix roles.

Within this setting of juxtaposition in tasks, I return to my opening figure of repository as island. Clearly, the present Archive of Folk Culture, now integral to the Folklife Center's function at the Library of Congress, cannot be isolated from centuries of American experience or thought. Neither filiopietistic adulation nor revisionist carping focuses our vision clearly on granite cliff or coral strand. To see our archive as a uniformly contoured circle suggests dim sight. To sense it as a tranquil abode suggests only partial comprehension. The archive's land-mass is irregular; its beaches, indented; its shores, varied.

Note on Further Reading

This list of selected references is grouped by the four main individuals and three central ideas of my essay. Items are arranged chronologically within sections.

WENDELL

Self, Robert T. *Barrett Wendell.* Boston: Twayne, 1975. (Includes full bibliographic citations.)

LOMAX

Lomax, John Avery. *Cowboy Songs and Other Frontier Ballads.* New York: Sturgis and Walton, 1910.

————. *Adventures of a Ballad Hunter.* New York: Macmillan, 1947.

McNutt, James Charles. *Beyond Regionalism: Texas Folklorists and the Emergence of a Post-Regional Consciousness.* Austin: University of Texas, 1982. (This thesis includes a Lomax bibliography.)

GORDON

Kodish, Debora. "A National Project with Many Workers." *Quarterly Journal of the Library of Congress* 35 (October 1978): 218–33.

————. *"Good Friends and Bad Enemies": Robert Winslow Gordon and the Study of American Folklore.* Forthcoming from the University of Illinois Press.

KALLEN

Kallen, Horace Meyer. *Culture and Democracy in the United States.* New York: Boni and Liveright, 1924.

————. *Cultural Pluralism and the American Idea.* Philadelphia: University of Pennsylvania Press, 1956.

BALLAD STUDIES

Wilgus, D. K. *Anglo-American Folksong Scholarship since 1898.* New Brunswick: Rutgers University Press, 1959.

Leach, MacEdward, and Tristram P. Coffin, eds. *The Critics and the Ballad.* Carbondale: Southern Illinois University Press, 1961.

Porter, James, ed. *The Ballad Image: Essays Presented to Bertrand Harris Bronson.* Los Angeles: UCLA Center for the Study of Comparative Folklore and Mythology, 1983.

RECORDING TOOLS

Brady, Erika, et al. *The Federal Cylinder Project, Vol. 1: Introduction and Inventory.* American Folklife Center, Library of Congress, 1984.

Gronow, Pekka, Richard Spottswood, et al. *Ethnic Recordings in America: A Neglected Heritage.* Washington: American Folklife Center, Library of Congress, 1982.

CULTURAL PLURALISM

Matthews, F. H. "The Revolt against Americanism: Cultural Pluralism and Cultural Relativism as an Ideology of Liberation." *Canadian Review of American Studies* 1 (Spring 1970): 4–31.

Greenbaum, William. "America in Search of a New Ideal: An Essay on the Rise of Pluralism." *Harvard Educational Review* 44 (August 1974): 411–40.

Higham, John. "Ethnic Pluralism in Modern American Thought." Chap. 10 in *Send These to Me.* New York: Atheneum, 1975.

Gans, Herbert J. "Symbolic Ethnicity: The Future of Ethnic Groups and Cultures in America." In *On the Making of Americans: Essays in Honor of David Riesman,* ed. Herbert J. Gans. Philadelphia: University of Pennsylvania Press, 1979.

Mann, Arthur. *The One and the Many: Reflections on the American Identity.* Chicago: University of Chicago Press, 1979.

Wacker, R. Fred. "Assimilation and Cultural Pluralism in American Social Thought." *Phylon* 40 (December 1979): 325–33.

Gleason, Philip. "Americans All: World War II and the Shaping of American Identity." *Review of Politics* 43 (October 1981): 483–518.

"THE TEAMSTER IN JACK MacDONALD'S CREW:" A Song in Context and Its Singing

By Edward D. Ives

M usic is universal in human culture: so far we have never found people without it. That in itself is a remarkable thing, and I can in no way satisfactorily account for it. I can understand why all peoples have to gather food, construct some sort of shelter, or develop systems of kinship or political and social organization. But why they have to make music is beyond me. Yet make it they do, always.

So far as I know, the most universal form of music is song. That makes sense when you consider that the basic equipment for singing is immediately available to every human being. It involves a special use of language—again something available to all members of a culture—in which words are put together to form a discrete and patterned entity culturally recognized as something quite different from mere speech or conversation. The words are uttered in a special way that arranges the pitch, duration, loudness, and timbre of a sequence of sounds into patterns different from either mere noise or ordinary speech. This synthesis is song.

Before we go further, I want to make an important distinction between a song and a singing of that song. A song is a mentifact, a

Joseph Walsh, Morell Rear, Prince Edward Island, who sang "The Teamster in Jack MacDonald's Crew" for the author on September 1, 1965. (NA P 253)

concept, an idea. It has existence in the mind apart from its actual performance, and we can recognize and discuss its content, style, and structure. A singing of that song—let's call it a performance—is its physical manifestation, the only way it can be known and make the synaptic leap from one mind to another. Performance too can be analyzed, in such terms as how the voice is used, where and when singing takes place, who sings, or who listens. What follows here has to do with both the song and its performance, but having made the separation we must remember that for all its usefulness it is only a construct. Frequently we cannot know the dancer from the dance—or if you prefer Wallace Stevens to Yeats:

> Beauty is momentary in the mind—
> The fitful tracing of a portal;
> But in the flesh it is immortal.[1]

Just as there is no such thing as a universal language (though language is universal), there is no such thing as a universal music. A song is created within a particular tradition to be performed in an expected manner to a specific audience for certain reasons and with anticipated or hoped-for results. No part of this continuum can be separated from any other without doing violence to the whole—or (if we do make such a separation) we must recognize the potential distortions that may arise from so doing. Let me give two brief examples.

Samuel Barber, a professional composer, took a poem, "Dover Beach," written by a professional literary man, Matthew Arnold, and set it to music. It was intended to be sung by a professional singer, accompanied by a string quartet, all of whom would have spent much time rehearsing this piece before performing it in a concert hall—a building especially built for such performances—as part of a program of similar songs for an audience that has paid to come and hear it.[2] Joe Scott, a New Brunswick woodsman, made up a song about his friend Guy Reed, who was killed when a pile of logs he was working on collapsed. He made up the words, set them to a familiar tune, and sold the product to other woodsmen in the area, with the expectation that it would be sung in the lumber-camp evenings—or in kitchens or parlors at home later on—by men like himself for a small group of friends, any one of whom might then sing another song while the singer of "Guy Reed" listened.[3]

Each song, Samuel Barber's "Dover Beach" and Joe Scott's "Guy Reed," fits its matrix perfectly, and appropriate aesthetic standards could operate in each situation. Barber took "old" words and set them to a tune and accompaniment of his own devising, while Scott made up a "new" set of words which he set to a familiar tune, yet within his own tradition each would have been said to have created a "new" song. The singer of "Dover Beach" would be praised for projection and control of beautiful tone (though good diction would be expected too), while the singer of "Guy Reed" would be praised for having a good memory and getting his words out good and clear (though it would be expected he could also "carry the air"). Each tradition grew out of its own culture with its own value systems and history, and examples of each deserve to be listened to hard. Neither should be judged according to some foreign code of conscience or against some absolute concept of beauty and excellence. There are no aesthetic absolutes, to begin with, and any appeal to them is more often than not simply the inappropriate application of one's own code.

Let me back off a bit on my dogmatism about the nonexistence of absolutes in music and poetry. Since they *are* cultural universals, it seems at least reasonable to entertain the notion that there might be criteria that can be universally applied. I do not know what they are, but I am sure that aesthetic criteria developed from the study of Western elitist art do not necessarily embody them. If aesthetic absolutes exist, our understanding of them will come from the work that anthropologists, folklorists, ethnomusicologists, psychologists, and—yes, even so!—physiologists are doing in the study of different art forms in different cultures and the complex interrelationships these forms have with the peoples who participate in them. But any absolutes so derived must be based on the totality of man's musical and poetic experience, insofar as that is possible, and insofar as it is not possible their tentative nature should be clearly understood.

What I am arguing for, then, is the principle of the essential equivalence of all art forms as elements in systems of expressive culture to be taken on their own terms. It is a tough and uncomfortable assignment—and one of the central tasks of all anthropology—that carries with it all the doubts and uncertainties that come when one abandons revelation for reason and close observation. It sometimes stands the known world on its head, and eternal verities about creativity, genius, greatness, and even Art begin to have the sound of brass and tinkling cymbal. It commits one to such blasphemies as the assertion that Joe Scott, the woodsman-songmaker, is the artistic equivalent of William Butler Yeats, however uncomfortable and ridiculous one may feel at first in making such an assertion. What's the payoff? Why bother? Because of the splendors one finds in odd and unexpected places and what these splendors reveal to us of what it means to be a human

The tune has been transposed so that its final note falls on G. The original pitch is given in the catch signature.

The Teamster in Jack MacDonald's Crew

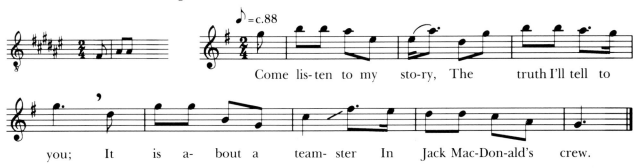

Come lis-ten to my sto-ry, The truth I'll tell to you; It is a-bout a team-ster In Jack Mac-Don-ald's crew.

being, "sustaining, for a while," as James Agee said, "without defense, the enormous assaults of the universe."[4]

Let's get down to cases. I have already written three books on woodsmen and farmers who, like Yeats and Shakespeare, sustained those enormous assaults and made art that helped them and their fellow humans endure.[5] Joe Scott, for example, took his deep hurt and from it made ballads of such things as lost love, murder, violent death on the job, poverty, drunkenness, and sick and lonely suicide. He endowed the sordid and meaningless with momentary dignity and worth, and several generations sang his songs and took strength from so doing. That is the sort of splendor I am talking about. What I would like to do now is take one ballad—not one of Scott's—and show how it too is a splendor of sorts.

Joe Walsh had a big farm out in Morell Rear on the east end of Canada's Prince Edward Island. He was about seventy when I first met him, September 1, 1965, and I have already fully described that first meeting in *Lawrence Doyle*.[6] That evening we sat in the kitchen of his big farmhouse—Joe and his wife Winnie, Bobby, our children (who were wonderfully quiet), and I—and Joe sang ten songs for us in a clear, gentle tenor voice that was just right for both the room and the songs. He loved to sing and had always been known as a singer, which, as I have suggested, meant more that he had a large repertoire, a good memory, and could get his words out

plainly than that he had a "good voice." One song he sang was the following:[7]

The Teamster in Jack MacDonald's Crew

1
Come listen to my story,
 The truth I'll tell to you;
It is about a teamster
 In Jack MacDonald's crew.

2
Our crew it was a merry one
 Of eighteen men or more;
Our winter's work had scarce begun
 When Death had darkened our door.

3
We were talking after supper when
 One of the teamsters said,
"I hear young Stubbs complaining of
 A pain that's in his head."

4
The night passed on and morning came,
 The sickness it grew worse;
We moved him from the lower bunk
 Into the upper berth.

5

And when we went to breakfast
 We dared not leave him alone;
We wrapped him up in his blankets warm
 All for to take him home.

6

Jack MacDonald and Tom Proctor
 Took a pair of trotty bays,
And before the stars had ceased to shine
 They were miles upon their way.

7

They took him to his little home
 In the town of Sherman Mills,
And to break the news unto his wife
 It did require great skill.

8

They sent for Dr. Harris while
 His wife and family cried.
But to rescue him from Death's cold grasp
 It was in vain they tried.

9

Here's to MacDonald and his crew,
 Our blessing do we give;
And may their troubles they be few
 And happy may they live.

10

And when Death comes knocking at our door
 And we are called to go,
Let us pray that we will meet our Lord,
 Let his mercy on us show.

*"I haven't thought of that song for forty years," said Joe afterwards, "but it's still there, you know." [8] I'm always amazed at how singers can dredge something up after forty years and find it still bright and clear. In all honesty, though, I should point out that the forty years had taken their toll. When Joe started to sing "The Teamster," he omitted the second stanza. Then in 1970, five years later, when I asked him to sing the song again for me, he sang it without that second stanza. Afterwards he mentioned that he'd left a verse out. When I suggested he sing it for me, he mumbled over that second stanza as if he *had* just sung it and then sang the following:

It fell unto a married man,
 Leslie Stubbs by name,
Who came into the lumberwoods
 His family to maintain.

Obviously that second stanza was unstable in Joe's memory, while the "new" stanza was barely emerging from the forty years of dormancy. What further singings would have been like is an interesting question I never had the chance to answer. Joe Walsh died in 1975 when his house burned down. Rest him.

If I was amazed at Joe's memory, I was also immodestly amazed that here was a song about the Maine woods that I had never heard before, nor (to my further immodest amazement) have I heard it since, though I have asked for it repeatedly. Yet I was not too amazed by my amazement. I knew that new songs were constantly being made in the lumbercamps, and this one followed a very traditional pattern.

What I had, then, was a problem in creativity, in how newness comes about, which brings up a paradox that can be stated in several ways: the new is always seen against the background of the old, creativity is a function of tradition, and without constant creativity tradition dies. Analogies are tempting but risky, and while I recognize that we should not expect too much of them, I am tempted to risk one now. Any song, any poem—any work of art, for that matter—is the resultant of three vectors.[9] First, there is the poet's knowledge of work that has preceded his, the models he will have to draw on—which is to say, the available tradition. Second, there is the new raw material, the "event" if you will, which presents itself to the poet for shaping. Third, there is the individuality of the poet himself, the hardest of the three vectors to describe but one that is clearly present in every work of art. The resultant "new" work will be "published" in some form, and if it is accepted it will itself become part of the tradition for other poets. All this is true for any work of art, but let's see how it applies to the song in question. We can begin by taking a look at the raw material from which it was made, the event itself.

Since information on that event was scattered and hard to come by, it might interest the reader to follow out with me the process by which I brought it together. All I had to start from were four proper names ("young Stubbs," Jack MacDonald, Tom Proctor, and a Dr. Harris), the name of the town of Sherman Mills, and Joe Walsh's statement that he had learned the song in a lumbercamp near Katahdin Iron Works about 1911. Using that date as my point of departure and hazarding that the ballad had been composed not too long before that, I checked the U.S. Census for 1900 under Sherman and Sherman Mills, where I quickly found the name of a Dr. Francis Harris, aged fifty, which suggested to me that I was at least on the right track. Then I found a Walter Stubbs, aged

Map of Maine, showing locations of Sherman Mills and Katahdin Iron Works. *Map drawn by Stephen Bicknell*

thirty-one, farm laborer, married with two children. That looked about right. Since a farm laborer might well have worked in the woods in the winter, that notation presented no problem, but the Stubbs in the song is described as "young Stubbs," and thirty-one was a little old for young, I felt, especially around 1900. Checking a little further, I found a second candidate, Wilton Stubbs—aged thirty, farmer, married, with three children—who appeared to be an equally good candidate and, because of his age, an equally doubtful one. That appeared, though, to exhaust the possibilities, until a more careful reading showed me an Earl Stubbs, a laborer, twenty years old, who was boarding with a family by the name of Bryant, but while his age was nearer what could have been called "young," he was single and childless. At this point, I wrote to Roland V. Webb, Town Manager of Sherman Mills, laying my problem and its three solutions before him, and a few days later I received a phone call from him saying that of

the three men Earl Stubbs was almost certainly my man and (mirabile dictu) that Earl Stubbs's daughter was still living in the area.[10]

On Monday, March 17, 1980, I made a trip to Sherman Mills to check whatever official records were available. They showed that the death dates for Walter and Wilton Stubbs eliminated them as candidates (coming as they did long after Joe Walsh learned the song). That left me with young Earl, and for him everything fell into place. He had married Thankful Coffin on October 16, 1900 (several months after the census had been completed), and they had had three children: Vance (born 1901), Lilla May (born 1903), and Annie (born 1905). He had died at age 28 on January 23, 1908, of "cerebral meningitis," and Dr. Harris had signed the death certificate. On February 8, just over two weeks after his death, Thankful gave birth to their fourth child, a son, whom she named after his father, Earl. Everything sounded right—even the headache as an onset symptom of meningitis—and my visit with Lilla May Stubbs (now Mrs. Hartley Anderson) that same day was especially helpful in confirming the identification.[11] Though she had been only five when her father died, she was able to tell me both what she remembered seeing and what she had been told. Putting this information together with what I was able to find in the newspapers from around the time of Stubbs's death (and adding a few careful and moderately educated surmises of my own), I was able to piece together the following story:

It had been a ferociously cold and nasty January, the newspapers said, adding that "Grip and grip colds still holds sway in this locality [i.e., Patten], new subjects are claimed nearly every day [.] in some instances whole families are down with it."[12] Young Stubbs and his family had been living as tenants on a farm on the Golden Ridge Road, but (as was so often the way) he had gone into the woods for the winter to work in a camp some sixty miles to the northwest. No one is quite sure, but one man claimed that Tom Proctor was the boss and Jack MacDonald was his foreman. *"The men had played cards that night," Mrs. Anderson had been told, "and about nine o'clock they went to bed. . . . And then it was told to me that about twelve o'clock they heard him say, 'God, such a pain in my head,' and that's the last words that he ever did say." They decided right away to bring him home. "They had to travel with that tote team for sixty miles," said Mrs. Anderson. "They covered him up with a blanket and brought him out right there in January and brought him here, and he never did speak or anything." Although she did not recall the funeral itself, she recalled seeing her dead father:

*They held me up to the casket to look at him . . . and I went for years that I . . . couldn't even hear a sad song or anything but I would cry when I was a little girl. . . . 'Course my mother was left without any money. As I remember it people have told me that the town took up a collection to bury him.[13]

Summing up the available facts, about all we can say is that in the cruel winter of 1908 a young teamster contracted spinal meningitis in a small lumbercamp well to the north of Maine's Mount Katahdin and was brought some sixty miles to his home in Sherman Mills, where he died. It was not, in the world's eye, a significant passing. Earl Stubbs never even rated an obituary. But he did rate a ballad.

Where did Joe Walsh pick this ballad up? The first time I asked him that question, he was anything but positive. *"I believe in uh, I believe in Gilead [Maine]," he said. "Let me see now. No, it wouldn't be Gilead; it must have been the Iron Works," he continued, referring to his second trip to the Maine woods around 1911 to work near Katahdin Iron Works. He further claimed the song was made up by two men, one of whom was a fellow Islander, Sife Mooney, though whether Mooney was in the same camp with Joe there in the Iron Works was not entirely clear. Then when I asked him the same question in 1970, he gave the following answer:

*There was a man by the name of Sife Mooney over here in Ruskin. He was up there in that crew that winter, and him and another fella it was [made that up]. I learned it from a fella that taught school over there, Tom Keefe was his name. He taught school over in that section where this Sife Mooney lived.

Thus, Joe Walsh either learned the song in a lumbercamp about a hundred miles to the south of where it was written (and about three years after the event it celebrates), or he learned it back home on Prince Edward Island from a friend. Whichever way it was, he knew it was composed by a fellow Islander, and he almost certainly learned it during those early years when he was still traveling back and forth from Prince Edward Island to the lumberwoods.

So much for the facts; let us now turn to the tradition. Our opening observation should be that its force will first be felt not in how a poet shapes a song but in what he perceives as a suitable subject. Death on the job has always been an acceptable subject for Anglo-American traditional song, and lum-

berwoods tradition is full of examples, from the well-known "Jam on Gerry's Rock" [14] to Joe Scott's "Guy Reed" to "The Teamster in Jack MacDonald's Crew." However, "The Teamster" is different, in that all of the other songs I know of are about violent and accidental death—a man killed when a jam hauled or a landing broke or a tree limb fell on him—not death from sickness. Right from the beginning, then, our poet was trying something a bit new.

All artists work within the terms of their audience's expectations. The artist may decide to thwart or challenge those expectations in some way or ways, giving us experimentation, the breaking of new ground, something new and different. In the traditions of contemporary painting and poetry, for example, we can go so far as to say that experimentation and change *are* the expectation; we insist on boldness and freshness of expression, which can leave us with the lovely paradox that change *is* the tradition. What, then, would the presumed audience for "The Teamster" have expected of a song?

First of all, they would have expected it to be true, to tell what really happened.[15] "*All* them songs was true," one man told me; that is a basic assumption, and it would mean that anyone making up a new song would be expected not to fabricate. Second, it should tell that truth in language that is straightforward enough to be immediately intelligible. Freshness of expression was not valued, yet at the same time the language was expected to be somewhat elevated and

"poetic." Words like "merry" and "unto" were not part of the everyday vocabulary of woodsmen, for example, and clichés about Death darking our door or "Death's cold grasp" have it both ways in being at once familiar (that is, immediately intelligible) and poetic. Third, it was not at all expected that the tune must be new and recognizably different. Finally, it should follow an appropriate form, a structure that allowed it to say all the things a song like this was supposed to say.

The basic structure of death-on-the-job songs was as traditional as that of the pastoral elegy or the medieval dream poem. Since I have discussed it at some length in *Joe Scott*, I will simply summarize it here while showing how "The Teamster" exemplifies it.[16] The structure can be outlined as follows: an invitational or come-all-ye opening, the setting, the accident, the discovery of the body, and an aftermath (which may include a mention of loved ones, a funeral or burial scene, and a closing piety or prayer). "The Teamster" fits this structure perfectly at first, beginning as it does with a come-all-ye and a description of the setting:

1
Come listen to my story,
 The truth I'll tell to you;
It is about a teamster
 In Jack MacDonald's crew.

2
Our crew it was a merry one
 Of eighteen men or more;
Our winter's work had scarce begun
 When Death had darked our door.

There is a small problem here. The second stanza speaks of the work as having "scarce begun," yet it is late January and the crews have been in the woods since October. However, up to this time the main task has been felling the trees and hauling them out to be yarded up in great piles along the main logging roads. By January the deep snows would have ended this phase, and, as the song says, the *"winter's* work" would have begun: the loading of those logs on huge "two-sleds" and hauling them over the snow-packed roads to the river, where they would be landed in preparation for the spring drive downriver to the mills. This was work where teamsters were the key men, and it should be remembered that young Stubbs was a teamster. I should also point out in passing that both the "come listen" and the "it is about" statements are conventional fictions (the audience already being in place and knowing what was to be sung, having perhaps even requested this particular song), hence part of

the elevated language, the "poetry," as well as the structure.

In the central accident/discovery sections, however, our poet has his work cut out for him; since Stubbs was not killed in an accident, there was no body to be discovered, and, as part of the aftermath, no mournful tidings to be carried home to loved ones. But the spirit of this matter is present in that the poet describes the sickness, the crew's attempts to deal with it, and the taking of Stubbs himself home, and it seems to me that he works out this adaptation rather well. The final section is a thoroughly traditional one, a prayer or pious wish that generalizes this specific death and makes it a part of all our lives:

And when Death comes knocking at our door
 And we are called to go,
Let us pray that we will meet our Lord,
 Let His mercy on us show.

"The Teamster," then, in that it follows the pattern and yet adapts it, is both satisfyingly the same as other death-in-the-woods ballads and surprisingly different from them. But there is an even more basic difference: All the others are about the man who died, his heroism or bravery, while "The Teamster" is not so much about Earl Stubbs as it is about the crew. To be sure, the crew is mentioned in all the others as witnessing the accident or searching for the body or whatever, but in the present song Stubbs himself is completely passive. It is what the crew does to try to help him that occupies the center of the poem, and while what they did might make general sense to an outsider, it would have spoken volumes to a woodsman. The classic example is the fourth stanza:

The night passed on and morning came,
 The sickness it grew worse;
We moved him from the lower bunk
 Into the upper berth.

The standard lumbercamp was built with two layers of bunks, and the upper bunks could sometimes be uncomfortably warm in the early evening when the fire was still up, but as the night wore on and the fire died down, the lower bunks would be the first to get cold. Moving poor sick Stubbs from his lower to an upper bunk thus becomes an act of deep significance, expressive of the crew's tender concern for their comrade. Add to that that breakfast in a lumbercamp came early enough so that the men could be at their tasks at first light, sometimes after a lantern-lit walk of some distance. Someone stays with Stubbs while the others go to eat, and when the decision is made to take him home MacDonald and Proctor

leave right away, while it is still dark. *They* break the news to his wife ("it did require great skill"), and *they* send for the doctor ("while his wife and family cried"). MacDonald and his crew are the heroes of the song, and they are the ones toasted. The funeral is not even mentioned and there is no overt extension of sympathy to the widow and children, either or both of which are standard elements of many such songs. "The Teamster," then, is an occupational song, written by a woodsman for other woodsmen, and would have been fully intelligible only to woodsmen. It was almost certainly written by a member of the crew rather than by a sympathetic townsman, and in this regard, I was interested to find that Earl Stubbs's daughter knew nothing at all about there ever having been such a song until I sang it to her.

Why, we may ask, did this song get written at all? Was there something unusual about the central act? Did MacDonald and his men act differently from the way other crews would have acted? I cannot speak finally on that, but all I have heard about the way sickness was handled in the lumbercamps and all I have learned about how men behave when one of their number is taken seriously ill make me see their behavior as perfectly normal. Not even the song makes the point that they did anything particularly heroic or unusual. They were just men doing what they could. The only difference was that there was someone around of a poetical turn of mind. In the same way, many humorous, unambitious men have died but only Alfred Pollexfen had Yeats to raise his cry with that of the visionary white sea bird, "lamenting that a man should die." [17] The poetry is of the poet, not of the event.

One final traditional aspect we should consider: the stanza form and its concomitant tune. The universal practice was to take an old tune and set new words to it, and while I have no question that this is what our poet has done, I cannot comment further on the specific tune, since this is the only song I have heard it to. Of course it is possible he made the tune up, but it is extremely unlikely and in no way would it have been considered necessary for the making of a new song. In general, though, most poets working at this time, in this metier, used the so-called double or come-all-ye stanza: four seven-stress lines rhyming *a a b b* with a tune to fit. Our poet chose instead the shorter "common meter" or "ballad stanza" of four lines alternating four and three stresses and rhyming *a b c b*. His tune, too, has certain unusual features. The first two phrases center in the octave, the last two descend to the tonic, which gives the song a range of a major tenth, making it a little difficult for the average voice to handle (if you pitch the first part comfortably, you wind up scraping bottom at the end). I

should also point out that this use of the shorter stanza form probably helped to make this ballad about half as long as most of its counterparts.

In all that we have discussed so far, we have seen that the poet was conscious of a tradition of such songs, which he then adapted to his material in ways that were a blend of that tradition and some innovations of his own. In no way do I intend to praise him for his innovations, which would be to give in to what T. S. Eliot spoke of as "our tendency to insist, when we praise a poet, upon those aspects of his work in which he least resembles anyone else." [18] I simply wish to point out what was the creative tradition within which the poet was working and against which his audience would have seen his work.

Once the creative problem had been solved to the author's satisfaction, the song would be presented to its public by being sung. Others would either pick it up or not. If they did not the song died; if they did, it was passed on and became part of the tradition against which future work—even for that matter past work—would be judged, which is just about what Eliot means when he says that "Whoever has approved this idea of order . . . will not find it preposterous that the past should be altered by the present as much as the present is directed by the past." [19]

But "The Teamster" was not picked up. At least it did not enter into any significant or widespread oral tradition, and we might well take that fact as evidence that its intended audience did not approve of it. Very well, then, what intrinsic reasons might have led to such nonacceptance? If it was originally presented to Jack MacDonald's crew (and I assume it was), they hardly could have faulted it as not being about "something that really happened." Might the basic story have been correct but the details wrong? That is possible, but I doubt it; it is just too straightforward and carefully factual for me to imagine that the songmaker was not making every effort to get it all down right. But these matters would only have been problems, as I have said, for Jack MacDonald's crew. Beyond that small circle, verisimilitude, not veracity, would have been sufficient, though the veracity would have been assumed and might even have been supported by testimonial ("I was in the camp where that happened.". . ."My father knew that Tom Proctor, and . . ."). The general situation described—serious illness far from home—was one any woodsman would have been familiar with; the details of the story were right in a general way; and the careful use of proper names would have served as validation. Truth-telling was probably not the problem.

Typical double-decker bunks in a Maine lumber camp. Two men slept in each bunk, as a rule. Such bunks earned the name of "muzzle-loaders," because the only way to get into them was from the open end. (NA P 693)

On the other hand, poetry—or the lack of it—may have been. Granted, the song follows a traditional poetic form, and granted that its language has its heightened moments, nevertheless it is all very spare and quotidian:

> We moved him from the lower bunk
> Into the upper berth.

I tend to see those lines as fine *because* they are spare and understated, hence rich with implication, but I have been raised on red wheelbarrows beside white chickens and the Scots nobles of Percy's "Sir Patrick Spens," whose "hats they swam aboone." [20] The economy of the Child ballads has long been praised by scholars, but anyone who has worked with traditional song in the Northeast knows that economy is not the ticket, while beautiful language is:

> Here's adieu to Prince Edward's Island
> That garden in the seas,
> No more I'll walk its flowery banks
> To enjoy a summer's breeze.
> No more I'll view those gallant ships
> As they go swimming by
> With their streamers floating on the breeze
> Above the canvas high. [21]

That is from "Peter Emberly," probably the best known woods ballad in the Northeast. Joe Scott took his lead from such diction, and the lushness of his language is one of the reasons why his songs caught on and were sung all over Maine and the Maritimes. [22] The point is this: the economy and unpretentiousness that I personally find appealing is more than likely one of the reasons "The Teamster" never caught on.

So much for intrinsic reasons. There are some extrinsic circumstances that can help explain, or at least mitigate, "The Teamster's" apparent failure to be accepted into oral tradition. First, we were, in 1908, getting on toward the end of an era in which singing played an important part in Maine lumbercamp life.[23] Second, since songs of this sort were written not for posterity but for the moment, the present audience, we should perhaps not use continuity as a criterion of acceptance so much as what the judgment of the poem was at the time of its relevance, something we have almost no chance of knowing now. Of course, continuity is one sort of evidence of approval by contemporaries, which certainly makes it appear that "The Teamster" did not make the cut.[24]

But on the other hand Joe Walsh *did* learn and remember it, and Joe Walsh represents that critical band of enthusiasts who chiefly carry on *any* artistic tradition, be that tradition Italian opera, classical guitar, contemporary poetry, or old songs.[25] Why did he learn it? The simplest answer is that he liked it, and simple answers are often best. He certainly didn't learn the song because of its personal associations; he never knew any of the people named, and he had no idea where Sherman Mills was. Depending on where he learned it, though, his aesthetic judgment may have been influenced by extrinsic factors. If he learned it in the woods at Katahdin Iron Works, he may have heard it sung there by one of its authors, a fellow Islander from Kings County, Sife Mooney. If he learned it on Prince Edward Island from his friend Tom Keefe, that association (since Keefe knew it was by Mooney) would have been reinforced by the song's being about the lumberwoods, very much part of Joe's experience at the time. These associations would certainly have contributed to Joe's interest in the song, but I have no hesitation in saying that his main interest was aesthetic: he thought it was a good song, one that his fellow woodsmen would listen to. Joe was a singer. *"I always sang," he said, "especially when we were up in the Iron Works. . . . I was only eighteen, and they used to keep me at it all the time. Every night." [26] Obviously a singer like Joe would be on the lookout for new material, and he might even learn a song he didn't much care for simply because people wanted to hear it. He admitted to me, for example, that that was why he learned "The *Flying Cloud*," but he never made any such statement about "The Teamster." Whatever his reasons were for learning it, though, "The Teamster" thus came into the charge of one discerning and caring aficionado. That the tradition within which it was created and had relevance was a cul de sac was not the fault of either Joe or the song but of the changing social and eco-

nomic patterns that brought an end to the all-winter lumbercamp. Even so, the song lay there quietly in the dark at the back of Joe's mind until a junketing folklorist called it back into the light by asking for a lumberwoods song.

We come at last to see how complex even a so-called simple song can be. We have seen how a particular song developed out of a specific tradition falling together with a specific event in the mind of a specific someone we call an artist, a poet, and how it then went on to become part of the tradition—that continuum of creation/consumption—out of which it arose. In this sense, "The Teamster" is perfectly comparable to "Dover Beach," its creator to Samuel Barber and Matthew Arnold, and Joe Walsh—singing that night in his kitchen for me and my family—to my dear dead sister and her accompanists who performed "Dover Beach" in concert, stunningly, in the terrible June of 1940. The elements in each comparison are vastly different, but that should not obscure the much more important fact of their essential identity. That we should not judge the products of one tradition by the standards of the other should by now be too obvious to labor further, and it should be just as obvious that in this context pronouncements about higher and lower forms or great and little traditions are entirely trivial in that they cloud that identity, that universality of the aesthetic impulse, that folklorists and anthropologists should labor to have shine forth. In his 1974 presidential address to the American Folklore Society, Dell Hymes put our position well:

> Succinctly put, folklorists believe that capacity for aesthetic experience, for shaping of deeply felt values into meaningful, apposite form, is present in all communities, and will find some means of expression among all. We do not disdain concert halls, art museums, quiet libraries, far from it—most of us are university scholars and that is part of our life. But our work is rooted in recognition that beauty, form, and meaningful expression may arise wherever people have a chance, even half a chance, to share what they enjoy or must endure.[27]

"The Teamster's" maker shared with his friends, and Joe Walsh shared with me and my family, what they must all endure. The full aesthetic worth and integrity of a song shines forth only in performance, and that means performance in proper context. I never heard singing in a lumbercamp; I'm far too young for that. But I have come close to it, listening to

men sing the old songs in kitchens and parlors, the unadorned voice letting the song do all the work—not explaining, not dramatizing—the singer's face a mask, the eyes closed or looking out on nothing, while we who listened looked out on nothing too, letting the song come in.

Notes

Versions of this paper have been presented as public lectures at the University of New Brunswick, Fredericton, N.B., March 19, 1980; Mount Allison University, Sackville, N.B., November 17, 1980; George Mason University, Fairfax, Va., April 10, 1981; and the University of Illinois, Urbana, Ill., April 30, 1981. I would like to take this opportunity to thank Jeff Todd Titon for a careful reading of an early draft, and my colleague Erling Skorpen, philosopher, whose comments in a seminar position paper about a "woodsman's awkward ballad" first impassioned me to write this paper.

All interviews are on file in the Northeast Archives of Folklore and Oral History, South Stevens Hall, University of Maine, Orono, Maine, and they are cited in this paper as "NA" followed by the accession and page number (e.g., NA 971.013). An asterisk before a quotation means that it is taken verbatim from a tape recording.

1. "Peter Quince at the Clavier," from *The Collected Poems of Wallace Stevens* (New York: Knopf, 1955), 91.
2. See Nathan Broder, *Samuel Barber* (New York: G. Schirmer, 1954), 21, 33, 61 for commentary. It is an interesting aside that Barber, not a trained singer at all, performed and made a recording of his own composition with the Curtis String Quartet in 1936 (RCA Victor 8998, out of print; re-released in 1978 by New World: NW 229). Several other recordings are now available.
3. Edward D. Ives, *Joe Scott: The Woodsman Songmaker* (Champaign, Ill.: University of Illinois Press, 1978), 140–77.
4. James Agee and Walker Evans, *Let Us Now Praise Famous Men* (New York: Ballantine Books, 1966), 54.
5. *Larry Gorman: The Man Who Made the Songs* (Bloomington, Ind.: Indiana University Press, 1964; reprinted New York: Arno Press, 1977); *Lawrence Doyle: The Farmer-Poet of Prince Edward Island*, Maine Studies no. 92 (Orono, Me.: University Press, 1971); and *Joe Scott*.
6. Ives, *Lawrence Doyle*, xv–xviii.
7. For Joe Walsh's singing of the song, see NA Ives 65.13, pp. 18–19. It

may also be heard on *Songs of Labor and Livelihood*, Folk Music in America (Washington, D.C.: Library of Congress, 1978), vol. 8, side A, band 9. For a second singing (referred to below), see NA Ives 70.6, pp. 026–027, and 70.7, p. 004 (July 20, 1970).
8. NA Ives 65.13, p. 19.
9. The same analogy is worked out somewhat more elaborately in Edward D. Ives, "The Study of Regional Songs and Ballads" in Richard M. Dorson, ed., *Handbook of American Folklore* (Bloomington, Ind.: Indiana University Press, 1983), 212–13.
10. My thanks to Mr. Webb for his generous help.
11. This interview is NA accession 1306.
12. *Bangor Daily News*, January 24, 1908.
13. NA 1306.005–006.
14. G. Malcom Laws, Jr., *Native American Balladry*, revised edition (Philadelphia: American Folklore Society, 1964), 147, (Laws C-1).
15. See Herbert Halpert, "Truth in Folk-Songs—Some Observations on the Folk-Singer's Attitude," in John Harrington Cox, *Traditional Ballads and Folk-Songs Mainly from West Virginia* vol. 15 (Philadelphia: American Folklore Society Bibliographical and Special Series, 1964), xiii–xx; Ives, *Joe Scott*, 300–301; John Ashton, "Truth in Folksong: Some Developments and Applications," *Canadian Folk Music Journal* 5 (1977): 12–17.
16. Ives, *Joe Scott*, 156–60.
17. W. B. Yeats, *Collected Poems* (New York: Macmillan, 1959), 154.
18. T. S. Eliot, *Selected Essays 1917–1932* (New York: Harcourt Brace, 1932), 4.
19. Ibid, 5.
20. (Child 58) Francis James Child, *The English and Scottish Popular Ballads*, vol. 2 (Boston: Houghton Mifflin, 1882–98), 20. For the wheelbarrow allusion, see William Carlos Williams, *The Collected Earlier Poems* (Norfolk, Conn.: New Directions, 1951), 277.
21. "Peter Emberly" (Laws C-27). The particular stanza quoted here is from the singing of Wilmot MacDonald, Glenwood, New Brunswick. See Louise Manny and James Reginald Wilson, *Songs of Miramichi* (Fredericton, N.B.: Brunswick Press, 1968), 161.
22. Ives, *Joe Scott*, passim, but especially 409–10.
23. Ibid., 381–82.
24. See Ives, *Lawrence Doyle*, 250–51, for further discussion of this point.
25. Ibid., 251–52.
26. NA Ives 65.13, p. 17.
27. Dell Hymes, "Folklore's Nature and the Sun's Myth," *Journal of American Folklore* 88 (October–December 1975), 346.

RANGE CULTURE AND SOCIETY IN THE NORTH AMERICAN WEST

By John W. Bennett

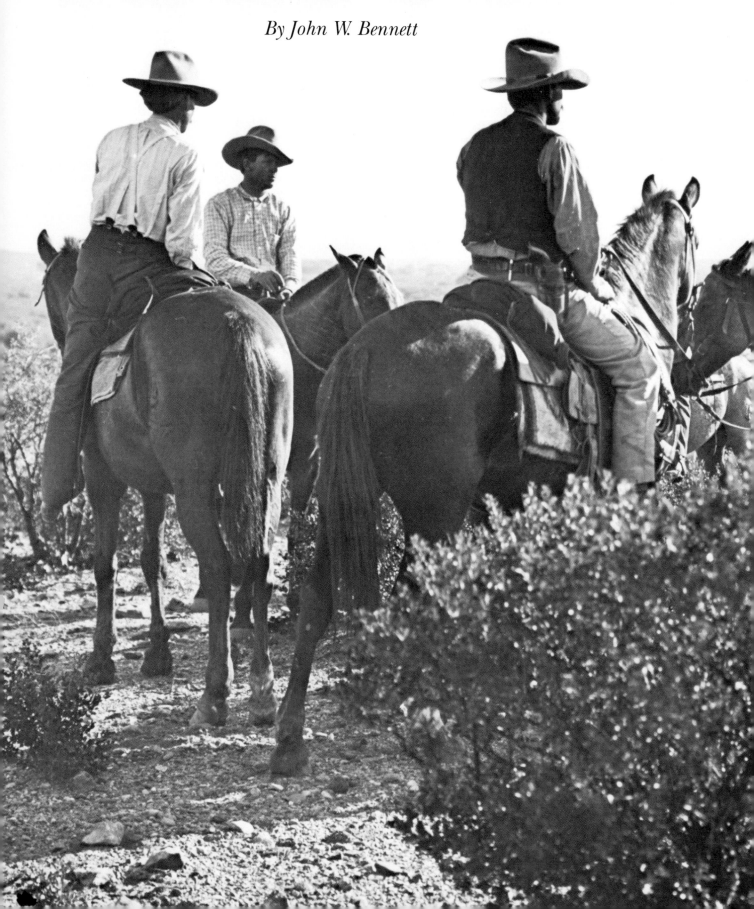

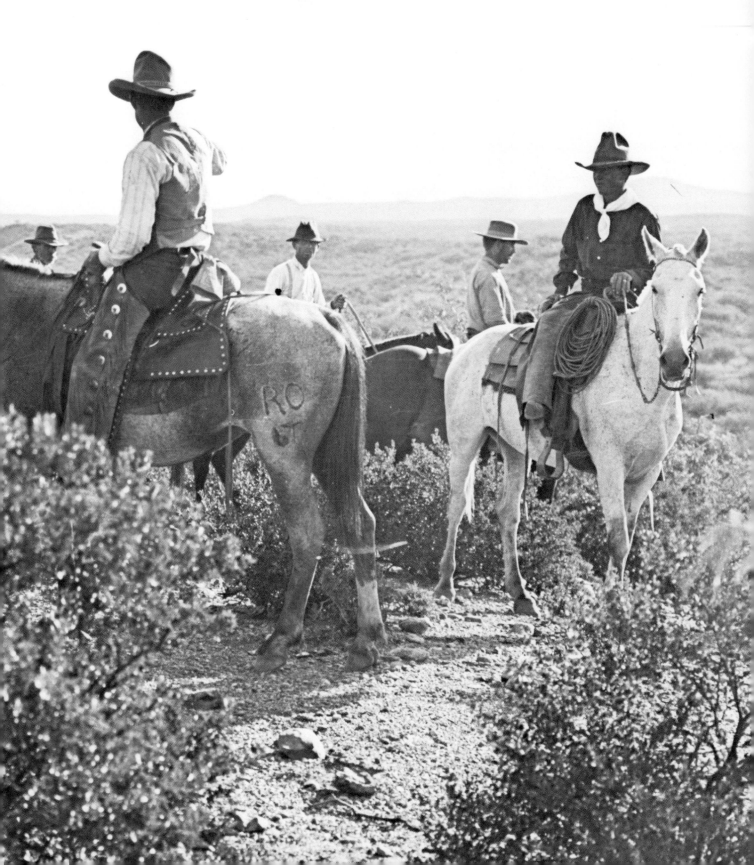

This informal essay has an intellectual background derived from sociology and anthropology, two scholarly fields to which the writer owes considerable allegiance. The culture of the North American West has been described principally by historians, folklorists, and purveyors of the serious and not-so-serious entertainment media. From Owen Wister to John Wayne,

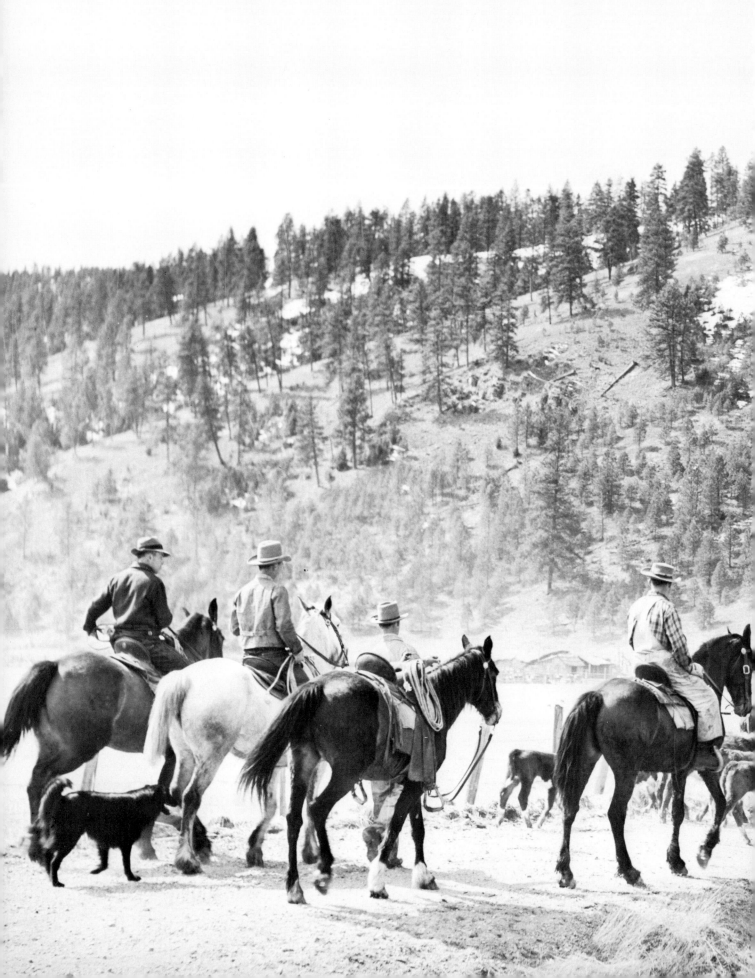

Driving cattle into the corral for branding and dehorning, Bitterroot Valley, Ravalli County, Montana, in the 1930s. *Photograph by John Vachon. Farm Security Administration file, Prints and Photographs Division, Library of Congress*
Preceding pages: Ranch foreman and his men at the start of a day, about 1910. *Erwin Smith Collection, Prints and Photographs Division, Library of Congress*

we have been saturated, drenched, drowned in ten-gallon hats, cows and horses, and romantic sunsets. Here we shall take a more pedestrian, but more realistic, look at the life of these people who live in the country (and increasingly, part of the time in the city) and who raise animals for pleasure and profit.

Social scientists are unromantic people: they deal with the facts and figures of human activities: how people relate to one another; how they gain power; how material interests may influence behavior; how people must make compromises between their hopes and aspirations in order to survive in society. I shall focus on two groups of people in the ranching industry: the ranchers, or *owners* of the means of production; and the cowhands, or *workers* in these enterprises. Owners and workers; employers and employees: sets of terms rarely used to describe those romantic ranchers and cowboys.

My academic habits impel me to formally introduce my subject, and to stake out my positions on key issues. First of all, I shall explain the meaning of "range culture and society." I have selected the modifier "range," rather than "western" or "ranching," because I wish to suggest that underneath the social relationships and cultural ideas lay two ecological factors: first, a considerable amount of *space* in relation to the number of human beings populating that space; and second, the necessity for these humans to learn how to use marginal and often refractory physical resources (grass, soil, changeable weather) in order to survive or at least make a living. The low population density permitted much greater physical and job mobility than is available in urban environments, and less personal attachment to particular places.[1] The *open* range no longer exists, but its practices shaped a mental outlook and a set of behaviors and habits which persist—though in greatly modified form. The resources factor led to a set of individualistic attitudes, featuring an emphasis on physical strength, competence, and active performance, rather than the use of words, sedentary skills, and manipulative capabilities. These elements, likewise, persist in altered but nonetheless significant form. Societies and cultures rarely completely lose anything: they simply adapt the past to the present.

Therefore, by "range culture and society" I mean the distinctive patterns of social organization, human relations, ideas, and styles of behavior that developed in the western half of North America around the production of livestock, principally horses and cattle, in the last quarter of the nineteenth century and the first half of the twentieth. The patterns were based on the geographical factors mentioned, but also on the social inheritance—the things people brought with

Rancher Les Stewart and cowboy Chuck Wheelock work side by side at Stewart's Ninety-Six Ranch, Humboldt County, Nevada. *Photograph by Howard W. Marshall for the American Folklife Center's Paradise Valley Folklife Project, 1978*

them when they moved westward. This was not an indigenous population, but a borrowed one—it was required to adapt its imported institutions to a new environment, as Walter Webb so eloquently pointed out a generation ago (Webb 1931). The social inheritance is northern Euro-American. While many of the artifacts and much of the terminology of western livestock production had roots in Hispanic sources, the ideas of individualism, common law, land tenure, and sex roles are all part of the nineteenth-century heritage of northern European movement to the New World and its subsequent extensions and evolution on U.S. and Canadian soil.

Numerous elements of the symbolic content of range culture became a focus of nostalgic and romantic attention in the popular culture of North America almost as soon as the range industry emerged in the West; its emergence did not take place in a wilderness, as it is so often supposed, but on the rural fringe of a literate and well-organized national society. The symbols emphasize wild and colorful behavior in an exotic landscape, and thus romanticize the system. They tend to obscure the social and economic realities of range society.

Some distinctive Euro-American institutions shaped range society and culture. The rectilinear grid survey and freehold tenure modified the fluid, early open-range adaptations to irregularly distributed physical resources. This introduced the need for "intensive" livestock production—irrigated pasture, breeding experiments, and so on. The rectilinear grid tenure system resulted in serious inequities because of its nonconformity to irregular resource location, and the consequence was a series of government institutions concerned with regulating and collectivizing grazing and water use. Subsidized grazing on public lands made it possible to raise large numbers of cattle at extremely low overhead, prolonging the ranching era into a period when straight livestock production would be difficult to sustain economically (see Voigt 1976 for a history). This, in turn, has tended to preserve the distinctive culture. Law enforcement in the United States was put in the hands of the local community, although the wide open spaces required a system of federal marshalls for a time; in Canada, the Royal Canadian Mounted Police have continued to act as a contractual local police force in dozens of western communities. The frontier society had a natural orientation toward individual achievement, reinforced by the strong traditions of North American culture generally in its challenge to the European status system.

Range society also was founded in the economic institution of the free and competitive market for agricultural products, and ranchers have remained among the staunchest advocates of this system. Livestock was produced for sale from the very beginning: there was no introductory period of subsistence production, as there was in the Middle East, Central Asia, and Africa—all areas where livestock were a mainstay of food production in grassland and desert regions. North American cattlemen, despite their romantic traditions, were businessmen from the beginning. Range culture thus has a mingling of two disparate behavioral styles: the self-made

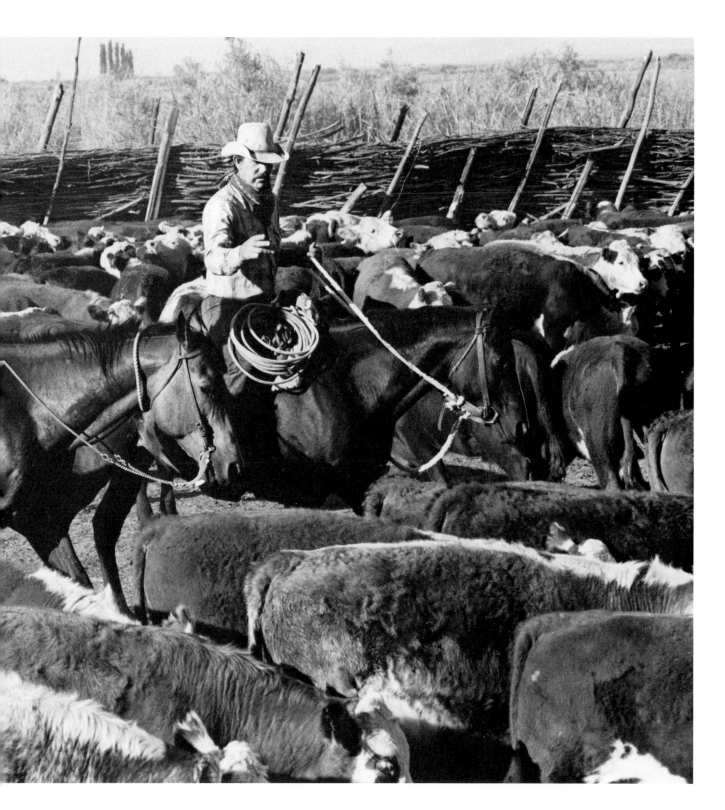

man of the frontier, with his pride in overcoming physical hardship and the need to bend nature to fit human purposes; and the sober deportment of the tradesman and farmer, out to make money or at least a good living. In many ranching communities, the two styles are in latent conflict: rich old ranch families may pride themselves on their simple life, and look askance on younger or newcomer ranchers who display their wealth—or sometimes, the other way around.

The two most ubiquitous occupational symbols of range society were the rancher and the cowboy. They are both known by a variety of labels: cowboys are also cowmen, cowhands, and ranch hands; ranchers are also cattlemen, rangemen, cattle kings, and land barons. There were big men and little men on the range; the social status differed, but the down-to-earth roles and the symbols introduced so early in the history of the industry tended to blur the differences.[2]

An important consequence of the early public attention given range society and culture is the strong self-consciousness acquired by participants from the very beginning. Range people knew they were different from urbanites and easterners; they were aware of the attention lavished on them in popular literature, and it helped forge their social attitudes. First, public attention created a strong sense of personal involvement with the way of life—it was not just a way of making a living but a culture. Second, it was responsible for a strong feeling of prestige, since it was known that people on the outside valued the way of life, no matter how difficult it might be to live and to endure. To be a cowboy or a rancher was a matter of considerable self-awareness. Third, it prevented or at least delayed the emergence of an industrial concept of labor-management relations. Rancher and cowboy shared a common culture; they were participants in a general way of life.

Let us consider this "common culture" of ranchers and cowboys. In no other system of employer-employee relationships in modern industrial society is so much held in common by two sides. Analogs can be found in frontier situations the world over and at any historical period: the farmers and peasantry of early medieval Europe come to mind, since both the smallholders and the working landless peasants shared a similar modest life, a similar folk version of Christianity, and similar problems with the nobility and the organized Church.

In the North American West, ranchers and cowboys came from generally similar social origins: they were adventurers, casual laborers, war veterans, and occasionally small businessmen or storekeepers who made their way west to carve out a new life. If you were lucky, or had a special quantum of energy, you might get hold of land and become a rancher; if you came later, and could not get land, you worked for the rancher as a cowboy. Both had rather limited education and a detachment from the orderly bourgeois life of townsmen in the East and the Middle West. These are generalizations; there are few statistics available. It is of course obvious that there were differences between the groups at the end of the scale: the handful of European and eastern capitalists who became cattle barons; the numbers of illiterate or unskilled drifters who became cowhands. But our thesis is that the majority had broadly similar social origins and abilities.

Moreover, the social and occupational mobility of the system meant that cowboys, especially in the early years, had considerable opportunity to become ranchers—they participated in a version of what some rural economists and sociologists have called the "agricultural ladder" (Spillman 1919 is the original statement). Land changed hands; the good cowboy could start buying some and accumulate a small breeding herd, often depending on his rancher-employer to stake him. Or, after learning the trade as a cowhand, he moved on to virgin territory and started ranching on the open range. As time passed, a substantial majority of small and medium-sized ranchers were former cowboys. The shared culture was part of the system of economic mobility; the mobility facilitated the sharing.

The distinctive technology and work habits of the range created a common set of recreational pursuits, some of which, like the rodeo (as suggested by Elizabeth Lawrence in her 1982 book on the topic), have attained the status of social ceremonials, implementing and symbolizing the shared culture of rancher and cowboy as well as the solidarity and purposes of the community. The breaking and riding of horses; the need for both the rancher and his hand to "know cow"; the concern for fencing; the techniques of pasture management and irrigation—all elements of the production system were equally known to employer and employee, and out of them came a matrix of meaning and value. Both the rancher and his cowboys can be seen today in the local rodeos, competing against each other; both may be found at the local bar, or beer hall, as it may be known in Canada, bending an elbow and participating jointly in the endless round of tall tales and elaborate ironic humor.

The common experiential sector of both rancher and cowboy is nicely illustrated by an aphorism the writer has picked up in various localities in the northern range regions: "Who is the rancher? The best paid manual laborer in the country! And who is the cowboy? The worst paid manual laborer!" While the remark connotes a status—or at least income—differential, the emphasis is on the common experience. Both are manual laborers: that is, they come from the same lowly origins (whether they really do or not) and do the same kind of work (whether they really do or not). On the whole—the barons and the working stiffs always excepted—they *do*.

Ethnicity concerns the national cultural and religious backgrounds displayed by these western pioneers. The majority of the people coming West to engage in livestock production after the Civil War in the United States, or after the Dominion Act in Canada, were indigenous to North America, mainly the Midwestern states and provinces. For a time Mis-

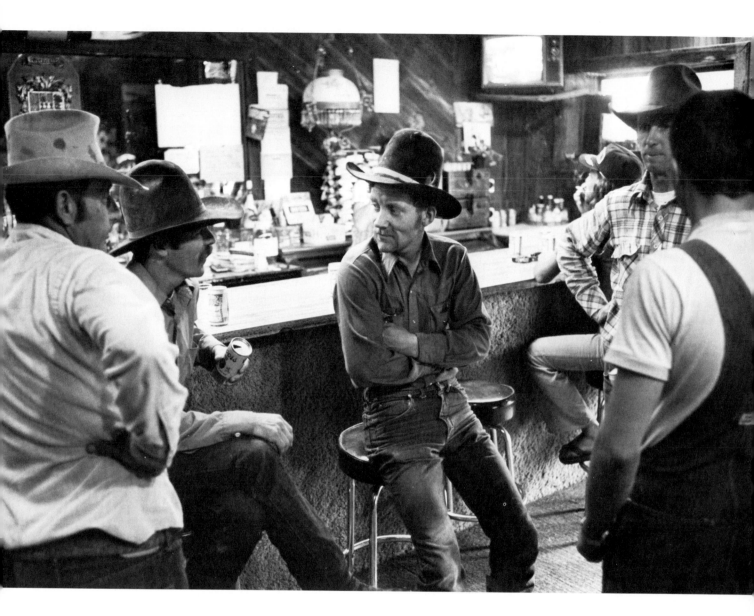

souri was a spawning ground of cowboys; they came off the small hill farms in the Ozarks where the economic depression of the late nineteenth century made local farming nonviable (Charlie Russell, the preeminent cowboy artist, came from south St. Louis!). Thus the mountain culture of the Middle Border played its role in forging the general way of life and attitudes of western communities—and certainly the rusticity of the cowboy behavior. Many early ranchers in Alberta and Saskatchewan were discharged Mounted Policemen, and a substantial plurality of these were really small-town boys and even a few city fellows from eastern Canada. The general heritage of all these people was northern European-North American, principally Scotch-Irish-English or, to a lesser extent, Scandinavian-German. In the farming districts, on the other hand, while many people were from this same stock, many others were from eastern or southern European countries. The latter found ranching a difficult occupation: their "peasant" background created a strong attachment to the soil and to ingrown family living (also, in some localities, to the Catholic Church—and orthodox religion has generally not

formed a suitable base for western ranching lifeways). At the other extreme, a handful of European sons of nobility also tried western life and ranching, but it was essentially a matter of seeking adventure, and few stayed in the business. All in all, the dominant ethnic background of the ranching industry was "anglo"; that is, the Scotch-Irish-English-midwestern cultural background with its casual Protestantism and strong individualism.

But there was also a fairly strong southern American element in the ethnic background. After the Civil War, numbers of southern rural and small-town people, and Confederate veterans, made their way West—in some regions, like Texas, forming the dominant popular stratum. On the whole these people carried the same cultural patterns as their northern relatives, but with the added elements of racial attitudes and a strong romantic conception of the role of women. The racial attitudes have tended to persist in range culture, but they lack the special virulence or prejudice associated with racial occupational competition found elsewhere in North America. Western racism was more a kind of exclusivism—a feeling of

strangeness, even humility, toward people of other races and nationalities that did not fit instantly into the rangeways. People of Jewish descent were and are considered to be merchants and buyers, not cattlemen or even farmers. Negroes were tolerated as the occasional cowboy, but none, or at least very few, entered livestock production. There have always been a few black rodeo stars—there are always one or two with membership in the Professional Rodeo Cowboys organization—and they are usually treated with elaborate courtesy and deference: honored exotics, honored because, despite their handicaps, they have made it. The racial attitudes come down to a kind of embarrassment. One feels it today when ranchers are introduced to black or Oriental people in hotels or in town: they really do not know how to talk to them.

In the sphere of relations to nature there was a concern in range culture for what I have called elsewhere (Bennett 1969, p. 94) the "Wild." That is, not "Nature" as it is known by urban intellectuals, nor the "Wilderness" as it is defined by preservationists, but the rough-edged outdoors, with its unpredictable topography and drainage and varied flora, with its different capacities and problems for grazing; wild animals for the hunt, and the interesting competition between domestic and wild animals. The Wild offered opportunities for another kind of adventure, and also the fellowship of kindred rough souls: the Teddy Roosevelt mixture.

The culture also offered impressive opportunities for the control of social interaction. One could associate with his fellow ranchers and cowboys but could also not do so if he chose; above all, one could avoid town life and the local farmers. More accurately, one could define one's social participation with minimal concern for social or communal convention. The rancher enjoyed the town on festive occasions as well as anyone, and the joshing arguments with the nesters, but the point is that it could be turned on and off. One could, and can, jump on the horse or in the pickup and ride down the road to see friends, relatives, and associates on business or pleasure—but then one *need not* do so. Of course the telephone and the automobile have weakened such control, but the attitudes, and much of the practice, persist. The famous hospitality and egalitarian openness of the West actually were rooted in its restrictive interaction: outsiders were welcomed because of the element of novelty and surprise: their arrival was not something one planned, or had to perform as a duty, but rather a spontaneous, involuntary experience. It was, in a sense, the working-off of guilt over preferring isolation in a frontier situation demanding mutual aid and friendship.

The pervading egalitarianism is the most pronounced feature, at least to the tourist easterner, who is almost immediately won over by the sight of ranchers and their cowhands consorting together as buddies. But this enthusiasm gives way to puzzlement when he learns what the rancher earns, or the value of the property he owns, and compares it with the wages the cowboy is able to extract from his employer. Wages have improved greatly in the past two decades on the range, but they are still below what a hard-working man with industrial skills might obtain in a factory or a service industry. And there has been a flight of rural labor to the cities in the West; consequently, obtaining good ranch hands, particularly the live-in sort, complete with wife and kiddies, has become extremely difficult in many localities. In recent years, ranchers have had to share more than culture with their cowboys.

From the standpoint of the "shared-culture" theme, the real disparity in economic status, combined with the enthusiastic public egalitarianism of employer and employee, is difficult to understand—it is the despair of farm-labor organizers who have tried at intervals through the years to mobilize the cowhands. On the whole the common cultural consciousness, combined with the opportunities for occupational mobility, have managed to defeat serious unionization. The physical mobility of the cowboy also helps to make permanent labor organization difficult—as difficult or more so than it was for baseball players or lumbermen. These transient trades are refractory; they evade the urban industrial social system.

There has always been a kind of dual image of the cowboy; one side emphasizes his colorful behavior and manliness, the other, the hard work and privation of the life. Theodore Roosevelt[3] put it very well:

But everywhere among these plainsmen and mountainmen, and more important than any, are the cowboys. . . . Singly, or in twos or threes, they gallop their wiry little horses down the street, their lithe, supple figures erect. . . . they are as hardy and self-reliant as any man who ever breathed—with bronzed, set faces, and keen eyes that look all the world straight in the face without flinching. . . . Peril and hardship, and years of long toil broken by weeks of brutal dissipation, draw haggard lines across their faces. . . . many a young fellow comes out hot with enthusiasm for life on the plains, only to learn . . . that the cowboy business is like any other and has to be learned by serving a painful apprenticeship. . . . the

After driving cattle a distance of about ten miles, cowboys Chuck Wheelock and Northern Paiute Indian Clale Northrup, along with rancher Les Stewart's son Fred, rest at the Black Ridge line camp operated by Stewart's Ninety-Six Ranch, Humboldt County, Nevada. *Photograph by Suzi Jones for the Paradise Valley Folklife Project, 1978*

endurance of rough fare, hard living, dirt, exposure . . . and month after month of the dullest monotony (Roosevelt 1899, pp. 9–10).

There is, moreover, sufficient evidence of hostility between rancher and cowhand to make it clear that the shared culture does not necessarily imply love and kisses. Novels and belles lettres generally are full of this: the classic western tale often contrasts the evil rancher with the simple, noble cowboys; or, on the other side, the honest rancher with the renegade cowboy. Cowboy reminiscences contain plenty of material suggesting that the "boss" was, after all, a taskmaster and often a tyrant. Still, despite the undercurrent of distrust, the common consciousness prevails in most places. Ranchers and their range employees work more as partners than as boss and laborers; ranch hands eat at the noon dinner table with the rancher and his wife and family; they are gravely introduced to the visitors as a kind of extended kin.

This participative sharing—or the paternalism—of life on the ranch is a major compensatory factor for the relatively low wages and the insecurity of job tenure. One of the romantic elements in the older folk image of the cowboys is his mobility: his movement from job to job, recreational sprees in the towns, occasional lawlessness, and his proclivity for a wild and reckless life. The facts are of course difficult to obtain, but no doubt much of this imagery has a real basis. It was the behavior of people without a stake in an economic system, other than what they could temporarily buy with their labor. However, as time passed, it was in the interest of the rancher to make things as secure as possible for his hands, and an important part of this was to treat them as junior members of the family and kin group. Not all ranchers were congenial employers, but the tendency was part of the system and helps account for the attractions cowboying had for its incumbents.

Range culture, like all ways of life based on extractive resources, displays a mixture of ideological elements which are difficult to generalize about. In the first place, it is intensely entrepreneurial—a factor based on the individualism of the frontier and the basic instrumental character of livestock production by kin-based social units (the "family ranch"). These people had to make it on their own—with, of course, due respect to the market. But the market could become for them a kind of weather factor: it was there, you had to conform, but you could also manipulate it, swim in it and chart your own course to a certain extent—especially if you had the brains to figure it out. And that is the essence of

nineteenth-century entrepreneurialism, carried forward into the twentieth century. Many changes have occurred—the small rancher has to depend on the government for hand-outs just as the farmer does these days, but the raising of cattle retains an individualistic operating strategy exceeding that for farming. The multiplicity of ways of marketing cattle persists; your product is not automatically channeled into grain cooperatives and government purchase schemes to the extent the farmer's field crops are, and the fluidity of the marketing system helps preserve the entrepreneurial spirit.

In a 1972 paper on Arizona ranchers, Smith and Martin diagnosed what they called "ranch fundamentalism": a configuration of attitudes shared by both ranchers and cowboys. In essence, the attitudes modify the classic profit-maximization model ("economic man") in the direction of more modest profit-seeking in order to live a comfortable and self-defined way of life. It is characteristic especially of the small- and medium-sized ranchers, who may have their own quiet resentment of the big fellows who build elaborate ranch houses, indulge in the horse hobby, and drive Cadillacs. But even the big operators generally show a respect for the range and water resources which helps to check rampant exploitation for profit. The goals do not always coincide, and in recent decades, rising costs of operation have weighted the resource-use strategies toward excessive grazing and increase of herds. Still, it is in some degree a cultural-ecological ethic: you have to make a decent living, but not at the expense of your environmental heritage—or at the expense of the peace of mind of your family members.

The attitude perhaps shows up not so much in production activities but in the way property is conceived and managed. A majority of ranchers everywhere in the West are confronted with a crucial decision: they can sit on their land and raise cattle, or they can sell the land to an urban investor and make a small fortune. The money can be invested in a business or securities, and the rate of return can be in considerable excess of what can be made from livestock. The fact that so many ranchers elect to stay in the cattle business and not realize the larger returns on their property is proof of the "fundamentalism" of the business. Or in other terms, the culture—the way of life—is more highly valued than profits. Good for them! They are among the very few operators in the North American economy who have resisted a purely pecuniary orientation. That puts them in a class apart from the other resource extractors: the miners, foresters, and wheat farmers, who are often content to "mine" their resources and damn the consequences. Of course there is serious collective

overgrazing and abuse of the land, but the range has a remarkable capacity for recovery, and ranchers often follow a strategy of cycles of abuse and recovery—an approach not fully appreciated or understood by conservationists.

The cowboy is in a similar position. Those who forgo the higher wages obtainable in the towns, in automotive repair and similar service trades, for more modest pay on the ranch, are likewise engaged in trading off income for a way of life—for the opportunity of doing what they like to do, hard as it may be. And similarly—the town businessmen who buy ranches, though certainly interested in profits and investment value, are putting their money into something that does not offer as much return as sales or industry. The glamor of participating in range society and culture is return enough. A "satisficing" spirit prevails: it is a trade against pure money, and therefore the economist, imbued with classical models of profit maximization, finds it difficult to account for the behavior.

But economic analysis can still be applied by manipulating the terminology. The economist can define the ranching spirit as a form of consumerism rather than production. The rancher, in this sense, values his occupation more highly than the returns to scale of investment he can obtain from its product. Thus, the difference between what you pay for the ranch, or what you get for selling livestock, and what you could obtain from an alternative use of capital is a measure of the value of "consumer goods"—that is, range culture—you have elected to enjoy.

A few fortunes were made in cattle alone, but most great "ranching" fortunes were made on land and oil and minerals, not livestock. Money derived from cattle was used to accumulate property of greater exchange value: value that was carried on the backs of the stock market, real estate, mining and energy industries. The people who stayed in ranching always did well, especially if they accumulated land and water, but this was modest wealth, not endless riches. The media have been aware of this: Edna Ferber's novel *Giant* and the morally debased but nevertheless structurally accurate spinoffs like the TV show "Dallas" convey the larger business interests that a few big operators developed out of an original stake in grazing land. This activity and its cultural values extend beyond the scope of our concerns in this essay, but they are nonetheless part of the larger system—a projection of the basic entrepreneurial spirit inherent in ranching from the beginning.

"Ranch fundamentalism," then, contains a number of elements, some of which we have already discussed:

1 Land fundamentalism: land is valuable as space, not only as property; as a symbol of presence and stability, not merely capital.
2 Familial fundamentalism: a large family is a good thing; your children can spread the presence of the family economically and socially in the region.
3 Rural fundamentalism: the country is better than the city—quieter, more authentic, more honest, more moral.
4 Conservationist fundamentalism: one should husband resources, not abuse them, or at least manage them in such a way that cycles of overuse alternate with underuse.
5 Managerial fundamentalism: a "satisficing" strategy is better than raw maximization.

Turning from some of the characteristics of range culture to the social organization of the rancher-cowboy system, we also move from cultural anthropology to sociology. Both disciplines (plus economics, as we have just seen) are needed to understand ways of life; none, by itself, does an adequate job.

The first pattern is the method of occupational training. We shall use the term *apprenticeship* since it defines the system better than any other. Apprenticeship is a rather medieval-sounding term, in this age of trade schools and formal accreditation by diploma. But as a method of training practitioners certain trades and crafts it hangs on, because there is really no better way of learning them. The art of cowboying involves practical experience on horses and on terrain; the roping, riding, welding, and automotive repairing are all important, but equally important, for example, is the ability to understand how pastures can be fenced in order to maximize grazing (not necessarily income maximization) while at the same time protecting the plant cover for future use. That is, cowboys have to know how to move animals around with horses, dogs, or jeeps, and how to open and close fences. This pattern is different for every single ranch: the cowboy must develop a sense of how ranches differ and be prepared to vary his strategies. He may receive directions from the rancher-proprietor, but he still has to be able to understand the instructions and be prepared on occasion to argue against them if experience teaches him they are wrong. Thus a certain degree of autonomy of decision-making is inherent in the cowhand role, and thus begins the entrepreneurial course of instruction that will serve him in good stead if and when he strikes out on his own.

The cowboy learns such skills by working, not by going to school. The situation is similar, though not identical, for the rancher's son. The best way to learn to run a ranch after inheriting one (or buying one) is to work on one, and if you can watch (and silently criticize) your father, so much the better. The rancher's son is thus really a built-in cowboy, and often he is treated more casually or callously by his father than are his dad's cowhands, who, after all, know more about the place than the young son. If the son shows unusual aptitude, he may become a straw boss, a foreman, and thus he begins his managerial training by giving orders to the hands—and, incidentally, palling around with them in town. Thus begins egalitarianism.

The son has one advantage over the apprentice cowhand: he can go to college. The debate as to whether agricultural school helps future ranchers continues; the evidence is not clear, and most certainly the actual day-to-day management of a ranch, with all its movement and crisis, cannot be learned in the university. But the rancher's son can go to business school and acquire the literacy and technical training which is increasingly necessary to run a ranching enterprise and stay abreast of the market, the government benefit programs, and the technology and science of livestock breeding, irrigation, and cultivated pasture.

The apprenticeship system, operating within both the rancher and the cowboy groups, contributes to the sense of mystery and arcana surrounding extensive livestock production on relatively large tracts of land. The "know cow" slogan, mentioned earlier, nicely sums it up: only those who have been through the apprenticeship system can really understand the routinized yet intricate behavior of cattle in search of optimal forage and water, and the breeding rituals of the beef herd. Formal instruction is more common today than it was in the past, when learning-by-doing was the only possible method. But the techniques of ranching really have not changed much in a century—in contrast to crop farming, which is subject to much greater scientization. The apprenticeship system thus helps forge the shared culture of rancher-cowboy society; these are all men who, like GIs in World War II, went through basic training together and thereby have something no one else has.

Apprenticeship leads to paternalism, our second pattern of range society. The term is inexact and has unfortunate connotations of medieval guilds or Japanese feudal relations. There are similarities, but the distinctive character of paternalism in range society is its fusion with egalitarianism. Indeed, paternalistic relations are definitionally opposed to

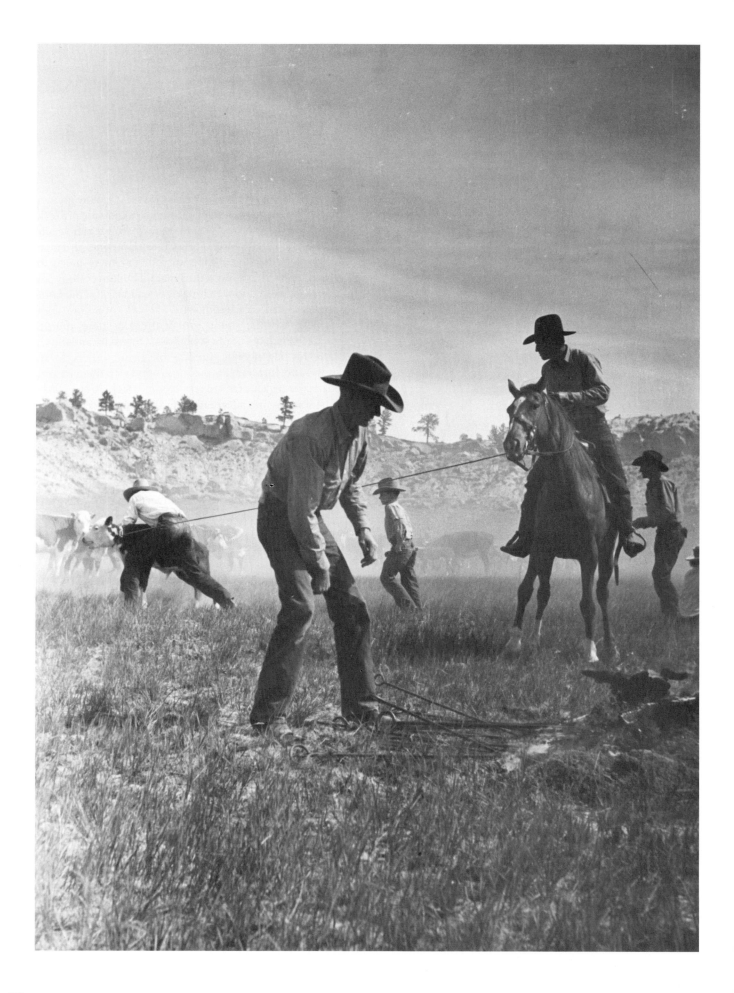

Ranch children acquire cowboy skills and values early, as at this roundup on the Quarter Circle U Brewster-Arnold Ranch Company near Birney, Montana, June 1939. *Photograph by Arthur Rothstein. Farm Security Administration file, Prints and Photographs Division, Library of Congress*

In a parking lot near the scene of a team roping competition, McDermitt, Nevada, 1980, Buck Taylor gives a lesson to his son Rex Elder Taylor, who is nicknamed "Dally" after a roping technique. The Taylors have come to the contest from Princeton, Oregon. *Photograph by Carl Fleischhauer for the Paradise Valley Folklife Project*

egalitarianism, but nothing is really inherently opposed in social organization: combinations of apparent polarities are the order of things. The point is that if apprenticeship becomes the dominant theme of training and learning in a craft, the teacher tends to become a sponsor of the people he educates. And if the pupil shows unusual abilities, the teacher or master is likely to maintain an interest in his welfare and help him make his own start. Probably a majority of the cowboys who become ranchers were helped to do so by their former employers, who saw to it that they were staked with enough land and animals to make a start in the business. In this sense, paternalism is the introductory phase of egalitarianism: the former apprentice becomes a fellow-rancher, and the egalitarian relationship emerges.

Paternalism in range society was also based on the economic situation. Since cowboys have never been well paid relative to the return from livestock production, assistance beyond the savings capacity was needed. The system also provided a strong incentive for ambitious and skilled cowhands who might want to move into ranching. They were motivated to work hard and "learn cow" because by doing so they might be able to earn the right to receive paternalistic assistance. The system extends beyond the ranch itself to the retired old ranchers in the little western towns who make a specialty of lending money to promising starters. And beyond this, businessmen with a soft spot for ranching, and who may own ranching properties themselves, often provide substantial loans of capital to young former cowhand-ranchers. In the small city of Medicine Hat, Alberta, a local hardware magnate did this for a generation, finding the practice lucrative not only in terms of repayments at interest (usually slightly lower than bank prime rates, and on informal schedules), but in continuing business relationships over tools, machinery, vehicles, and breeding stock. Bankers may cultivate somewhat similar relationships with young starters, although generally banks are less flexible in their terms.

These relationships carry a strong familial flavor in the range districts. We have already mentioned the importance of large families—sons and daughters through marriage establish linkages among ranches, permitting capital accumulation and transfer and the development of dynastic enterprises which may come to dominate the industry in the locality. The senior or established rancher is a father to his children, but a foster-father to his gifted cowhands, who become a kind of fictive kin, extending the network of obligations and loyalties that enable the rancher to maintain his labor force and his lucrative financial ties.

All these patterns may exist in the crop-farming community as well, and most certainly in the farmer-rancher community, which has spread rapidly in recent decades. That is, the practice of raising livestock in modest numbers as an adjunct to crop farming on medium-to-large farms has become a mainstay of many agricultural districts and regions in the West. As farmers merge into the ranching trade, they pick up the social and cultural patterns of the range world. In many western districts, the modern cowboy is a farmer's son. After all, there are more farmers than ranchers almost everywhere, since their land spreads are smaller, and hence there is more room for operators. Thus a social as well as an economic bond is established between the farm and ranch families, and in some western regions the kin networks run jointly, making

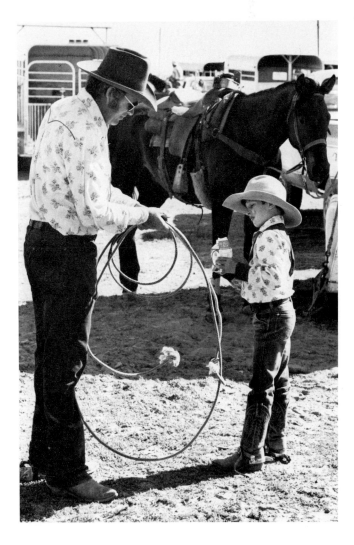

the cultural and occupational distinctions between farming and ranching largely ceremonial or a matter of stylistic nuance.

Then there is the town-country relational system. We have already mentioned the financial and business ties serving the needs of the young cowboy-ranchers. But there is more: ranchers, to an extent perhaps greater than farmers, and possibly because of more money, have always shown an interest in entrepreneurial ventures. The largeness of ranch families also helped: one or more of the sons would elect to establish, with family financial help, service trades and enterprises in the towns serving the country: machinery dealerships, hardware, furniture, automotive repair and welding, construction businesses specializing in farm and ranch buildings. These businesses strengthened the family fortunes and permitted land expansion—as we noted earlier in the case of the big land-cattle enterprises, with their many business ramifications, extending into urban areas.

But two sectors of the small western town life that ranchers and cowboys have had little to do with are the religious and

Ranch wife Marie Stewart serves midday lunch to her husband, son, and a branding crew at work on the Stewarts' Ninety-Six Ranch, October 1979. Joining the Stewarts and the crew for lunch are visiting filmmakers who are documenting the event for the American Folklife Center. Mrs. Stewart does not herself join the group at the table. The unoccupied chair belongs to the photographer. *Photograph by Carl Fleischhauer for the Paradise Valley Folklife Project*

town churches, the school boards, or the volunteer social assistance bodies. These groups are usually served mainly by the retired farmers and the small-town merchants. The relative detachment of the rancher from the social integrative rituals and activities of town-country society helps to define the range culture as detached, somewhat apart from the "normal" social life of rural areas. Ranchers and cowboys are therefore confirmed in their status as folk figures, as living representatives of a frontier mentality and way of life.

Finally, the women. The cowboy as symbol is of course intensely male: there are no female cowboys, although there are a few young women in the rodeo, usually not as professionals, and of course there are avid horsewomen on the ranches. A few women run ranches out west, but almost always as the result of a father or husband dying without a male successor. The public definition of the woman's role in range society is that of fiancé, mother, and housewife, and in the traditional literature she has been put on a pedestal: the southern element is particularly strong here. The novels and movies are full of cowboys and rangemen seeking vengeance for insults to women. And the literature also exploits the twist: the genteel, soft girl from the town displaying unexpected macho skills and bravery.

More important, though, is the fact that as captains of the domicile, women did play a vital role and also a sacrificial one. Women did the hard home chores, cooking the meals, tending the garden, raising and launching the kids, arranging the marriages, and maintaining the important social relationships with relatives and neighbors which supply the labor needs. Range women are active in the ladies' clubs and, when they can get to town, the churches. In recent decades women have taken over managerial tasks as well. In many districts women go to school longer than their men; they are better at writing and figuring (ranchers often marry school teachers). The intricate new systems of livestock performance testing and cross-breeding are monitored on many if not most ranches by the women, who keep the record books or operate the computer. Papa may get the public credit for production decisions, but mama prepares the information base necessary to make the decisions. As yet ranch women have not received due recognition of their important services, but this is growing. Women also receive formal training for their pursuits: their mothers school them in the household tasks, and the local high schools and trade schools supply the training in clerical skills. Women on ranches are, in some sense, more professionally trained for their roles than the men are for theirs.

social welfare activities. Ranchers may participate in the economic activities of small towns, but they enter less often into civic and church affairs (although their wives may do so). The pervading entrepreneurial spirit and the strong individualistic emphasis is responsible for a general lack of interest in the indigent, or the people who have not been able to "make it on their own," whatever the reasons. Ranch social networks help their own; they are not known for charity and benevolence toward the poor. Thus ranch families are not well represented in the congregations of the country and

To an increasing extent, cowboys marry and raise families and correspondingly demand employment situations where they can bring the family with them—the so-called "live-in" arrangements on the medium and larger ranches. These young women, sometimes from the same social origins and kin networks as the ranch wife, can develop intimate relationships with her, and the cowboy's slow progress toward rancherdom, or rancher-farmer status, is aided by his wife's ability to establish profitable relationships.

Women can also play a vital role in socializing the ranch sons. I noted earlier that the relationship between father and son is often strained, due to the fact that the son is an immature apprentice cowboy and may be treated as such by his father. The mother must play the countervailing nurturant role in such situations, and this means she is free, if she wishes, to direct his interests toward occupations other than livestock production. In many families, she is chiefly concerned with heading him away from cowboying or rodeo-riding—she considers them dangerous and demanding pursuits—but on the whole she is favorable toward ranching and will do what she can to encourage the boy, if he has talents and interests and strength, to follow in his father's footsteps. If there is more than one son, by necessity the mother will need to point the boys toward something other than the family ranch, since only one, in the majority of cases, can inherit. The mother is thus a crucial figure: she not only trains the daughters to be homemakers—or nurses or social workers—but also keeps equilibrium among the sons and their father. It is obvious that in some respects this confounds, or conflicts with, the urban-derived stereotypes of the "liberated women." [4] But it is not hard to understand why women are sometimes "put on a pedestal": their social role deserves special honor.

When we view the cowboy as an occupational type—an employee in a distinctive form of agricultural production—what happens to our understanding of him as a folk figure? I believe we can say that the character traits which fed the popular culture are rooted in the social and economic basis of ranching as an industry: the shared culture of ranchers and cowhands; the willingness to define the culture as a way of life and a means of enjoyment; its innate individualism and love of independence; its function as a source of recreational pursuits and performance skills. But beyond these obvious roots, there is the response of the outside world to the cowboy: the fascination exerted on sedentary urban minds by people who ride horses across open spaces and who have a heritage of pioneering exploration and the conquest of nature. These attractions were so strong that the image of the cowboy became a romantic one, and much of the hard reality of life as an underpaid agricultural laborer was ignored and forgotten.

The entire system of North American range culture and society is, in the last analysis, maintained by the basic institutions of livestock production for a "free" market. If ranchers are eventually absorbed into pooled marketing schemes, or "cattle boards," as various western governments have proposed from time to time, much of the distinctive character of the system will vanish. There is already, as a result of the inexorable spread of government assistance on all fronts, a growing disparity between frontier individualism and the actual integration—between the independent rancher on the one hand, and the vertically integrated rancher, selling his stock on contract to packers or supermarket chains, on the other. As this happens, the cowboy becomes less a romantic figure and more an industrial employee. Perhaps his day is over; we shall see.

A bit of light can be thrown on the future by comparative observations. In recent years I have studied the problems of economic development for migratory tribal pastoral livestock-raisers in Africa.[5] Largely subsistence producers, these several hundreds of thousands of people have been urged and assisted in a transition to more sedentary, intensive modes of production of animals for market. Obviously their culture differs greatly from the North American range patterns. But there are striking similarities in basic elements: the system of apprentice herdsmen—the "cowboys"—usually relatives; the ambiguous position of the chief herd-owner's sons; the similar subdued status of women; the struggles with government programs and inhibitions to free marketing of animals (pastoralists always sold animals, even though the majority were used for traction and subsistence). As the herders are induced to settle down, they experience problems similar to those of open-range ranchers of the West who were, in many respects, nomads like the pastoralists. And as they make the second transition—to commercial production—they experience a loss of tradition and react by intensifying the symbolic elements of that tradition.

So, likewise, the Old Western range culture has experienced a revitalization in recent decades: hobby ranchers, the preoccupation of the TV industry with cowboys and range families, the extension of western individualism and machismo into the mass cultural media. Although the cultural

content and heritage is so different as to be difficult of recognition, there are analogs to all these developments in Africa. The changes are very similar, and the uncertainty of the final outcome just as real.

Notes

This essay is based on the writer's experiences and research in his long-term study of social and economic development in Western Saskatchewan, with comparative research in adjoining regions of Alberta and Montana. The study was known as the Saskatchewan Cultural Ecology Research Program; its best-known publications are Bennett 1969; Bennett 1967; Bennett 1982; and Kohl 1976.

1. For a pioneer and classic economic analysis of the consequences of space for social development in western communities, see Anderson 1950.
2. For an account of the big men on the range, see Atherton 1961, perhaps the best one-volume treatment of the cattle kings. For a social survey of life on western ranges in the 1940s, see Sonnichsen 1950. Many of the patterns described by Sonnichsen have changed greatly, but a comparison of his findings and our own for the 1960–72 period suggests the unchanging foundation of range culture and society.
3. In the opinion of the writer, Roosevelt's articles on life as a pioneer rancher on ranches near Medora, North Dakota, remain the most eloquent and perceptive studies of the milieu of the rancher and cowhands ever produced (Roosevelt 1899). The pieces are particularly good at showing how the elite easterner was brought into equal association with rough westerners, in relationships of mutual dependence but also with a need for self-reliance.
4. For an extended analysis of the family relationships and sex roles among western agriculturalists, comparing farmers with ranchers, see our research publications, especially Kohl 1976 and Bennett 1982, chapters 5, 6, and 7.
5. For a survey of African pastoralists and their problems of development and social transition, see the collection of papers in Galaty, Aronson, and Salzman 1981.

Works Cited

Anderson, A. H. "Space as a Social Cost." *Journal of Farm Economics* 32 (1950): 411–29.

Atherton, Lewis. *The Cattle Kings.* Bloomington: Indiana University Press, 1961.

Bennett, John W. *Hutterian Brethren: The Agricultural Economy and Social Organization of a Communal People.* Stanford: Stanford University Press, 1967.

_____. *Northern Plainsmen: Adaptive Strategy and Agrarian Life.* Original edition published by Aldine Publishing Co., Chicago, 1969.

_____. *Of Time and the Enterprise: North American Family Farm Management in a Context of Resource Marginality.* Minneapolis: University of Minnesota Press, 1982.

Galaty, John G., D. Aronson, and P. C. Salzman. *The Future of Pastoral Peoples.* Ottawa, Canada, International Development Research Center, 1981.

Kohl, Seena B. *Working Together: Women and Family in Southwestern Saskatchewan.* Toronto: Holt Rinehart & Winston of Canada, Ltd., 1976.

Lawrence, Elizabeth A. *Rodeo: An Anthropologist Looks at the Wild and the Tame.* Knoxville: University of Tennessee Press, 1982.

Roosevelt, Theodore. *Ranch Life and the Hunting Trail.* New York: Century Co., 1899.

Smith, Arthur H., and Wm. E. Martin. "Socioeconomic Behavior of Cattle Ranchers, with Implications for Community Development in the West." *American Journal of Agricultural Economics* (May 1972): 217–25.

Sonnichsen, Chas. L. *Cowboys and Cattle Kings: Life on the Range Today.* Norman: University of Oklahoma Press, 1950.

Spillman, W. J. "The Agricultural Ladder." *American Economic Review* 9, Suppl. No. 1 (1919): 29–38.

Voigt, William, Jr. *Public Grazing Lands: Use and Misuse by Industry and Government.* New Brunswick: Rutgers University Press, 1976.

Webb, Walter P. *The Great Plains.* New York: Ginn and Co., 1931.

TOM AND I WERE COWBOYS

By John R. Erickson

Photographs by Kris Erickson

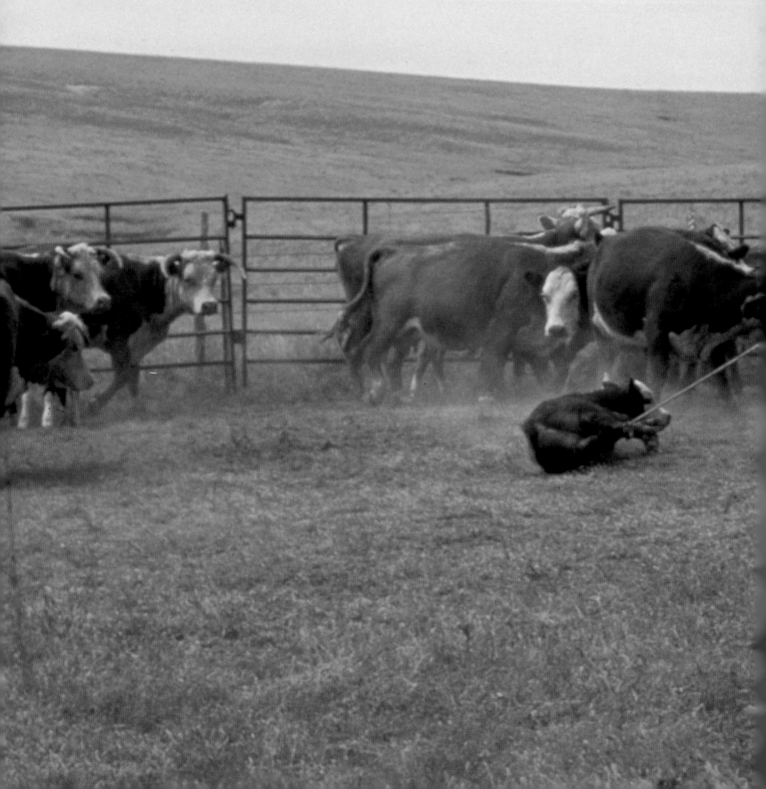

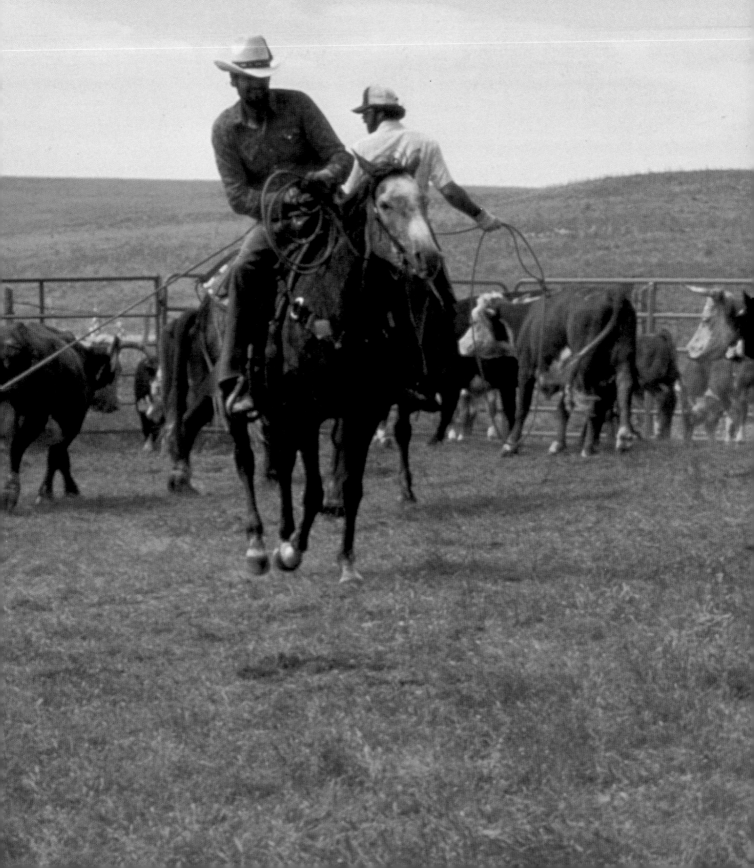

Tom and I were cowboys. We worked on a ranch in the northern Texas Panhandle, and to us the coming of spring was a special source of joy. The winter of 1979–80 had been a bear. The ice and snow and cutting winds of January and February had been bad, but the worst part of the winter had come toward the first of March, with a long period of cold rain. Day

after day it had rained. Slow rain, hard rain, rain mixed with snow and sleet, rain driven by a cruel northeast wind. We had worked out in it every day, wearing yellow slickers and four-buckle overshoes and cowboy hats that were soaked through with water.

But then spring had come, soft days heavy with the scent of green grass and the honking of cranes and geese flying north. And, like cowboys everywhere, we were filled with joy.

The coming of spring meant that we could throw our over-shoes in a corner of the saddle house, start practicing with our ropes, and get back to working with colts.

Tom had a bay mare named Bonnie that he had been bringing along since the fall. She was a tall, leggy mare, still green and awkward but eager to please. Tom had been patient with her and had brought her on slowly, and she promised to make a dandy saddle mare.

Top: John Erickson unloading a horse from a stock trailer at the Ellzey Ranch, Ochiltree County, in the Texas Panhandle
Bottom: Texas cowboy Tom Ellzey

One evening in April we had to drive a herd of steers several miles across country to a pasture along Wolf Creek. It was easy work, just right for a green horse.

The sun was slipping toward the horizon when we delivered the steers to the pasture and started back to headquarters. It was one of those times when a cowboy feels that he is one of God's chosen people, a lucky man to have been given the chance to follow the horseback life.

We trotted our horses toward home and played with our ropes, throwing at sagebrush and soapweeds. We came to a steep hill that led down to a draw. I was coiling up my rope and happened to be looking at Tom.

Bonnie stumbled in the caliche rock. She staggered several steps, trying to keep her feet. Her chest hit the ground. I kept thinking she would wallow to her feet. But she couldn't pull out of it. Her head and neck rolled under. I watched in horror as this thousand-pound animal tumbled down the hill and began a forward roll.

Tom was still in the stirrups, with the rope in his hands and a stunned expression on his face. I watched Bonnie's back end go up and over. And as Tom saw what was coming, I heard him murmur, "Oh God."

He plunged face-first to the rocky ground, then disappeared beneath the horse. I had seen wrecks before, but I had never seen one that was so certain to crush and cripple a man as this one.

I dived out of the saddle and ran to him, just as the mare rolled off of him. His eyes were closed, his face compressed in pain. I lifted his head off the rocks and cradled it in my arms. I feared that he might be dying.

"It's all right, Tom. Just lie still."

He blinked his eyes. "I can't tell how bad I'm hurt." He tried to sit up.

"Lie still, don't move."

"Got to." He struggled. I thought maybe he was delirious.

"Don't move, Tom."

"Got to. I'm in an ant den."

I stared at him. "*Ant den!* Hell, if you're worried about ants, you ain't hurt very bad." I let his head drop.

Five minutes later, we were ahorseback again. Tom walked funny for a couple of weeks, but he was all right. They say that to kill a genuine cowboy, you have to cut off his head and hide it.

I consider myself lucky to have had the chance to live the cowboy life. When I went into full-time cowboying in 1974 I had a feeling that I was getting on the tail-end of an era.

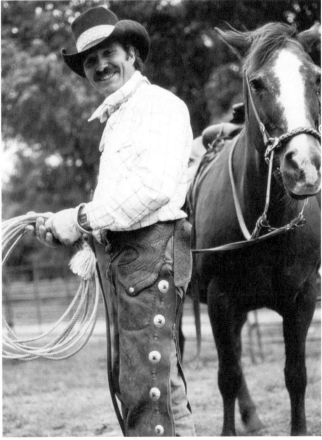

When I left cowboying seven and a half years later, I knew others who were going into it with the same thought. They figured this might be the last chance.

People have been building coffins for the American cowboy for about the last hundred years. According to some scholars, he was finished off around 1880 when the railroads brought an end to the trail-driving period. Other writers figure the cowboy quit breathing around the turn of the century. Or when the country started getting closed in with barbed wire. Or when the big ranches got split up. Or when pickups and stock trailers came on the scene.

In 1976, *The New Yorker* magazine put out the word that, by George, at last the cowboy was done for. In this "parable of failed promise," it was revealed that the old cowboy had finally succumbed to feed yards and modern technology. And maybe cirrhosis of the liver, since the guy in the story hit the jug pretty hard.

I was cowboying in Beaver County, Oklahoma, at the time *The New Yorker* scooped that story. I was working horseback ten to twelve hours a day at the time, and it was a little hard for

me to believe that the American cowboy had been flushed down the toilet of history.

The fact of the matter is that cowboys may be as hard to get rid of as roaches, and for the same reason: they're adaptable. This seems to be an ingredient in the cowboy that writers have missed over the years. It could be that writers, who tend to have a little of the romantic in them, have been drawn to the older cowboys who just naturally look and act and sound more like "real" cowboys are supposed to look, act, and sound.

An older man is apt to see change as a corruption. His whole life has been invested in doing things a certain way, and the older he gets the more he begins to think of his habits and patterns as "real," and to regard any kind of change as counterfeit.

I had a great-uncle named Bert Sherman who started cowboying in West Texas around 1920. He worked on big ranches, went out with the wagon in the spring, slept in the snow in a bedroll, and lived alone in line-camp shacks. When he was an old man, telling me about his adventures, he always

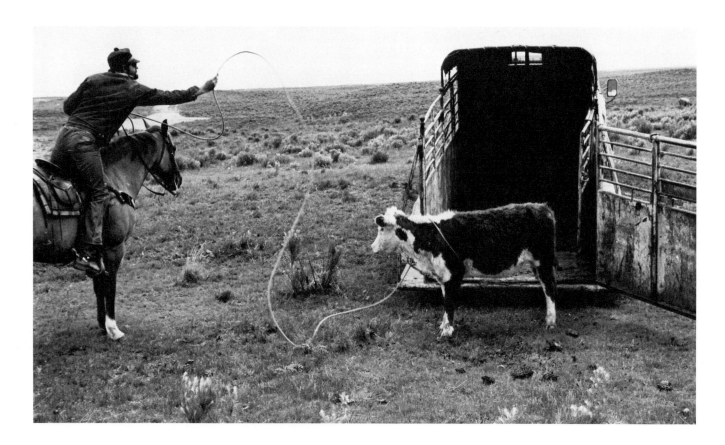

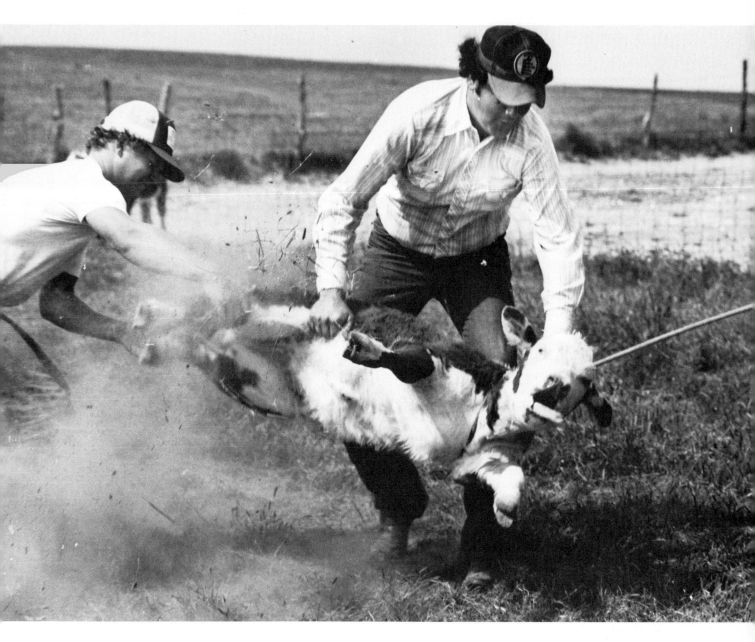

managed to let me know that the days of the "real" cowboy were about gone, and that the young bucks of the modern age didn't know cowboying from Shinola.

If I had been content with Uncle Bert's version of the American cowboy, I never would have gone into cowboying myself. And I never would have learned that Uncle Bert, God rest his soul and bow legs, was wrong.

What he perceived as the end of the Old West and the end of the cowboy was nothing more than the end of Uncle Bert's career. I can't blame him for wanting to take cowboying with him to the grave. It's a natural human tendency, this desire to possess something permanent and dignified, and to pronounce all future activity insignificant.

But it's the obligation of the young not to believe that and not to allow it. Surely God is wise for making young men stubborn and ignorant, because had he made them even halfway smart, the old men would have been right and the cowboy would have been dead eighty years ago.

Writers who dwell on the death of the cowboy and the end of the West have spent too much time listening to old men. The most important ingredient in the Cowboy Code is survival. Cowboying is alive today because, for a hundred and twenty years, young men have demanded that it stay alive. Through the force of their lives and actions, they have kept it alive, even when it demanded suffering and sacrifice.

This suggests to me that there is a certain spiritual or mythic quality in cowboying that is so powerful, so much a part of what we are as a people, that we will never see the last cowboy. I cannot conceive of any catastrophe that could get him out of our system.

Well, let's take a closer look at the modern cow-chaser and see exactly where and how he has changed. I would say that pickups and stock trailers have changed the cowboy's work habits about as much as anything.

Back in the old days—and I mean up to about 1950 or 1955 —when a crew of cowboys went out to do some cattle work, they rode out from headquarters before daylight, walked or trotted their horses to the roundup spot, did their work, and then rode home. On the bigger ranches that had thousands of calves to brand each spring, the crew went out with the chuckwagon and camped, and they might not see headquarters for weeks or even months.

There are still ranches around that use a wagon. In some cases, when the ranch is quite large, it is a necessity and a convenience, but in other cases I would guess that it has less to do with cost effectiveness than with nostalgia—you might call it the evolution of a work-form into an art-form. But most ranches today don't need or use a wagon. Distances from headquarters to pasture and from ranch to ranch have been shrunk by pickups and stock trailers.

When I cowboyed in the Oklahoma Panhandle in the late 1970s, I swapped out work with neighboring ranches. Every spring and fall, we would throw together a crew of anywhere from seven to twenty-five men. Every morning before daylight, I would load a fresh horse in my stock trailer and drive to the roundup point, meet the crew, do the day's work, and then drive home at night. Sometimes they were short trips, two or three miles over country roads, but other days I was driving thirty or forty miles to reach the roundup spot. This went on every day for two or three months as we worked our way down the Beaver River and then over into the Cimarron country.

Modern cowboys have been very clever in adapting their work habits to the machine age and in putting the pickup-trailer combination to good use out in the pasture. If a cowboy knows the right techniques and has the right kind of trailer, he can use the stock trailer to perform a wide range of jobs.

Let's use one of my experiences as an example. In the winter of 1980 I was working on a ranch in the Texas Panhandle. The outfit consisted of a block of grassland located on Wolf Creek, and in this country we ran mother cows year-round. But in the fall, winter, and early spring, we ran yearlings on leased wheat pasture.

In 1980 we had steers scattered all over the county, about six hundred head on five places up on the flats. These places averaged around twenty miles from headquarters. Since yearling cattle are prone to stray and get sick, they have to be checked closely and on a regular basis.

Usually my partner Tom and I would check the yearlings together, but one day in February I had to do the job alone.

That morning I loaded my mare into the stock trailer, threw in a bag of medicine, extra ropes, and a set of come-alongs (a small hand-operated winch), and headed for the flats.

At the Wright place, I rode through a bunch of big yearlings and found one that had bloated on the green wheat. If I had come a day later, I would have found him dead. I parked my pickup and trailer in the middle of the wheat field, and left the trailer gates open, which was something I always did. I roped the steer, which weighed around six hundred pounds, and drove him on a loose rope to the trailer.

When I reached the trailer, the gates were already open to receive an animal. I maneuvered the steer around until I could slack my rope and flip it over a steel ball welded to the top of the stock racks. Then I dallied my rope to the horn (*dally* means "turn around" the saddlehorn several times to hold it secure for pulling), spurred my mare, and tried to drag the steer into the trailer.

Why didn't I just drive him to a set of pens and load him there? Because there weren't any permanent corrals, and on wheat pasture there very seldom are.

The steer sulled and went down, and my little mare didn't have enough strength to drag that much weight. So I dismounted, tied the steer down with a pigging string, fitted a halter around his head, and winched him into the trailer with the come-alongs. Once I got him inside the trailer, I ran a rubber hose down his throat and let the gas out of his stomach. That gas pressure can become so intense that it will kill the beast by stopping his heart.

With the steer loaded in the front compartment of the trailer and my mare in the back, I drove ten miles to the Bryan place. I jumped out my mare and rode through that bunch and found a heifer with the bloody scours.

I roped this heifer, drove her to the trailer, and while the first steer was still shut into the front compartment, I dragged the heifer into the back compartment, closed the back gate of the trailer, opened the center gate, and put both sick animals up front.

Then I loaded my mare in the back and drove seven miles to the Anderson place. I found two small steers in this bunch that just weren't doing any good, so I roped them and loaded them the same way I had loaded the heifer. That gave me four head in the front compartment and my mare in the back.

Then I drove fifteen miles to the Northup Creek pasture. There I found a heifer that was stone blind with pinkeye. I stuck a loop on her, put her in the trailer, and headed for home.

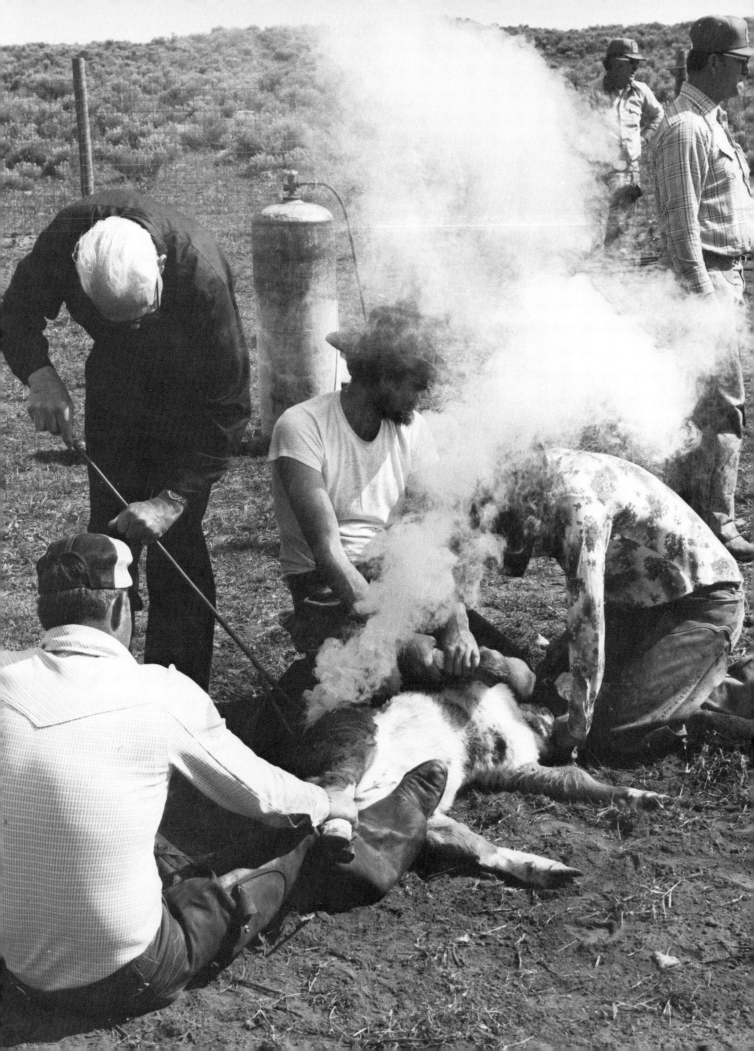

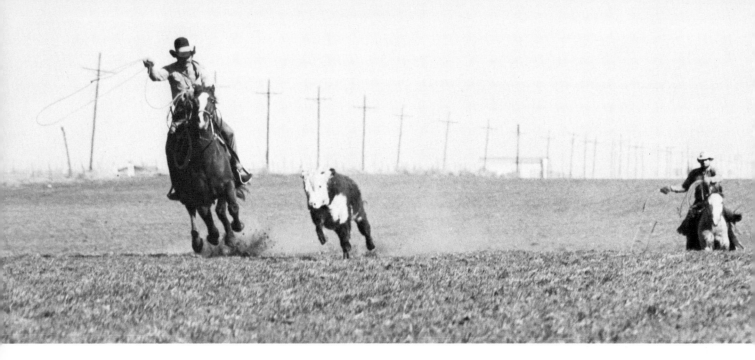

By the time I got to headquarters, I had covered seventy-five miles, checked six hundred head of yearlings on five different places, and I still had enough daylight to take care of my mare and run the cattle through the doctoring chute.

That gives a pretty fair idea of the tremendous mobility of the modern cowboy, and it also demonstrates the ways one man and one horse can use a stock trailer. It not only hauls a horse around the country, but it can be used as a portable catch pen in remote pastures where corrals don't exist.

Above: Tom Ellzey and John Erickson on the flats near Perryton, Texas. Ellzey is about to rope a steer so that it can be doctored for pinkeye.
Below: Ellzey and Erickson doctoring a steer for pinkeye
Opposite: Doctoring cattle on the Ellzey Ranch

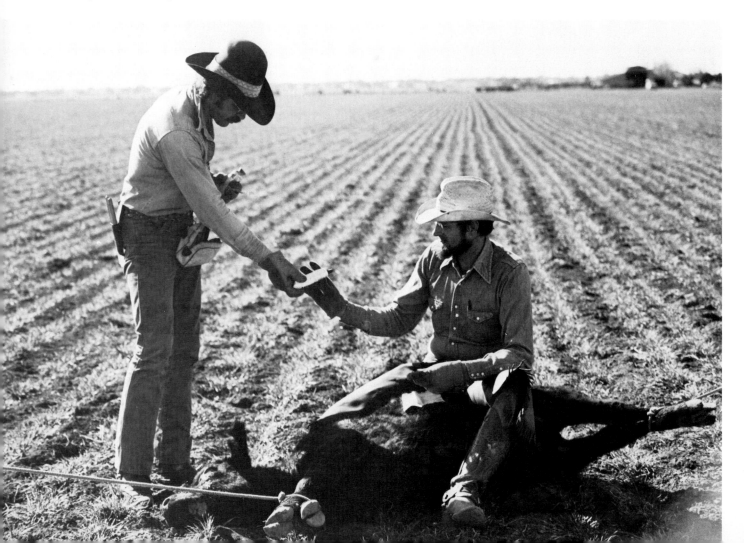

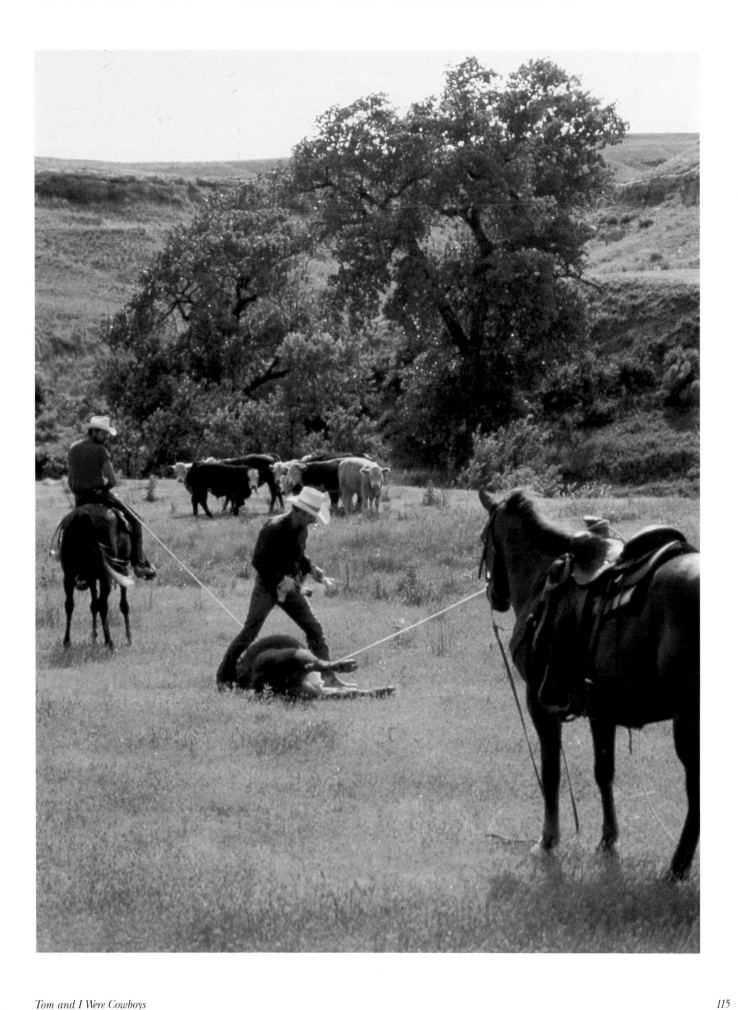

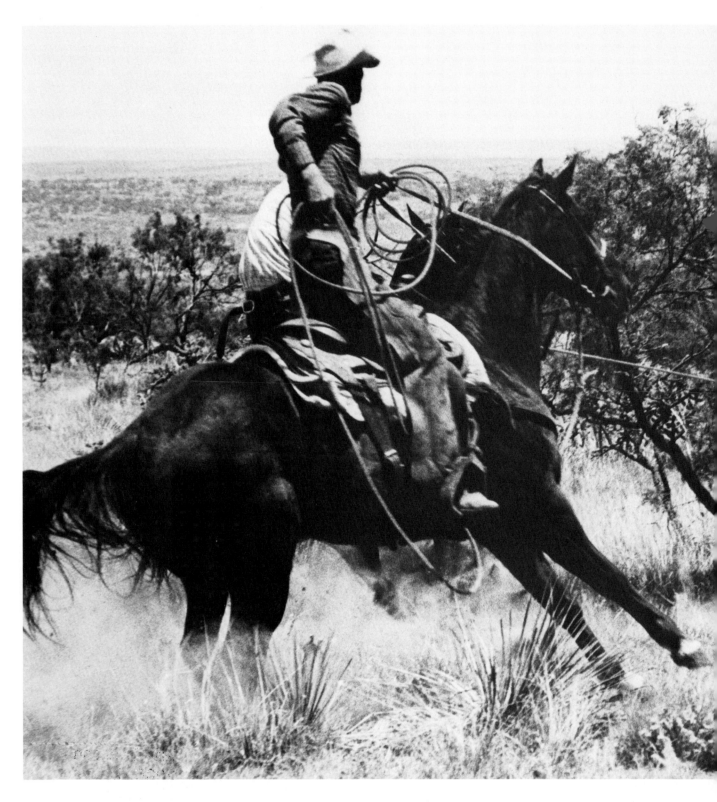

Of course there is another way of looking at all this, and it's the way my old Uncle Bert chose to see it. He sneered at the very idea of a cowboy hauling a horse instead of riding him. He saw this as just another example of whippersnappers lowering the standards of the profession, spoiling the horses while tearing up expensive machinery.

The old guys often express their contempt by saying, "There's two things you never see any more: a cowboy riding and a horse walking." Well, that's one way of looking at it, and there's a certain amount of truth in it. There's no denying that the increased use of pickups and trailers has changed the cowboy's relationship with the horse.

Obviously, when a cowboy hauls a horse, he's not riding him. Horses today are not ridden as far, as hard, or as often as they were in the old days. I've heard old-timers say that modern cowhorses are not as skilled as they were when they

remuda (a Spanish word meaning a herd of horses) every morning. A cowboy crew back then might have used a hundred or more horses, and although an individual cowboy might have had only ten horses in his personal string, he had the opportunity to study the habits and dispositions of the entire herd. In a remuda of horses, he would see every size, color, and disposition, and to that extent the old-time cowboy probably had a broader knowledge of horses than his modern counterpart.

I think we could come to a similar conclusion about roping. Depending on the type of work the cowboy is doing, he may need to rope an animal by the front legs, hind legs, head, or horns, and there is a technique for each type of throw. The old-time cowboy had anywhere from six to twenty roping techniques in his repertoire, which might include a regular heading loop, a heeling loop, a horn loop, the Blocker loop, the hoolihan, and three or four loops he used on the ground for roping horses.

A man from Wyoming once told me that he knew an old cowboy who knew twenty different ways of heeling an animal.

It appears to me that the modern cowboy has forgotten much of the old lore of roping. When I was cowboying, I never met a man who knew how to throw a Blocker loop, which was a standard technique up until about forty or fifty years ago, and probably the most versatile loop ever invented. A man who knew how to throw a Blocker could use it for roping heads, horns, forefeet, and heels, which just about covers everything a cowboy would want to catch. And I knew only a few men who knew how to use the hoolihan, a soft, quiet, counter-clockwise loop that is excellent for roping in a herd.

Most of the cowboys I worked with knew only two loops: a heading loop and a heeling loop. In both cases the technique came, not from a ranching tradition, but from the roping arena, where team ropers have developed a fast, efficient style of heading and heeling.

These two loops have become the standard roping techniques of the modern cowboy, and 90 percent of his pasture work can be done with them. The old-time cowboy had a broader range of techniques because he needed them, and when the need disappeared, most of the old roping styles were forgotten.

In both these areas—horses and roping—it would be easy to conclude that the standards of the profession have changed for the worse, and that the modern cowboy is only a pale imitation of his old-time counterpart. If you believe that the cowboy of 1880 was the standard by which all others must

were ridden ten or twelve hours a day. That might be true, but it's also true that modern horses live longer and work longer for the same reason, because they're not ridden into the ground on a regular basis.

You can argue either side of that question, but there's not much doubt that the modern cowboy doesn't come into contact with the number of horses the old-timer did. The old-timer who went with the wagon caught his horse out of a

be measured, if you believe that the cowboy of that period was the *real* cowboy, then it won't be hard to say that standards have gone to hell and God ain't making real cowboys any more. My Uncle Bert, wherever he is today, would stand up and applaud that. I expect that Charlie Russell, the great western artist and writer from Montana, would too.

I would rather not quarrel with such awesome authority, but I just can't buy that argument. The old-time cowboy did what he had to do to keep his job and earn his wages. He knew more loops and worked with more horses than today's cowboy, but today's cowboy knows more about pickups, stock trailers, cattle trucks, livestock genetics, animal nutrition, windmill technology, fence building, and veterinary medicine than the old-timer.

We could go on to say that the modern cowboy is probably cleaner, smells better, has better teeth and stronger bones, is

better informed on world affairs, has a much more realistic view of women (since he's likely to be married to one), is a lot more interested in children (since he's likely to have a few of his own), and doesn't spend nearly as much time in a whorehouse as the old-time cowboy did.

If a guy wanted to prove that the modern cowboy is a vast improvement over those dirty old bachelor cowboys, I think he could do it without much effort. But what would it prove? I can't see that we accomplish much by saying that either group is better than the other.

What we can say is that both groups have done what they had to do to keep a job in the cattle business, and over the years they have adapted to changing times. Today's cowboy is not the same as the cowboy of a hundred years ago, any more than today's quarter horse is the same as the little cow pony of a century ago. And that's good.

The first duty of any species is to survive. The cowboy has done that, and his mere survival is reason enough to win him respect. What do you suppose the odds are against a man on horseback, a relic of the Iron Age, surviving in the age of moon landings and computers?

I have an idea that at any point after 1945, the cattle industry could have phased out both cowboys and horses. It could have gone to a completely confined and automated operation supervised by technicians on motorcycles, and if cowboys had made the kind of demands for higher wages and better conditions that organized labor made in the industrial centers, I think it would have happened. And it still can. The technology is available.

Cowboys have survived, not so much because the industry needs them, but because they have needed themselves. They have been willing to sacrifice material comforts and security for the opportunity to participate in a way of life with roots going back into another era of human history, back to a time when mankind perceived order in the universe, participated in the rhythms of nature, and could believe in the dignity of life, work, and human virtue.

To most citizens of the modern age, that time is gone forever. Picasso must have had this in mind when he painted his famous picture called "Guernica," which shows a horseman and his mount shattered on the ground, like a toy that has been stomped. The painting seems to point to the end of an age when horses and horsemen mattered at all, as if the invention of planes and bombs and tanks had thrust all of mankind into a terrible new age when the virtues of the cavalier were obsolete, when one dull brute at the controls of an airplane could machinegun a whole regiment of noble horsemen into oblivion, without lifting a saber, dirtying a hand, or even looking his adversary in the eyes.

For a hundred years now writers have been waiting for the cowboy to die, waiting for the message of "Guernica" to reach the American heartland. Yet every year a small number of young Americans make the decision to take a ranch job. They go into cowboying because there is something in the horseback life that they need and want. I suspect that at least part of what they are looking for is the spiritual quality that has accrued to the cowboy and made him our most enduring mythological character.

The great cycle of history is taking us away from the age of the horse and the cavalier, yet there seems to be something in all of us that doesn't want to give up the cowboy and let him ride into the sunset for the last time.

This makes me think that, just as those young folks who go into cowboying need to keep the cowboy alive, we as a culture and a people need the spiritual vitality of the cowboy in our mythology. And that's why I don't think we will ever see the last cowboy. We need him. We need to know that he is out there. We need to know that this is who we used to be, and perhaps who we need to be and want to be.

And the more we change, the farther we move out into space and the deeper we probe into the atom, the more we will need him, for he is our magic mirror on the wall. When we look into the mirror, we see our past and our present, what we were and what we have become.

So ride on, cowboy, until somebody cuts off your head and hides it.

"BORN INTO THE STONE": Carvers at the Washington Cathedral

By Marjorie Hunt

The stone carvers at the National Cathedral in Washington, D.C., have worked together for over twenty years. They are highly skilled craftsmen whose ideas and actions are firmly rooted in their traditional heritage and their occupational community. "There used to be twelve or thirteen carvers in this workshop," remembers master carver Vincent Palumbo. "It was just like a family—my father, Morigi, Ratti, Guarente, Bresciani, Del Negro, Seferlis, Zic—many of us. We work,

we laugh, we joke. That was the beauty of it." *Photograph by Morton Broffman*

Opposite: The National Cathedral is a fourteenth-century gothic-style structure begun in 1907. Seventy-eight years later it nears completion, but construction continues on the West Towers. *Photograph, ca. 1970, courtesy of the Washington Cathedral*

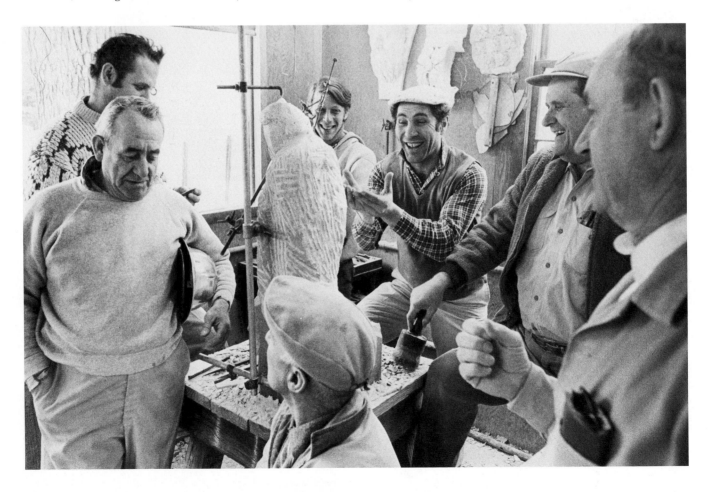

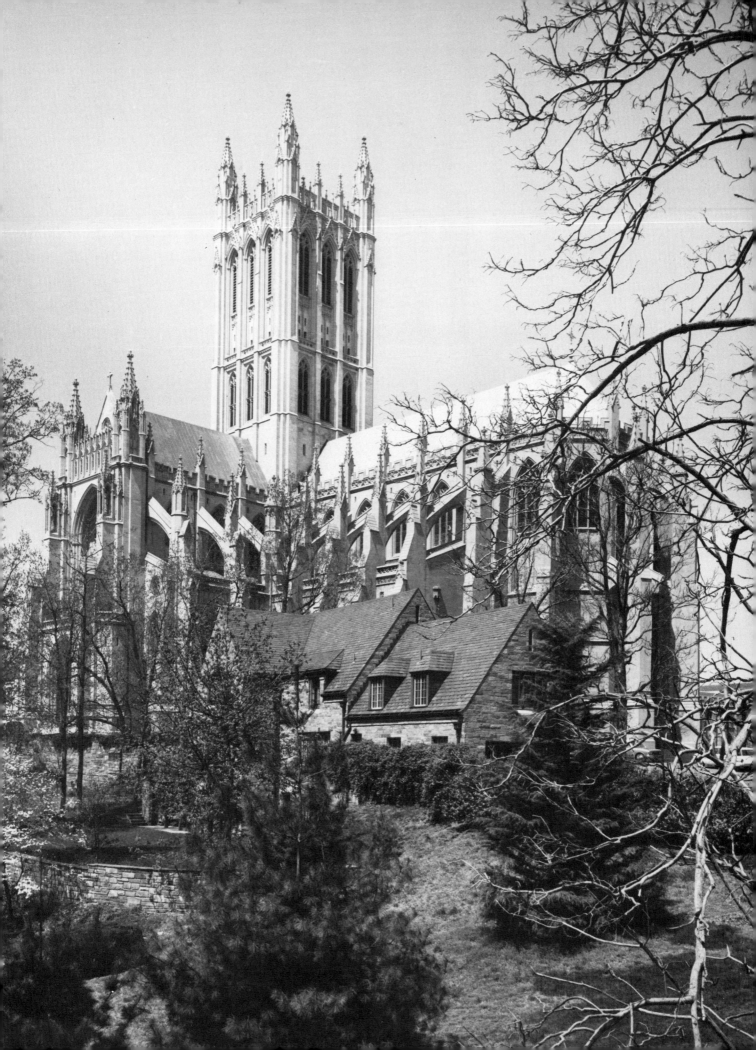

Above: Architectural elevation for the Washington Cathedral. *Courtesy of the Washington Cathedral*

Above right: Cathedral under construction, 1925.

Right: Most of the cathedral carvers were skilled Italian artisans who learned their trade in the stone shops of northern and southern Italy before immigrating to the United States. Others hailed from England, Germany, Greece, and Yugoslavia. "The carving workshop," boasts retired master carver Roger Morigi, "was just like the League of Nations!" Here we see Morigi (left) and his cousin arriving in New York harbor in 1927. *Photograph courtesy of Roger Morigi*

Some of the carvers have worked together for over half a century on such buildings as the U.S. Supreme Court, the U.S. Capitol, and the National Archives, as well as the Washington Cathedral. Roger Morigi's father, Napoleon Morigi, traveled back and forth between Italy and the United States in the 1890s to work on the first Library of Congress building, which was completed in 1897. This photograph was taken in the northeast wing of the Library on October 16, 1894.

As an occupational group, the carvers are proud of the historical depth and continuity of their trade. "Even God," jokes Vincent Palumbo, "God gave Moses the Ten Commandments on stone, so stone carving's got to be the oldest craft in the world!" *Prints and Photographs Division, Library of Congress*

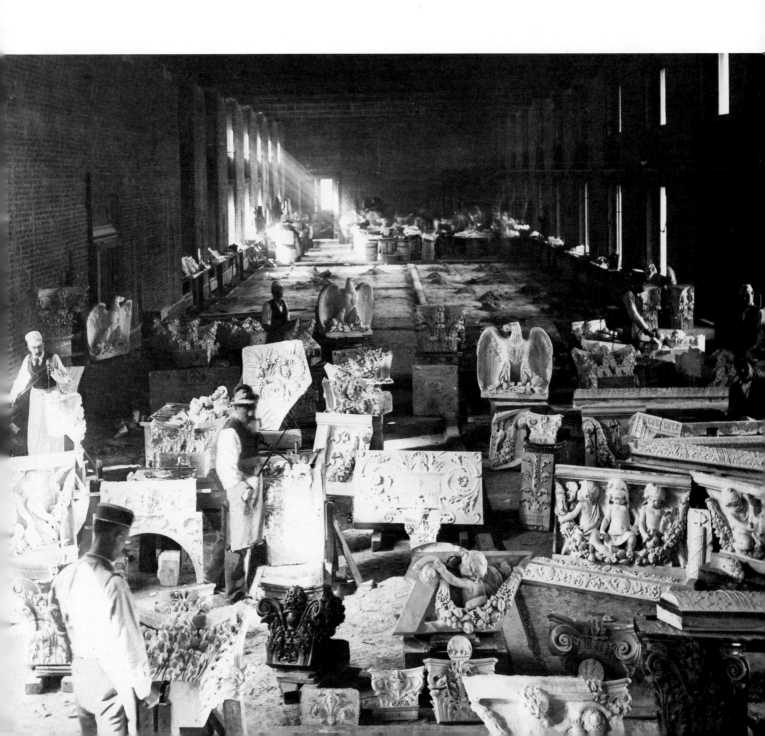

In recent years, with the advent of new building techniques, increased mechanization, and changing social and aesthetic values, the need for the stone carver's skills has almost completely disappeared. The carvers at the Washington Cathedral are now some of the last stone carvers working in the United States. "The stone man's work, it's shrinking every day," says Vincent Palumbo (shown here). "And today the new generation, they don't even want to bother because working the stone is all dirty, it's all dusty. The new generation, they just want to go around with a suit and play with computers."

The stone carvers practice a traditional art that is centuries old, a craft that has been passed down through the generations from father to son and from old master to apprentice. "Practically, I was born into the stone," says Palumbo, who was born and raised in the small town of Molfetta in southern Italy. "I come from generations. My great-grandfather, my grandfather, my father was in stone, so practically there was no apprenticeship for me, I was growing in the trade. I start to go to the shop with my father when I was nine years old. I clean up the shop, I look at the other guys to see how they're doing, and then my father he give me a piece of rock and make me play. And in this way I get interested in the trade, and as time was passing it was no more for play, it became for real." *Photograph by Morton Broffman*

Section of a sculpture studio, Pietrasanta, Carrara, Italy. The traditional stone carver's work did not begin and end at the stone shop doors; it was an integral part of everyday family and community life. "It was the whole atmosphere!" says Roger Morigi, born in 1907 in the village of Bisuchio in northern Italy. "When I first started carving that's all we ever dreamed about, that was it. You were surrounded by it. Even when people went to church, they would come out of church and there was a plaza where all the men would stop and talk, and that's all they used to talk about—carving. What this guy here was doing, what that guy over there was doing. You see, it was the whole atmosphere. You hear the old men talk, you listen, you try to emulate. . . . But now, there's no such thing no more, five o'clock you go home, goodbye, that's it." *Prints and Photographs Division, Library of Congress*

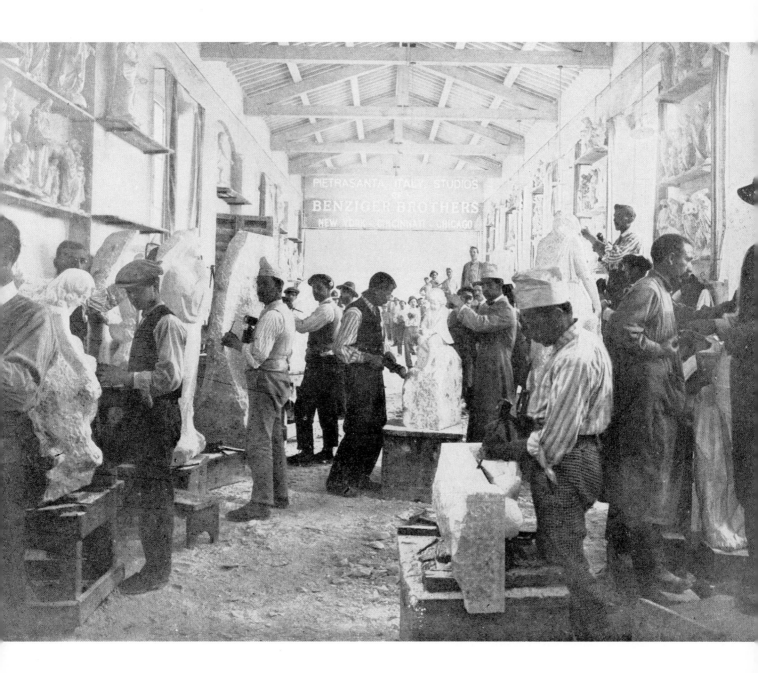

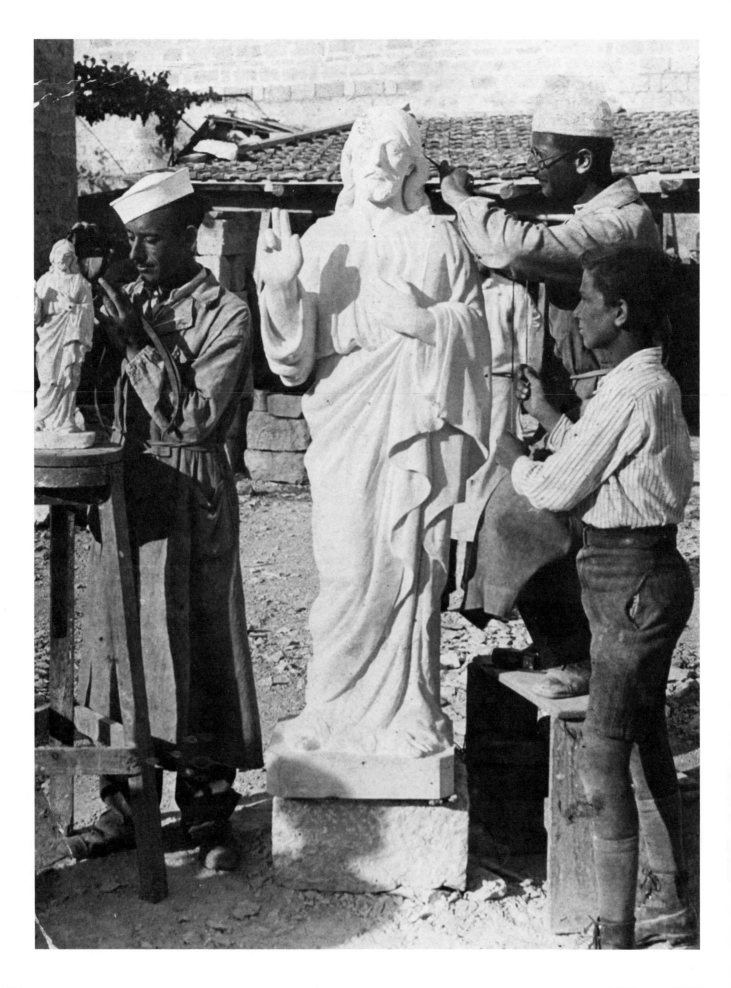

In the small world of the carving shop and in close interaction with the master carver, journeymen carvers, and his fellow apprentices, the carver systematically acquired his traditional skills, standards of workmanship, and aesthetic values. Here (opposite) Vincent Palumbo's father works with a young apprentice in their family stone shop in Molfetta, Italy. The old system of learning was rigorous and demanding, and the rules and stylistic criteria of the trade were deeply implanted in the apprentice's mind from the very first day of his seven-year apprenticeship.

Stone carver Constantine Seferlis from Sparta, Greece, describes the way new apprentices were ritually initiated into the workshop community: "I hear a lot of stories from the old people that the youngers have to start quite early and get into. And always they were under harsh discipline to follow instructions and patterns. And to break any ego, they used to trick them. The first thing they would try to introduce to him was to sharpen the hammer. They send him over and have him rubbing the hammer up on the stone, and all day they laugh at him, saying, 'That is a stupid thing you are doing, but you are good to follow what we try to tell you, because there is no room for mistakes in carving.'" *Photograph courtesy of Vincent Palumbo*

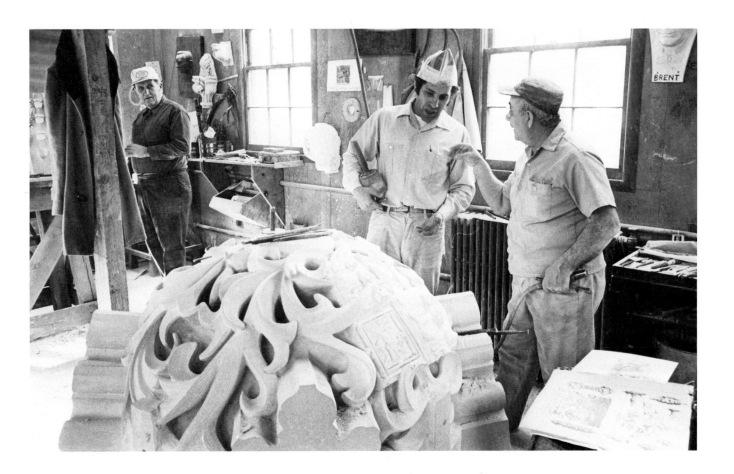

The carvers' world revolves around "working the stone." They are always watching one another work, talking about their tools and materials, comparing individual styles and techniques, and exchanging jokes and stories about their carving experiences and exploits. They continually perform for one another in stone, competing for the status and recognition accorded to skill and artistry. *Photograph by Morton Broffman*

As apprentices the carvers were taught to take pride in their workmanship and to strive for excellence. The learning process was characterized by observation and imitation and by years of practice and experience. "You are always learning, always learning," says Vincent Palumbo, "because every time you carve it's a different subject, a different type of stone. You are never complete!" Here Palumbo shows an apprentice how to use a file (below).

Over time each carver develops his own unique style of carving—he calls it his "touch." And yet, at the same time, his style is a composite of all that surrounds him in the carving work-shop, a combination of individual expression and community tradition. Roger Morigi says, "The main thing in carving, you *steal* carving. When I say *steal*, you see like you're in the shop and there are seven or eight apprentice boys, and there are carvers working there, too, so you watch one, you watch the other, you steal a little bit from one, you steal a little bit from another, then you put it all together yourself, you develop your *own* technique."

The stone carver's technique or "touch" is in fact his signature—the imprint of his personality. It is the vehicle by which he becomes one with his work. The good carver, like the good storyteller, does not change the structure or content of his work, but he can give it life and expression through his special "touch." Vincent Palumbo says of this work, "I like carving flowers, especially roses, because carving flowers you are completely *free*. You can twist the petals of the flowers so harmoniously. In other words, it's a challenge with the nature and the hardness of the stone to make the stone look like real. You've got to know how to give that feeling, even if it is on stone, that the flowers *move*. That's the challenge between the man working the stone and the nature of the flower. And that's very difficult; not too many can give that touch on stone." *Photographs by Morton Broffman*

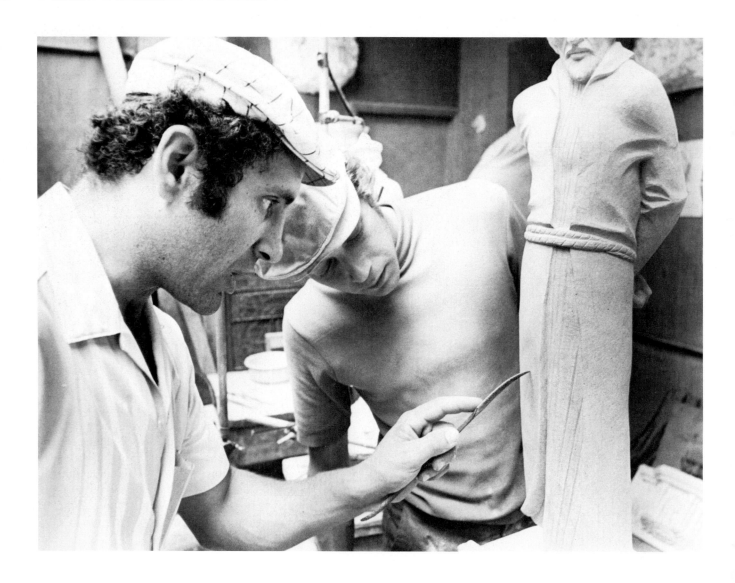

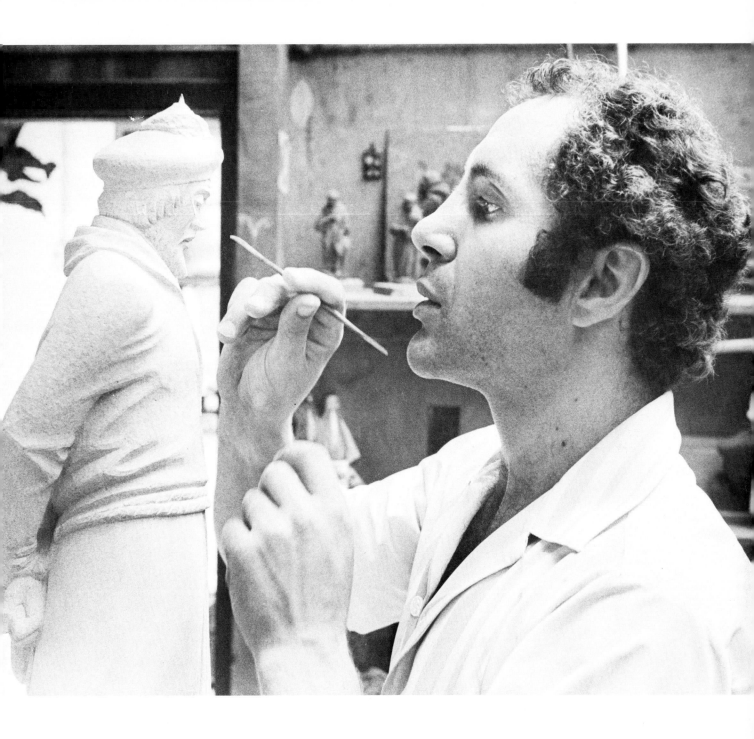

The carvers employ two basic types of carving: freehand carving for gargoyles, grotesques, flowers, finials, and crockets, in which the carver is free to express his own imagination in stone; and "working the model," in which the carver exactly translates a sculptor's clay model into stone. After a clay model is designed by a sculptor, the clay is cast into a plaster molding for the carver, who then transfers the image into stone. Here, Constantine Seferlis is shown in the carvers' workshop making a small clay model. *Photograph by Morton Broffman*

Opposite: Indiana limestone is used for most of the carving at the cathedral. Here workmen ease a huge piece of limestone into Roger Morigi's studio for the carving of the high altar. *Photograph by Morton Broffman*

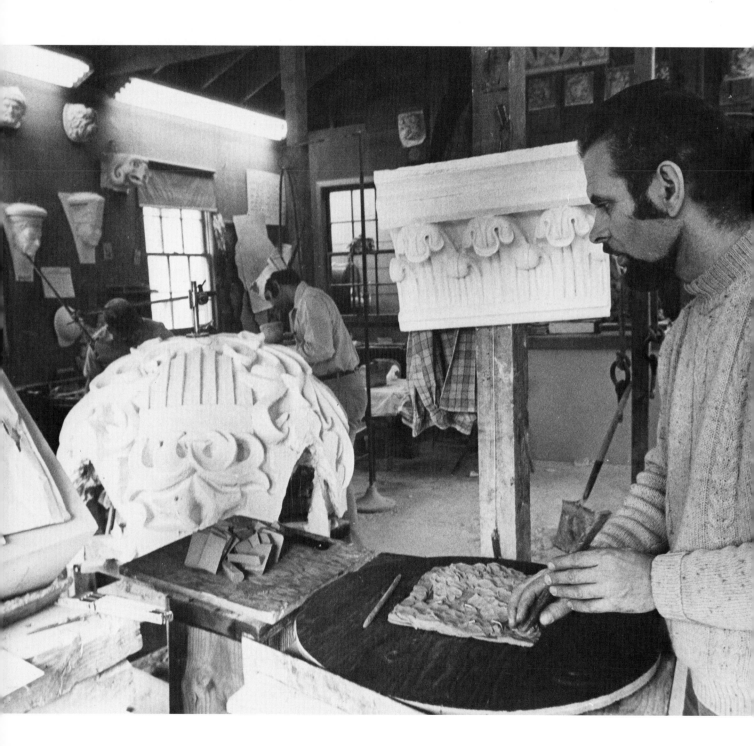

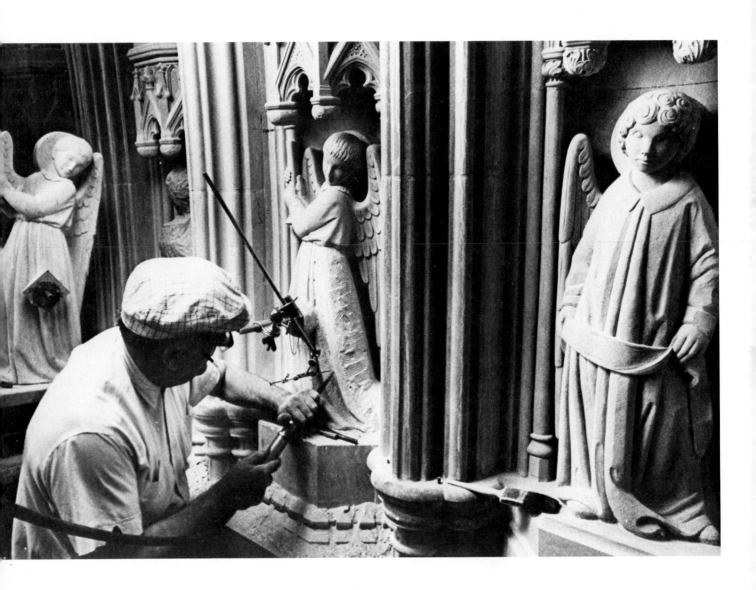

The carvers use a pointing machine to aid them. It tells the carver the depth to which he must carve at any given point on a statue. Before the pointing machine was developed, carvers used calipers. Under the arches of the cathedral's South Portal, Frank Zic, with pointing machine attached to the stone, carves to the required depth. The sculptor's model is on the left.

"When you work a model you've got to pay attention to the form and get the form like the model—you have to put in not your idea, but the idea of the sculptor. I try to understand and reproduce what is there, that's all. It didn't make any difference to me what it was—if it was upside down, but they put it like that, I'm gonna do it upside down. That's the way you like, that's the way you get!" With a close eye to the plaster model behind him, Roger Morigi uses a pneumatic hammer to carve the image of the Good Shepherd (opposite). *Photograph by Morton Broffman*

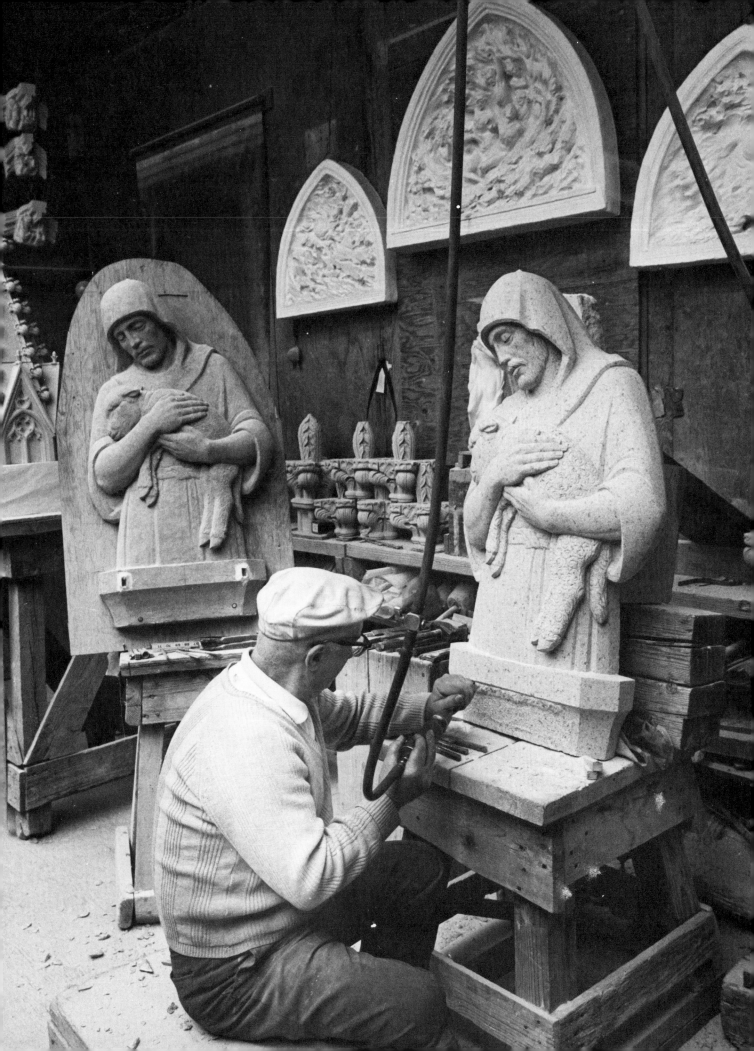

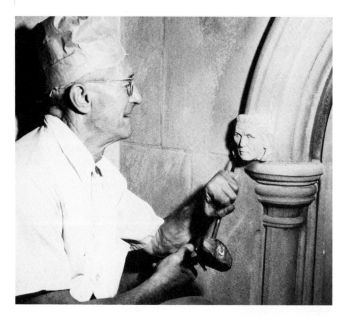

sense of freedom, connection, and challenge. They are able to exercise their own judgment and to express their thoughts and human spirit in stone. Roger Morigi says, "You cut and cut and all of a sudden you see something grow. The more you work, the better it comes out, you feel good inside. You work, it gets brilliant, you see it move . . . that's what makes the thing so encouraging. You carve and you see something else come out, and all of a sudden you say, 'Was it possible that I succeeded in doing something like that?' I don't know, it fills you with some kind of emotion—such a sense of satisfaction." *Photograph by Morton Broffman*

Above: The methods of carving and embellishing stone have changed very little over the centuries. Although today pneumatic hammers are used to speed up some of the rough-cutting, the traditional mallet and chisel must still be used on each piece. *Courtesy of the Washington Cathedral*

Right: Stone carvers view themselves as performers engaged in the skillful act of interpretation. "The sculptor is the composer," says Vincent Palumbo. "He creates whatever he has in his mind. And the carver is the performer. Our work is to transfer into stone what the sculptor creates in clay. But, nevertheless, on the carver goes much more responsibility, because the carver's doing the *finished* product." David Pye in his book *The Nature and Art of Workmanship* aptly describes craftsmanship as the "workmanship of risk." The carvers certainly attest to this: "The sculptor has the option with clay to put on and take off, but the carver's only got one chance and it's got to be the right one. If he takes off more than he's supposed to, he's ruined."

Opposite: As skilled craftsmen, the carvers have control over the process of creation, and thus the aesthetic possibilities of an object lie completely in their hands. Through the performance of skill, the carvers find a

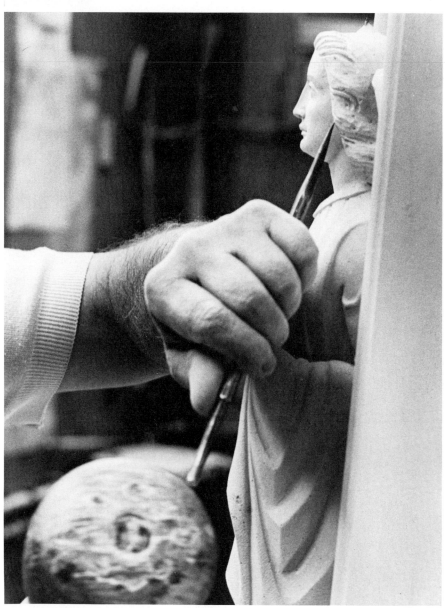

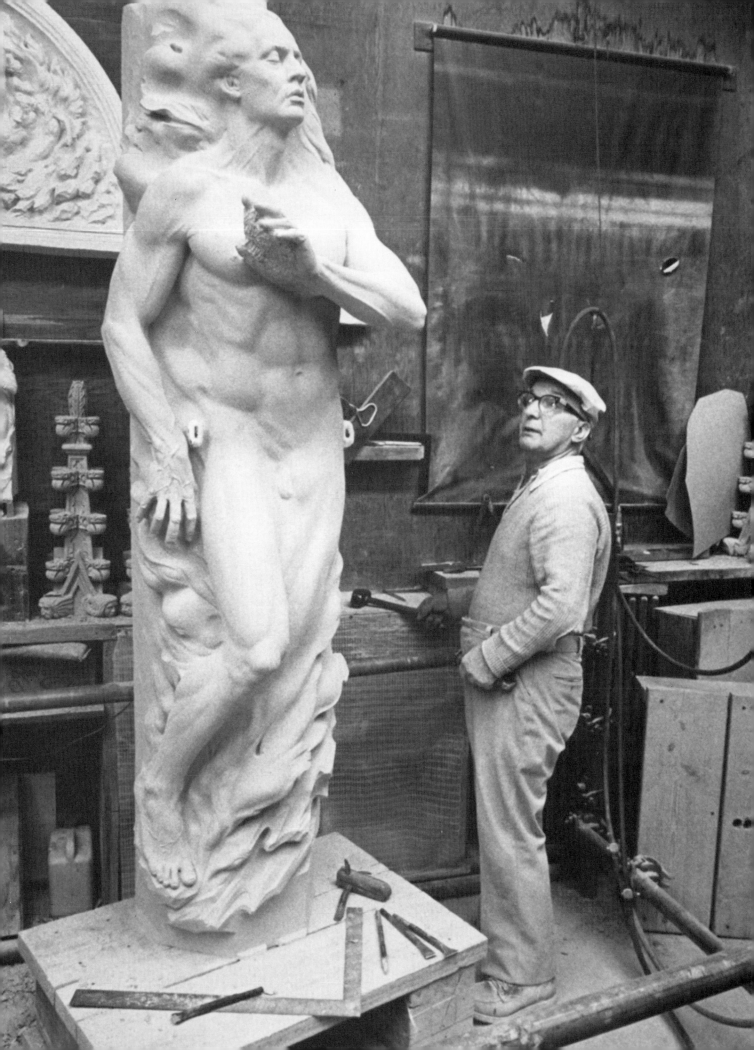

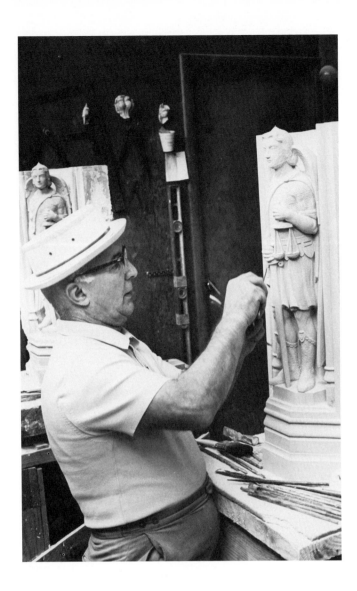

The meaning and pleasure of the stone carver's work is intrinsic to the act of making itself; to the "purposive acts of choice" that are integrally involved in a creative performance. The following exchange between stone carvers Roger Morigi and Frank Zic illustrates what John Ruskin called "delight in skill":

ROGER: Remember Scafaro, when we was working up in New York? We were carving the grotesques for Rockefeller Church on Riverside Drive, you know, those grotesques way on top of the door there. And for some reason or other, the way he was touching it, his, you know, "roar"—they came out like that—wild! You know, full of life. And mine, eh, they was all right, but they didn't have the life. I couldn't understand it. How the hell does he do it!

FRANK: Who was doin' this?

ROGER: Scafaro!

FRANK: The one with chewing tobacco?

ROGER: Yeah, one of the great carvers. He used to come to work with eight or ten tools. If you took one tool he had to go home because he couldn't work no more. So I watched him and I see the tools he used to give a certain touch and when he went to the bathroom, I went over and got the tools and I went and touched mine like that and that was it! And they was all broke up tools, I wouldn't use them to work, but they was the right tools for the certain thing. So when he came he was looking all over, looking all over. And I forgot that I'd taken his tools—so I went back and presented them to him and said, "Mr. Scafaro,"—because at that time older carvers, you call them "Mr."—"is that what you are looking for?" And he could speak English perfect, you never thought that he was Italian, you thought that he went to Oxford to learn how to speak English, that's how perfect he used to speak. And he said, "Yes." And I explained why I took them. And he said, "It makes my heart feel so good." And I said, "Why? I took your tools." And he said, "No because you are so interested to see how to make good work. Today, very few feel that way. To me, it makes me feel good!"

Photographs by Morton Broffman

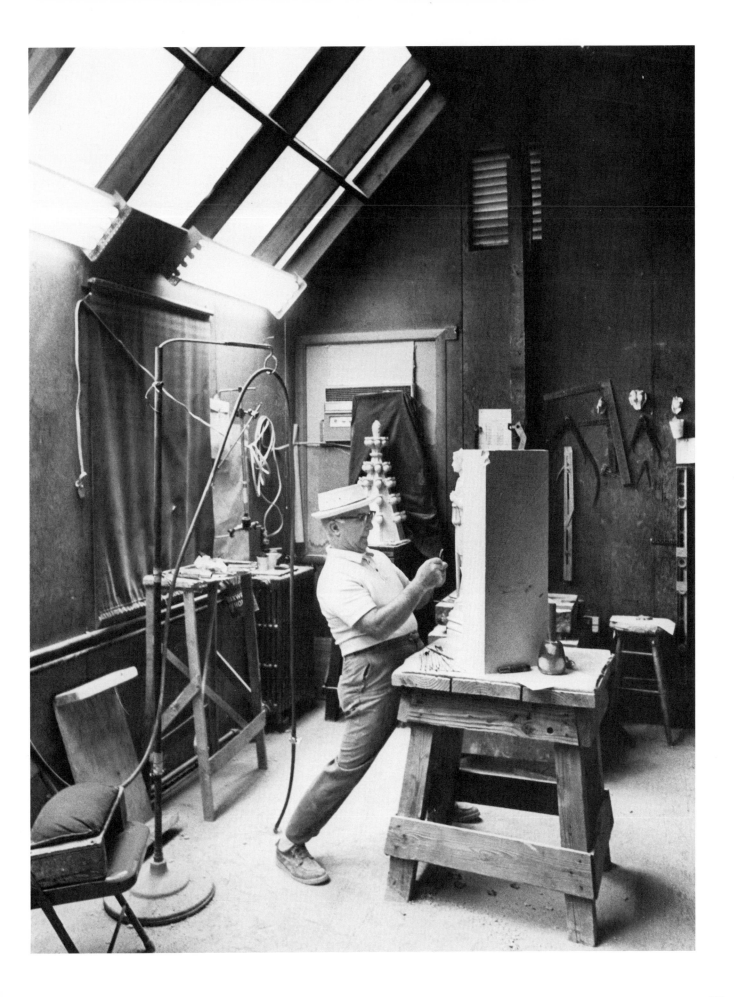

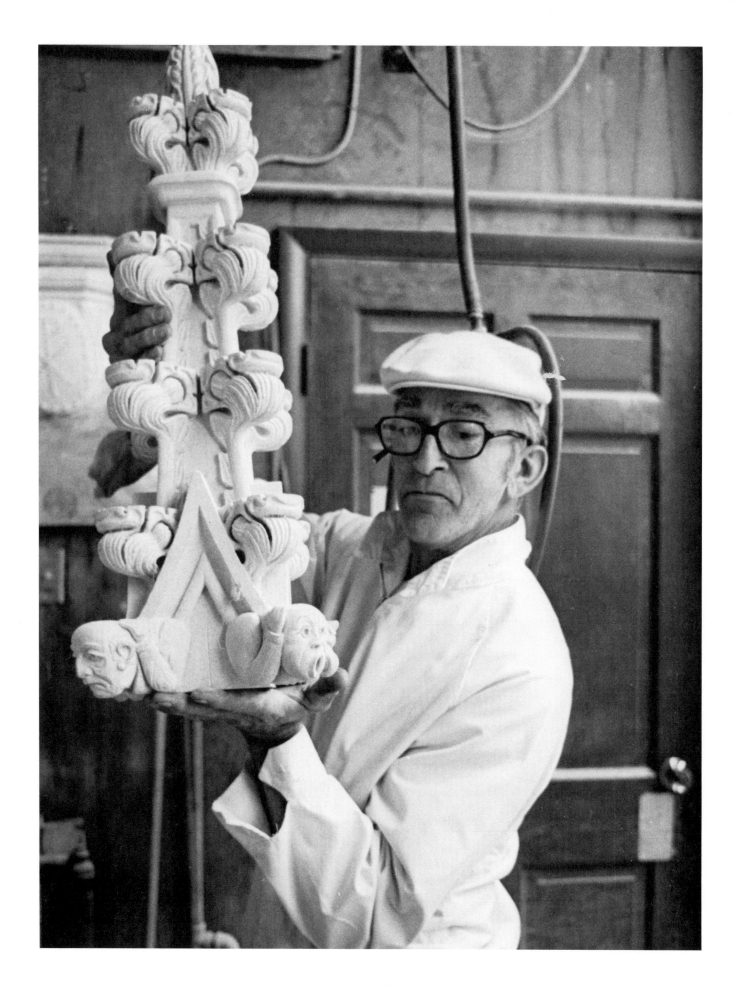

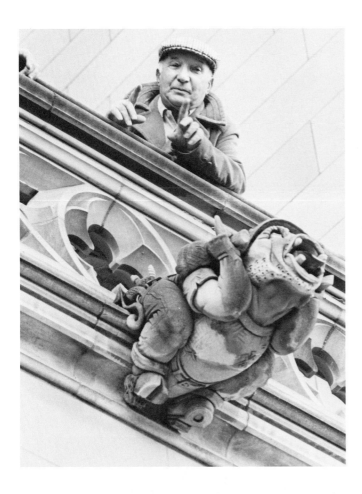

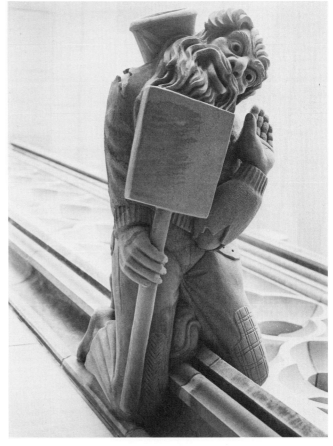

Opposite: In their free-hand carvings, such as gargoyles and grotesques, the carvers have the greatest latitude for creative expression. Each carving at the Washington Cathedral tells the story of what is important and meaningful to a community of craftsmen, and some tell stories of amusing incidents that have happened at the cathedral. This pinnacle depicts an argument between the master carver and his supervisor. *Photograph by Marjorie Hunt*

Above: Often the carvers themselves are depicted in stone. An example is this gargoyle of master carver Roger Morigi, complete with work clothes and tools. *Photograph by Larry Albee*

Right: Constantine Seferlis carved this hippie gargoyle during the 1960s. *Photograph by Larry Albee*

Vincent Palumbo meets retired stone carvers in the cathedral workshop for a luncheon reunion. The stone carvers at the Washington Cathedral are a community of workers who share not only the same traditional skills, knowledge, and aesthetic values, but the same daily experiences, the same customs, traditions, and good times. As Palumbo says, "Practically it was not work what we were doing; it was just living, everyday living." *Photograph by Paul Wagner*

Opposite: Frank Zic, Roger Marigi, and Vincent Palumbo pose as living statues in niches at the Washington Cathedral. *Photograph by Morton Broffman*

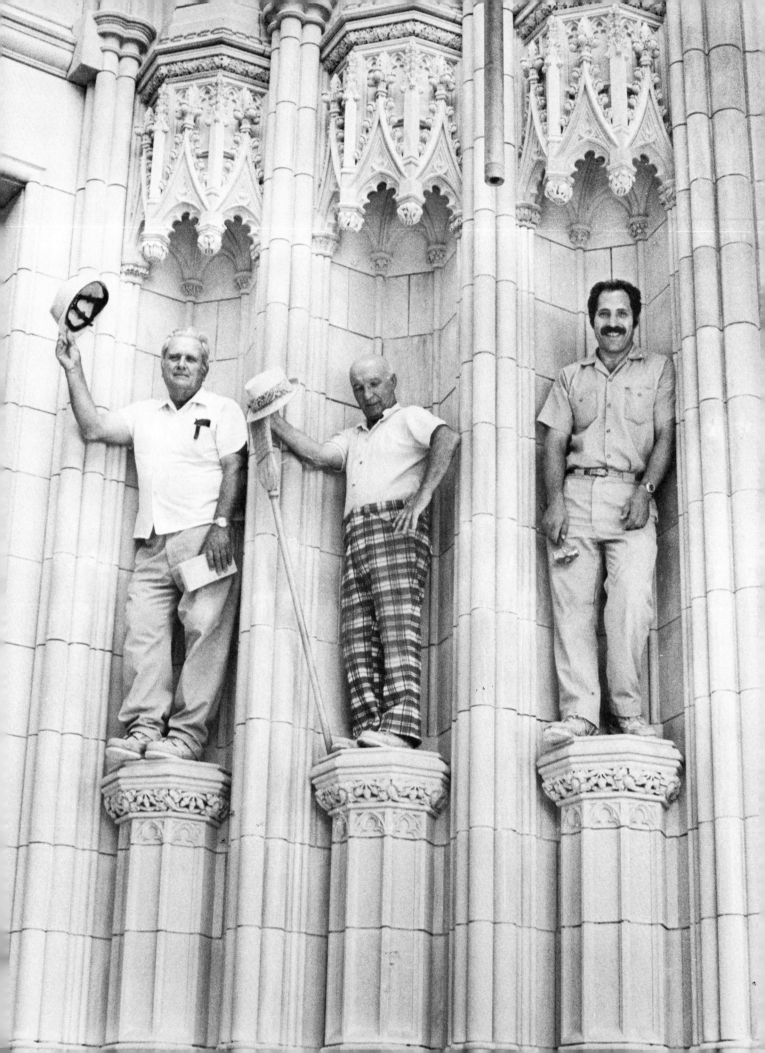

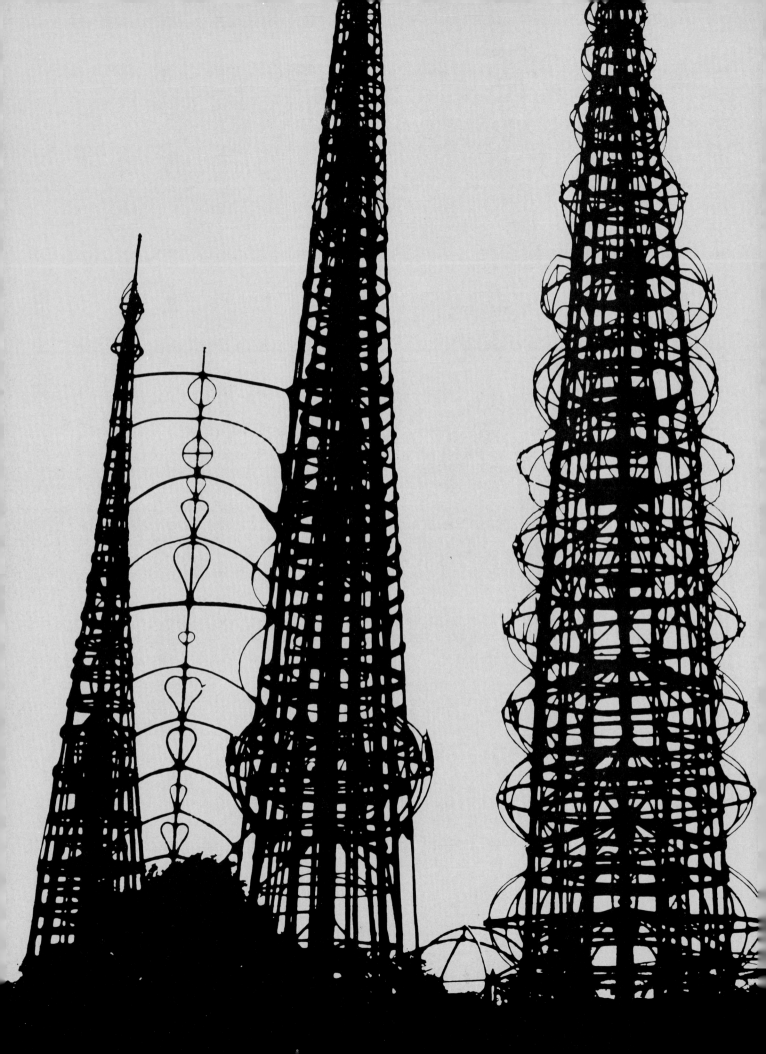

WATTS TOWERS AND THE *GIGLIO* TRADITION

By I. Sheldon Posen and Daniel Franklin Ward

This is a story with a punchline linking two seemingly isolated folk phenomena half a world apart. At one end is the southern Italian folk celebration of a Catholic saint's feast, the roots of which have usually led scholars back to ancient Greek myth and Dionysian worship. At the other end is a Los Angeles "environment" built by a supposed "crazy," which for

years nobody has been able to make head or tail of. It is now possible not only to speak of these two phenomena in the same breath, but to show that they are pieces in the same puzzle. This has come about because of the chance crossing of two paths of folklore scholarship, one in Los Angeles itself, the other midway between southern California and southern Italy, in the borough of Brooklyn, New York City. What those two paths were, how they crossed, and what it all means are the meat of the story.

It begins in Brooklyn. In January 1981, two University of Pennsylvania graduate students in folklore, Maxine Miska and I. Sheldon Posen, were hired for two years by a consortium of Brooklyn cultural institutions to survey the folklore of the borough and produce public programs based on what they found. The project was funded by grants from the National Endowment for the Arts and the National Endow-

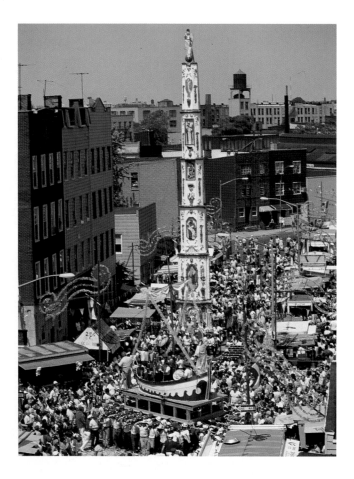

ment for the Humanities. One of the first steps Miska and Posen took was to retain New York photographer Martha Cooper, since a major aim of their project was documentation that might lead to a photographic exhibition of Brooklyn's folklore. They also hired part-time field researchers to work with particular ethnic groups or to cover specific folk events over the next two years. Their first chance at a major study of Brooklyn traditions came in the summer of 1981 with the celebration of the Feast of St. Paulinus in the Italian-American section of Williamsburg, a neighborhood to the northeast in the borough. Miska and Posen heard that a spectacular display would take place during the feast in the streets in front of the Church of Our Lady of Mount Carmel. They decided to cover the feast as thoroughly as possible and hired Joseph Sciorra, an anthropology graduate of Brooklyn College and a folklore enthusiast, as principal liaison with the community and field researcher on the feast; Posen would direct the work and assist Sciorra when possible.

The celebration proved to be even more rewarding than they had been led to expect—a rich and complex neighborhood event that centered on an annually erected tower some six stories high, weighing over three tons, called the *giglio* (pronounced *JILL-yo*). On three days during the feast, as hundreds of people from the neighborhood and the city watched and cheered, the gaily painted, gracefully tapering *giglio* was "danced" through the streets in front of the church on the shoulders of one hundred and twenty men. A street band riding at the base of the *giglio* provided the music. A second giant structure was part of the festivities as well—a great medieval-style galleon, outfitted with another band and several characters dressed in costumes reminiscent of "The Thief of Baghdad," complete with turbans and scimitar. Riding in their boat as the band played, they too were carried by one hundred and twenty men. The *giglio* and boat were danced separately on different days, but for the climax of the feast they were danced together so that they met at the crossroads before the church, their bearers' hands linking for an instant. The participants explained why this was done by referring to the statue of St. Paulinus atop each structure, and to the legend associated with him.

According to the parish priest, Paulinus was the patron saint of the small village of Nola, near Naples in southern Italy, the ancestral home of many of the Brooklyn community's residents. In the fifth century, while Paulinus was bishop of Nola, Vandals pillaged the town and carried many of its inhabitants off to northern Africa in chains. Paulinus himself was a captive, having volunteered to take the place of a

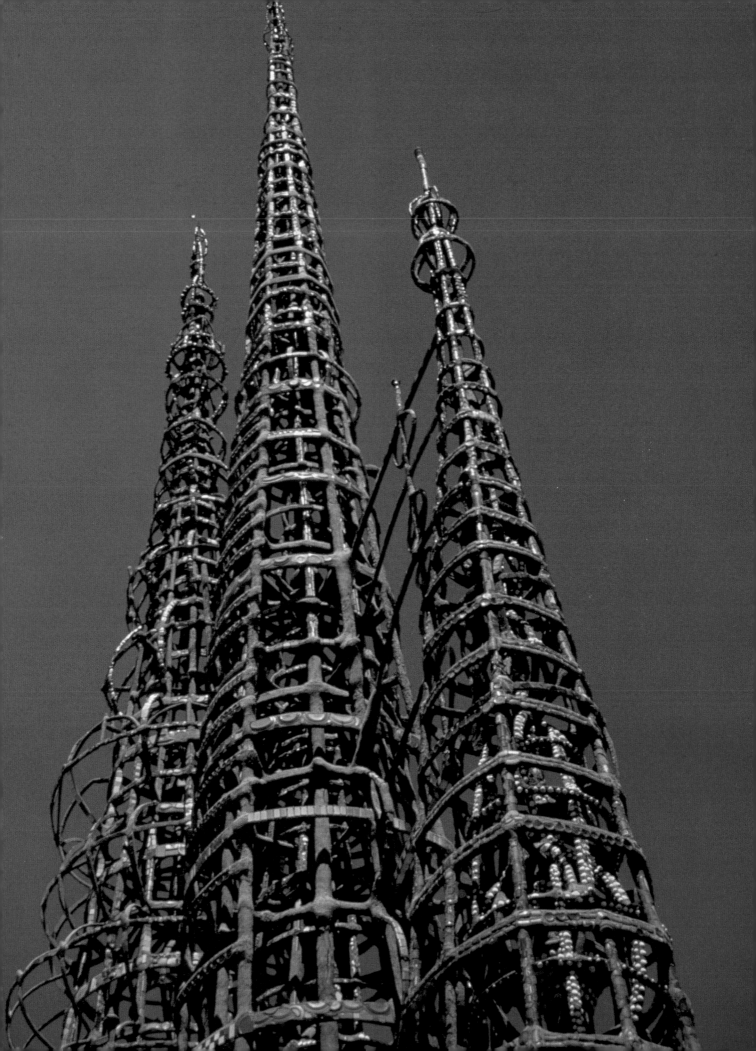

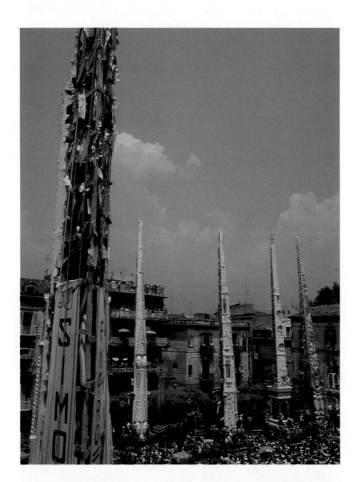

Left: Towers, Nola, Italy
Bottom left and opposite: Dancing the "ship" through the streets, Nola, Italy. *Photographs by G. Roli. Courtesy of* Atlante, *Istituto Geografico de Agostini*

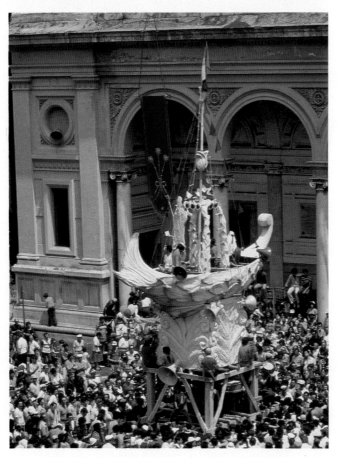

widow's only son. He was made a slave to a confidant and adviser to the Vandal king. "One day," said the priest, "Paulinus did the king a service: he interpreted a dream for him and foretold his future. As a reward for this divine gift, the king set Paulinus free, along with his fellow townspeople." They all returned to their village, accompanied by a Turk who had also intervened on their behalf. Their ship was greeted at dockside by the joyous villagers who bore "mountains of lilies" to welcome them. Every June 22 since that time, on the anniversary of the miraculous return of Paulinus, the residents of Nola and their descendants, wherever they may be, have erected the huge towers or *gigli* (meaning "lilies" in Italian) and danced them together with a galleon bearing a statue of the saint and a costumed Turk. On a gigantic scale, they are reenacting the miracle of Paulinus returning to his people.

Sciorra was able to ascertain that the *giglio* and boat had been danced in Brooklyn since about 1920, though some residents say it began just before the turn of the century with the arrival of the first immigrants to the neighborhood from Nola. Since the *giglio* is an old-world custom transplanted to the new, and since many Brooklyn residents maintain their ties with Nola and visit from time to time, Posen and Sciorra decided to find out as much as they could about the celebration there. They already knew, from a photograph on the wall of a Brooklyn cafe, that not one but eight *gigli* were built and danced every year in Nola. One of the few books they were able to find on the subject, *Chi 'e devoto: Feste popolari in Campania,* supplied more information. The custom of dancing the *gigli* in Nola, it said, has continued since medieval times. Now, each of the eight tall towers is sponsored by a group representing one of the old guilds—"market-gardeners, pork-butchers, innkeepers, bakers, butchers, cobblers, tailors, and smiths." The groups vie with one another in designing their *gigli* and in the dancing of the crews of lifters whom they hire for the day's celebration. During the feast, the crews bear the *gigli* through the narrow streets of Nola, the residents filling the air above them with confetti, and "amid the deafening music of the bands, nowadays reinforced by loudspeakers, the eight *gigli* and the ship with San Paolino and the Turk arrive in the cathedral square" in the center of town. There, to the delight of the thousands who have come from Naples and the other neighboring communities, the teams of lifters put the *gigli* through intricate, almost acrobatic, maneuvers with each other until, at evening, they are returned in procession to their separate quarters in the town. "The next day, they will emerge again, but this time they will be carried not by paid squads but by the

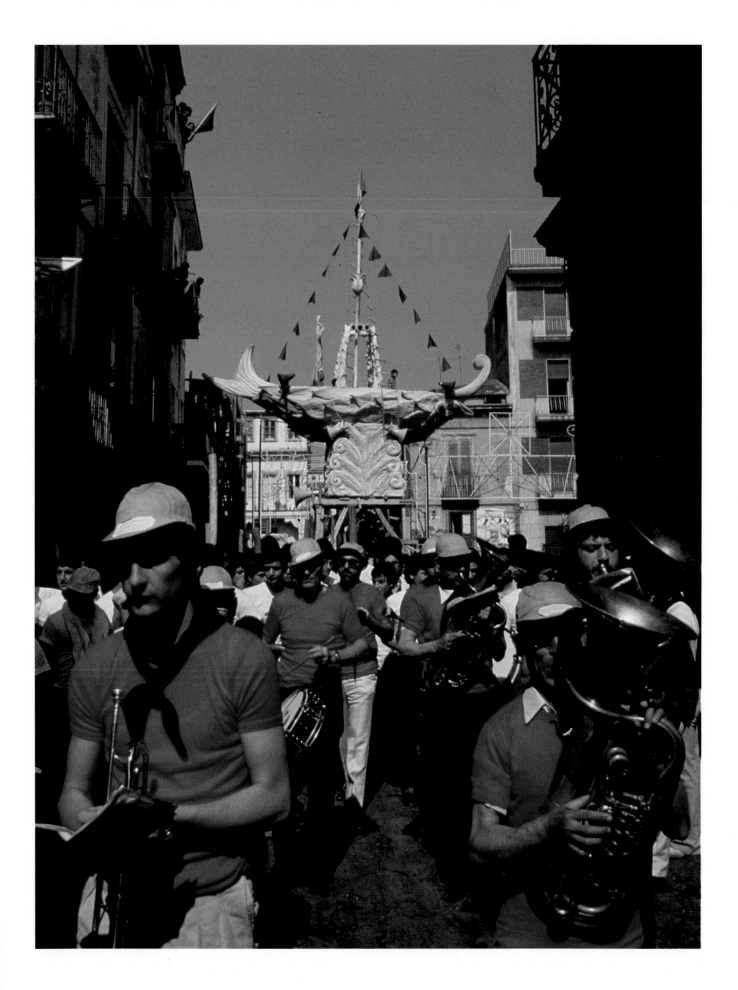

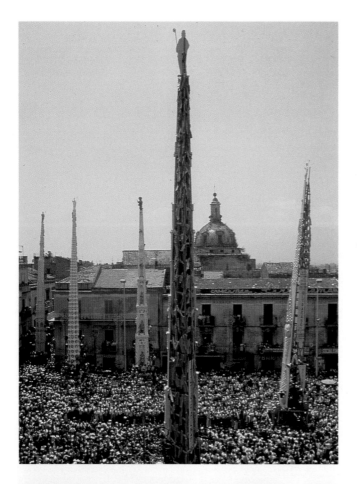

Left: St. Paulinus atop the towers, Nola, Italy. *Photograph by G. Roli. Courtesy of* Atlante, *Istituto Geografico de Agostini*
Bottom left: Tower for the Brooklyn festival, 1983. *Photograph by I. Sheldon Posen*
Bottom right: Statue of St. Paulinus for the top of the Brooklyn tower. *Photograph by Martha Cooper*

people of Nola, who will proudly *rock* the towers as *much* as possible and then show the bruises on their shoulders and the effects of a special muscular cramp called the 'corn of San Paolino.'" At the very end of the celebration, the towers are stripped of their ornaments, thrown over, and destroyed.

In addition to the manner of celebration, other points of comparison between the Nola and Brooklyn feasts were of interest, including the way the *gigli* were constructed. In each location, the towers had to be tall and graceful yet able to withstand the stresses of being lifted, turned, swayed, jolted, and roughly dropped during the various maneuvers of the dancing. (One found in both Nola and Brooklyn is a *numero due*—number two. The *giglio* is dropped to the ground and lifted again in the same motion, and the strain is severe on both the lifters and the structure.) The basic *giglio* construction, the researchers found out, was the same in Italy and Brooklyn: papier-mâché panels were built separately and hung on a four-sided, tapering, steeple-shaped framework.

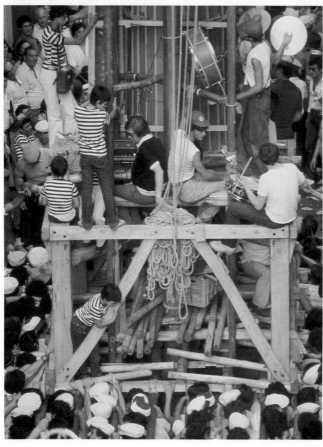

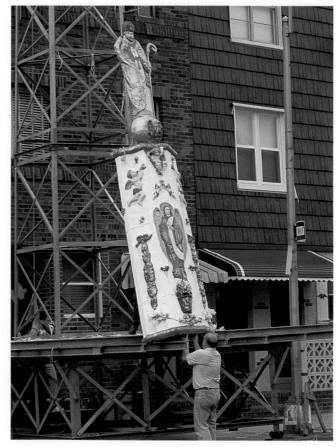

But there were important differences between the *gigli* of each place which Brooklyn residents described in talking about the history of the feast. In Brooklyn in recent years, they said, as skilled labor grew more and more scarce and expensive, the *giglio* framework material was changed to aluminum girders which could be quickly assembled or dismantled by a relatively inexperienced crew and reused year after year. Originally, a skilled carpenter had built the frame anew each year out of short pieces of lumber. As one man remembered, "he built it from the ground up, the pieces all crisscrossed and interlocked, because you're going up eighty, ninety feet in the air—the *giglio* was higher then." Another man remembers the craftsman, forty feet in the air atop the open, half-finished frame, calling down to his assistant, "'Throw up a piece eighteen inches' or 'sixteen inches,' whatever length he needed at that point to build the next level." A rope hung from the statue of St. Paulinus at the top of the *giglio*. It was tied off every thirty feet with foot loops formed in it so that men could ride there, squeezed inside the frame, while the *giglio* was being danced. "That way," said one of the older men, "when the *giglio* was dropped, the statue wouldn't flop off."

At first glance, the *gigli* in photographs of the Nola festival look very similar to the Brooklyn structures. But the Brooklynites pointed out the differences. "In Italy," they told Sciorra, "they put a pole in the center; over here, we didn't. Over here, the lumber is a little different—it's a little harder, a little stronger, so we did away with the pole. Over there, they used to nail everything around the pole as they went up. When we made it over here, we eliminated the pole, and so it was a lot lighter." The Nola *giglio* frames continue to be constructed in the old manner, around a central pole.

Covering the feast in Brooklyn proved to be an exhilarating and grand undertaking. While Cooper photographed every stage of it, from the preparations through the dancing to the dismantling of the *giglio*, Sciorra tape-recorded interviews with almost all major feast personnel and with Posen's help spoke with dozens of participants, observers, and neighbors while the feast was under way. Initial coverage was complete enough that, in April 1982, Posen was able to put together a slide presentation on Brooklyn's *giglio* celebration for the annual meeting of the New York Folklore Society at the American Museum of Natural History. In it, he outlined the workings of the feast and made a case for seeing it not only as a reenactment of the St. Paulinus legend but as a playing out of the major values and concerns of the feast community. At the suggestion of several colleagues, Posen

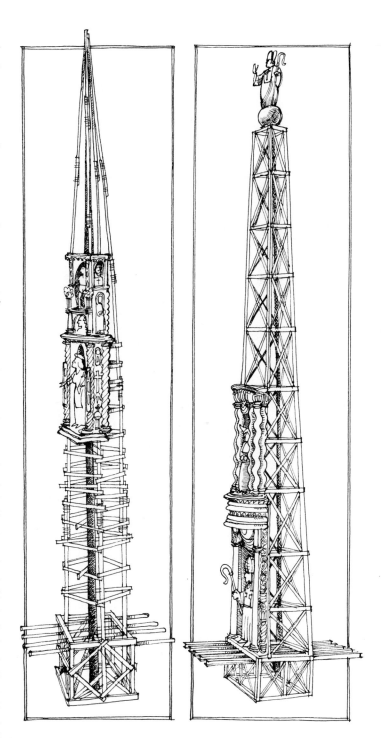

Brooklyn and Nola towers differ somewhat in construction; for example, the Italian tower (left) still uses a central pole, eliminated in the American version (right). *Drawings by Jan Adkins*

Simon (Sam) Rodia about 1950. *Courtesy of Daniel F. Ward*

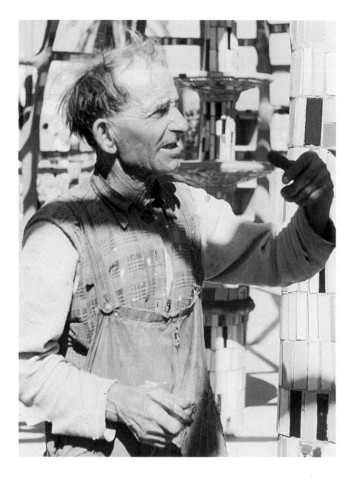

submitted the slide-show script to the museum's *Natural History* magazine, hoping they might be interested enough in an article that they would fund the coming summer's research on the feast. Not hearing from them, Posen, Sciorra, and Cooper covered the feast again on their own, taking more photographs, conducting more interviews, and honing their ideas on the celebration and its meaning. In the fall of 1982, *Natural History* accepted the idea of an article. Posen rewrote his script, checking with Sciorra at every point for facts and interpretation, then submitted it to the magazine along with Cooper's selection of her best slides. The article appeared in June 1983 under the byline of all three members of the research and documentation team. Its title was "Brooklyn's Dancing Tower."

The article contained one element the team had not planned on. It is a policy of *Natural History*, several months ahead of time, to solicit photographs through professional

channels on topics to be covered in upcoming issues. Not long before the *giglio* article went to press, the magazine editors received an entire shoot of the festival in Nola and decided to incorporate selected photographs within the Brooklyn story. They paired pictures of each place in an attempt to show parallel scenes: Brooklyn lifters, Nola lifters; long shot of Brooklyn *giglio* and boat in the streets before the church, long shot of Nola *gigli* in cathedral square, and so on. The result was that the Brooklyn and Nola celebrations of the Feast of St. Paulinus and their respective *gigli* were given national exposure in both print and photograph.

The story now shifts to the west coast of Canada and to August 1982, two months after the *Natural History* article appeared. Posen was in Vancouver for the International Congress of Anthropological and Ethnological Sciences, presenting his *giglio* slide show as part of a cross-cultural panel on religious processions involving monumental objects. After the lights had come on and the question period was over, Posen was approached by a man who introduced himself as Daniel Ward. He too was in Vancouver to present his research findings on a seemingly unique artifact that is constantly referred to as an outstanding example of folk art: Simon Rodia's famous "Watts Towers" in Los Angeles. It was in this regard that he wished to speak to Posen and he had astonishing news. Ward said that two months previous, some friends of his called to tell him that the Watts Towers, the topic of his doctoral dissertation in the American Culture Program at Bowling Green State University, had just appeared in *Natural History*. They said that there was a picture of the towers and some other "things" that looked like them in New York City. Suspecting that this was yet another of the shallow attempts to place the Watts Towers in a category with hot-dog-shaped hot-dog stands or so-called "folk art environments," Ward did not rush out to buy a copy of the magazine but made note of it. Several weeks later, at a meeting of the Committee for Simon Rodia's Towers in Watts, a member of the committee commented that there were some portable towers in Brooklyn that looked something like the Watts Towers and that photographs of these New York towers were in the recent *Natural History* magazine. Ward looked up the magazine at the library the next afternoon.

He quickly turned to the Brooklyn *giglio* article. "I took a glance at those pictures," he said, "especially those tall slender towers, and realized that this was the article that my friends called last month to tell me about—the one with the Watts Towers and 'things' like them. I looked again though, because I'd never seen so many people standing around the

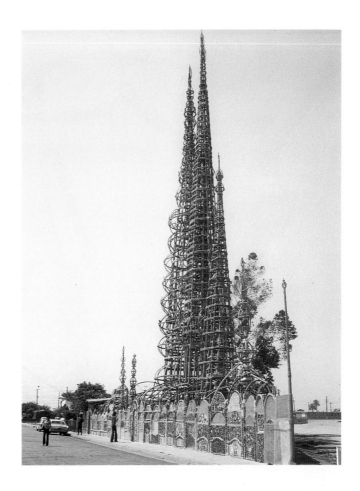

Watts Towers in Los Angeles. Surrounded by a mosaic wall that runs along the sidewalk, the overall site has the look of a ship. *Photograph by Seymour Rosen*

Watts Towers. Then I noticed the tall buildings behind the towers. Hardly anything in Watts is more than twenty feet tall, and there are no buildings behind the Watts Towers because that is where the railroad tracks are." Only on closer examination did Ward realize that he was not looking at Rodia's Towers. These were some towers in Italy.

Ward told Posen that he read the article with growing excitement: connections were being made in his head. "It just rang bells all over the place—the towers, southern Italy—but the clincher was the boat." For some reason that he never explained, Sam Rodia built a boat shape into his sculptural complex. He often referred to it as the "ship of Columbo" or "ship of Marco Polo" when visitors asked about it. Additionally, the entire Watts Towers complex looks very much like a ship with tall masts when viewed from the outside, particularly from the east tip of the tall walls surrounding the wedge-shaped Rodia property in Watts. The similarity of the form of Rodia's concrete structures to the Italian *gigli* was uncanny and, coupled with the use of a boat shape and the fact that the Nola celebration was near the place where Rodia spent his childhood, made it nearly impossible to rule out some connection between the Watts Towers and the processional towers in Italy.

The Watts Towers and their Italian immigrant builder have been tantalizing folk art scholars, Los Angeles city officials, and journalists like Calvin Trillin for decades. In 1959, the Eleventh International Assembly of Art Historians declared them the "paramount achievement of folk art in the United States." The same year the City of Los Angeles battled with its own citizens in an attempt to have the nonconforming structures demolished. The citizens prevailed and the Watts Towers became the anchor for attempts to "culturally revitalize" the impoverished Watts district of Los Angeles during the riot-torn years of the Great Society. The Watts Towers became a major tourist attraction in southern California, and they came to be accepted as important to the growing art community of Los Angeles. Most often the museum curators, artists, journalists, and scholars called the Watts Towers folk art. Folklorists, anthropologists, and others objected and pointed to the folly of labeling a unique artifact of this type "folk art."

The question boiled down to an argument over whether a common but imprecise use of the term *folk art* should be tolerated. Folk art authority Louis C. Jones suggested at the 1977 Winterthur Museum folk art conference that a compromise might be appropriate. Jones proposed that those artifacts accepted by everyone as folk art be thought of as "inner circle" works, and that those artifacts that are often but imprecisely called folk art—artifacts like the Watts Towers and schoolgirl art—be placed in an "outer circle" with the understanding that they may be classified as folk art only because they have for so long been called by that name. This proposal was rejected by the majority of the folklorists. In the Winter 1980 *Winterthur Portfolio*, folklorist John Vlach discussed the Watts Towers in an article surveying the study of American folk art. Vlach points out that the Watts Towers might better be thought of as contemporary sculpture, because they are simply not the product of any tradition of folk art production. Because they are the product of one man, working alone in isolation from any community, and because there is nothing like them anywhere else in the world, they cannot and must not be classified as folk art.

Despite the terminological debate, numerous amateur writers, scholars, and journalists continued to churn out articles and books grouping the Watts Towers with a perceived

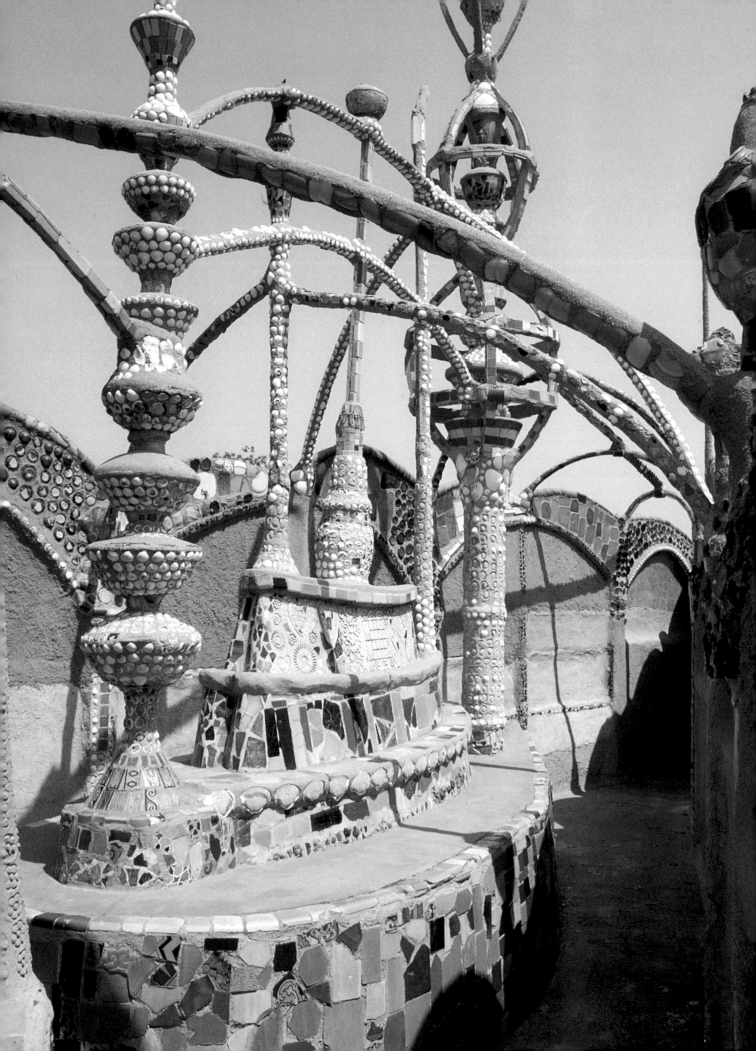

genre of "folk art environments" or "visionary" art. Yet Ward, a folklorist, remained steadfast in his desire to study the Watts Towers folklorically. Remembering what he heard during his own post-World War II childhood in southern California, Ward found the oral traditions surrounding Rodia's towers fascinating. He was told that "Tokyo Rose lived there and those were the broadcast towers for her programs" and "that man who built the Watts Towers was a spy for the Japanese." To a youngster like Ward, and probably to many adults, these legends all seemed true. The Watts Towers *did* look oriental. In Watts other oral traditions were tested by believing youths. Hundreds of plates, tiles, and shells decorating the surfaces of Rodia's work were systematically smashed by Watts children in attempts to locate a hidden fortune. Other Watts residents believed that Rodia's wife was buried beneath the massive monument. While it was the rich oral tradition surrounding the artifact that attracted Ward to the serious study of the Watts Towers, as preliminary research progressed the "folk art problem" continued to be raised. Why, Ward wondered, were people still calling these unique artifacts folk art?

To know that an artifact is a folk artifact, one must know the processes that generated the artifact. A folk artifact is not merely an object created by one of the "folk," but a material product of the folk process, a physical manifestation of the interplay of tradition and innovation, an inherently pragmatic mixture of communally accepted convention and situationally demanded invention. Although Sam Rodia was thought to be something of a "crazy" by many viewers of his work, few would have argued that he was not also "folk" by any definition of the term. Calling the Watts Towers "folk" art, however, raised the problem of Rodia's marginal position in the community of Watts. There were no other Italians around. How could Rodia and his work operate within a tradition if he was alone in his world?

Ward found that very little was known about the builder of the Watts Towers. He apparently had many friends, but most were dead by the time Ward began to seek them out. The only published information on Rodia depended on largely fictional newspaper reports and articles designed to make the Watts Towers seem more colorful. Official fact sheets given out at the towers also relied heavily on these reports — unverified oral traditions and embellishments and fabrications of boosters of the towers. For example, nearly all reports give the source of Rodia's livelihood as tilesetting, though no evidence of this has ever surfaced. It is even unclear why Rodia's name is said to be Simon because nobody living today who knew him ever called him by that name. He was known as Sam to everyone but those of his boosters who saw his towers before they met him. They continue to call him Simon. His Christian name and place and date of birth remain in dispute, but family tradition places his parents in a small village outside of Naples, Italy, in the late 1870s. Rodia's parents were property owners, and they are said to have sent their sons to America to avoid the Italian conscription. Rodia joined an older brother in the Pennsylvania coal mines until an accident took the brother's life. After that he traveled, taking a variety of unskilled jobs until about 1900, when he married and started a family. The marriage failed and a divorce became final in 1913. Again free to travel, Rodia moved around the country working odd jobs that included one, he claimed, at the famous Holy Ghost Grotto in Dickeyville, Wisconsin. By 1919, he settled in Long Beach, California, and took steady employment with a construction company. While in Long Beach, Rodia built some concrete structures near his house that were decorated in a fashion similar to his later structures in Watts, but there were no towers. In the early 1920s, Rodia began work on his Watts environment.

When Rodia moved to Watts it was a rural community between Los Angeles and Long Beach. He remained in Watts for most of the time between the commencement of his work and his abandonment of the project in 1954. During this period he was employed, usually as a construction laborer handling and placing both plain and reinforced concrete. He worked on his lawn decorations and towers in his spare time. It is clear from documents that during this time he was intensely concerned with religion and that he may have performed baptisms in fountains in his gardens but that he was not respectful of the Roman Catholic Church. An early published newspaper interview with Rodia suggests that immediately before beginning the work on his garden, he was a heavy drinker. His ability to interact with the other members of the Watts community seems to have decreased as the community become a densely populated black ghetto during World War II. Nonetheless, Rodia continued to work an average of eight hours every day, including holidays, on his towers. In 1954, Rodia sold the Watts property to a neighbor for enough money to purchase a bus ticket and moved back to Martinez, California, where he had some family. From that time until his death in 1965, he never returned to Los Angeles and, with the exception of comments he made one evening, refused to discuss his towers in Watts.

Fortunately, the one time Rodia answered questions about his Watts project, a young engineer tape recorded his comments. The recording was made at the University of Califor-

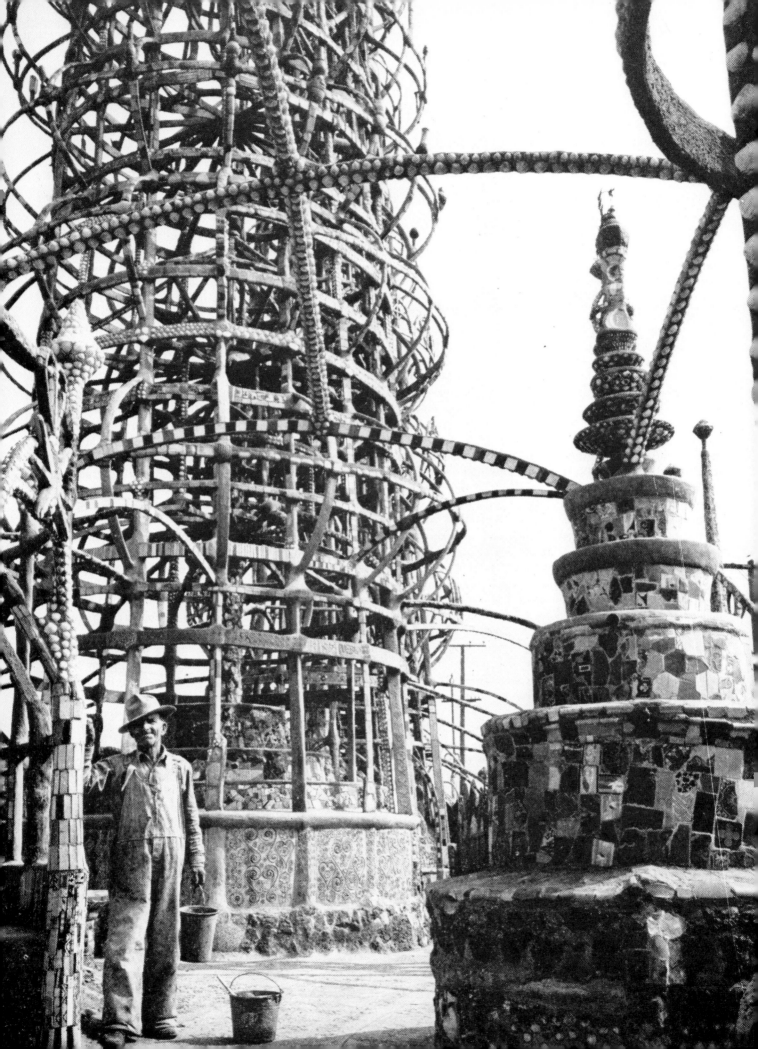

Opposite: Simon Rodia. *From* Arts and Architecture Magazine, *July 1951. Photograph by James Reed*
Below: Tile inlay on the Watts Towers' south wall. *Photograph by Jeanne Morgan*

nia, Berkeley, where a film of Rodia finishing the Watts Towers was being shown. The film was made by a student at the University of Southern California, and some members of the Committee for Simon Rodia's Towers in Watts invited Rodia to attend the film with them. He reluctantly agreed to do so. When the film began and the first image of the Watts Towers appeared, Rodia jumped out of his seat and pointed to the screen, proudly exclaiming, "That'sa my tower!" Following the showing of the film, Rodia talked briefly with members of the audience, who were primarily interested in his technique. He attempted to describe his sources of ideas and the inventive methods he devised to decorate the surfaces of his structures. He was never asked where he got the idea for the tower structures.

Many years earlier, when he still lived in Watts, Rodia was asked by one of his neighbors where he got his ideas. He told her that he got them from things he saw in Italy when he was young. He did not tell her what it was he saw in Italy. Perhaps he saw the *gigli* and boats at the celebration of St. Paulinus in Nola during a visit or while en route to Naples, his port of exit to the New World.

It is precisely this possibility that Ward was presenting at the Vancouver congress. Rodia was not some kind of "crazy" building a fantasy world for himself to live in to the exclusion of everyone else. Everyone who knew Rodia admitted that he had problems communicating with people, as a result of a language barrier that he never quite overcame. It was difficult for him to explain himself, his creations, his worldview, and his memories to either his English-speaking boosters or his Spanish-speaking friends. He did not know their words well enough to tell them anything but "that'sa new style tower" or "that'sa ship of Columbo" in his broken English. When Rodia talked, he talked about those things that concerned him the most — the breakdown of the family as the center of society, the high cost of getting by in a world where everything was too expensive, the way modern women were all dressing like

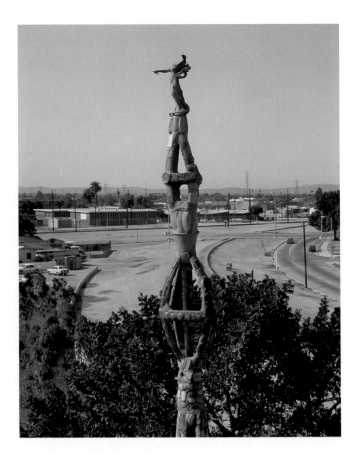

prostitutes. He did not seem to be a man who had lost touch with reality so much as a man who longed for a time when traditional values ruled. He retained his Italian worldview throughout his life.

Why would such a man build something like the Watts Towers? It is difficult to answer the question, but there are a number of possible answers. Perhaps he built one initially to see if he could do it. If Rodia had seen the celebration in Nola or some other community in Italy, he would have realized that the men most visibly associated with the *gigli* commanded great respect. Perhaps Rodia even knew the builders of the *gigli*. Using the materials with which he was familiar, reinforced concrete and stone, Rodia may have attempted to recreate the Italian *giglio* in the hope of receiving some appreciation from his neighbors or friends. Having done so, Rodia went on to build better towers, one after the next. The earlier towers were experimental prototypes, each failing in some respect. The final tower was the masterpiece, although it resembles the *giglio* the least.

Another possibility is that Rodia saw, or came to see, the *giglio* as a model for something useful in the construction industry. If he had watched the construction of *gigli* in Italy before emigrating, his work with reinforced concrete at various construction sites in California could have prompted him to experiment with those materials for some reason, possibly hoping to invent a new building structure that would be stronger and lighter than the types of structures he was helping to build at the construction sites.

Rodia's apparent anticlerical attitudes would seem at variance with a Catholic Church-sponsored celebration, and even with the legend of St. Paulinus. Still, the boat-shaped forms and the similarity between the earliest of Rodia's towers and the Italian *gigli* strongly suggest the influence of the Old World form on the new. Unlike the Brooklyn *gigli*, the traditional *giglio* constructed in Italy has a central pole around which the tapering frame is hung. Rodia's tower structure follows this configuration almost exactly. As the Brooklynites modified the structure eliminating the center pole, Rodia modified the materials used to construct the form. He used the materials he knew, and he had no concern for their weight because his towers would not dance. He had no need to fear that the statue atop his tower would topple unless an earthquake occurred.

Posen, Sciorra, and Cooper's article on the *giglio* in *Natural History* and his subsequent discussions with Posen inspired Ward to seek further correlations that could be made between the Watts Towers and the *gigli* of Brooklyn and Italy. The project is ongoing, but each new piece of Rodia data is now checked against data on the *gigli*. What has been examined to date makes a compelling case for the existence of a relationship.

A connection of meaning among the Watts and *giglio* towers solves a decades-old riddle and helps redeem, in great measure, a man long thought to be crazy. Sam Rodia worked all those years within a tradition — of form, of construction — and far from being a simple "naif" or nut, was one end of a relationship which individuals can be said to have with

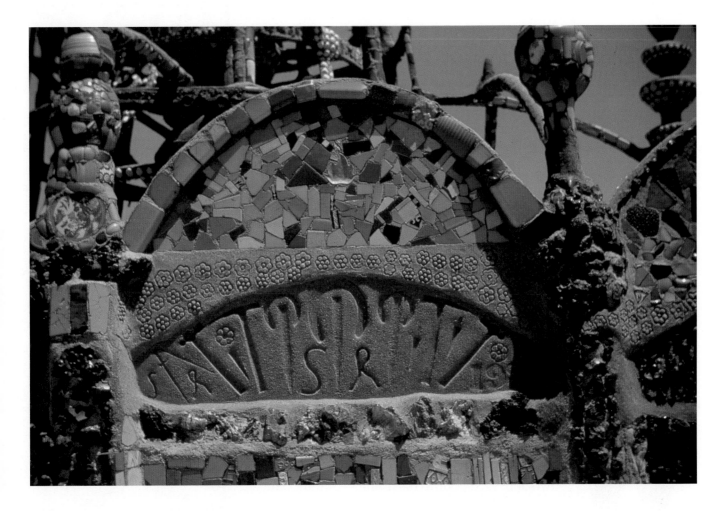

their communities, however far or isolated they appear to be from them. Not only that: since there is now evidence of just *what* he was building in his yard, there are realms of speculation for *why* he did so. Perhaps his motives were religious, a personal and unverbalized love for a saint or a labor for the greater glory of God; or they might have been biographical, an attempt by an immigrant to reproduce something from his homeland, perhaps influenced by the experiences of a childhood long ago and far away.

But the discovery, though valuable in answering some questions, is more to be valued for the questions it still raises, not just about Rodia and his work, but about all "informal art environments," if they can be called that, and the nature of folk art. What more do we now know about Sam Rodia, for instance, that we do not know about Fred Smith, Clarence Schmidt, James Hampton, Grandma Prisbrey, and others

who have been celebrated as artists in recent years? Would further biographical information — about a childhood, a model, an origin — give us more insight into such artists and the meaning of their work? Would it tell us what justifies the labor of years or decades in the arrangement of materials and space, with or without seeming reference to a community's values, aesthetics, or way of life?

In the end, it may only be possible to say that these are lone individuals, at the psychic outskirts of community, and "visionary" may not be so bad a term for many of them. What a discovery like the link among the towers can provide is some small insight into the visions of individuals like Rodia, a clue to where they are viewing from or what they are looking so intently at. There are still worlds to be explored to find out why such persons are driven or pleased to have their visions, and to act thus upon them.

HOWARD FINSTER:
Man of Visions

By John Turner
with text by Judith Dunham

I'd rather put one sermon out in art than fifty out of my
mouth. The main thing about my art is to have a message.
Preaching does very little good. But I find by doing it in art,
a man will see it, and the message will be printed on his
brain cells. —Howard Finster

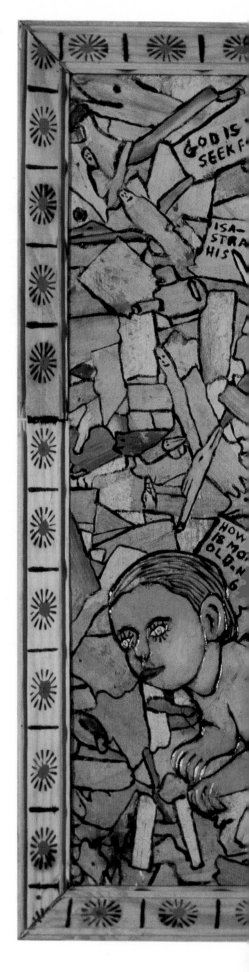

With as much determination as he preached
to Baptist congregations in rural Alabama and
Georgia for most of his life, Howard Finster
began in 1971 to build and plant a garden in the
two-acre yard behind his home in Summerville,
Georgia. Like many of his ideas, this one came
from a vision, wherein, he said, "it come to me
to build a paradise and decorate it with the Bible." Over the past
twenty years, Finster has filled his most celebrated creation not only
with vegetation but also with hundreds of objects, concrete pathways
embedded with broken glass, towers constructed from cast-offs, and
other impressive and eccentric structures—interspersed with Bible
verses handpainted on wooden signboards or spelled out in mosaic.

It was also a vision that in 1976 told Finster to paint "sacred art."
Applying to wood or metal the tractor enamel he used in his repair
business, he created pictures composed of Biblical messages and
images combined with his interpretation of the world, its moral con-
dition and dilemmas. Inhabited simultaneously by historical and

Howard Finster's portrait of himself as a month-old baby. *Phyllis Kind Gallery*

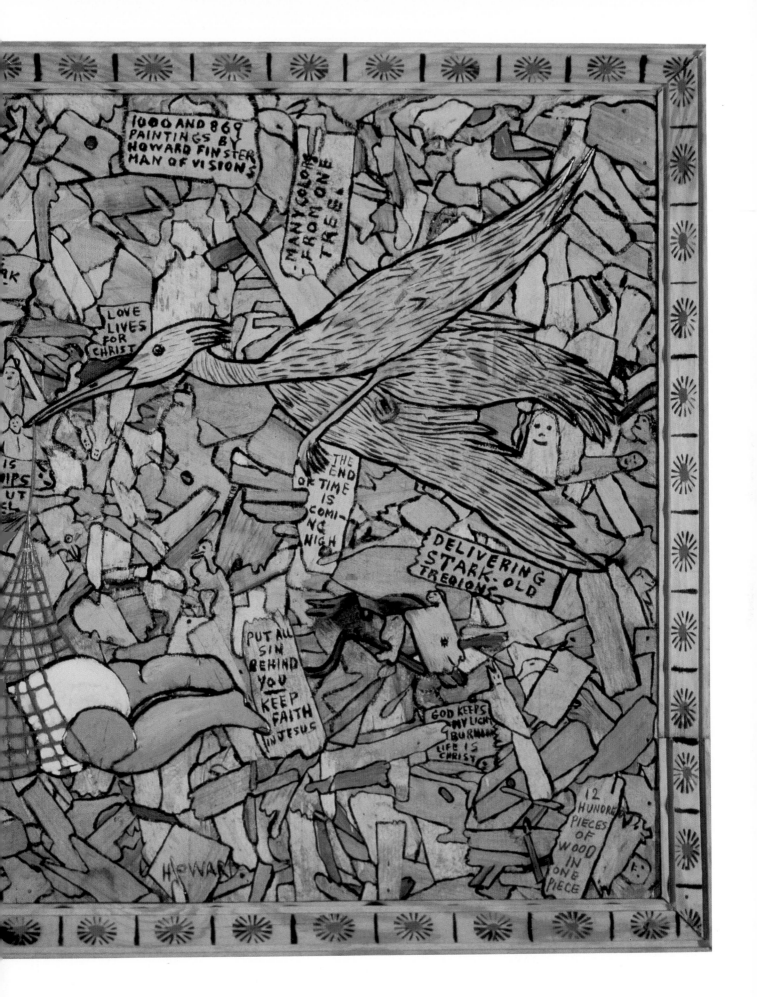

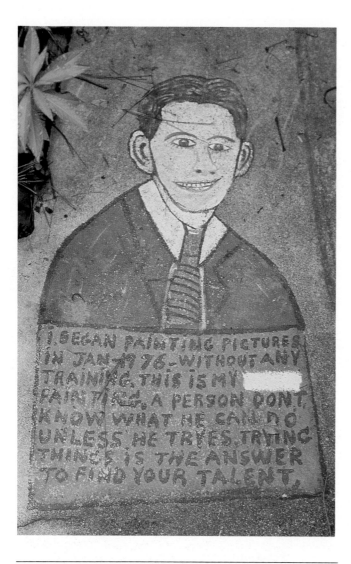

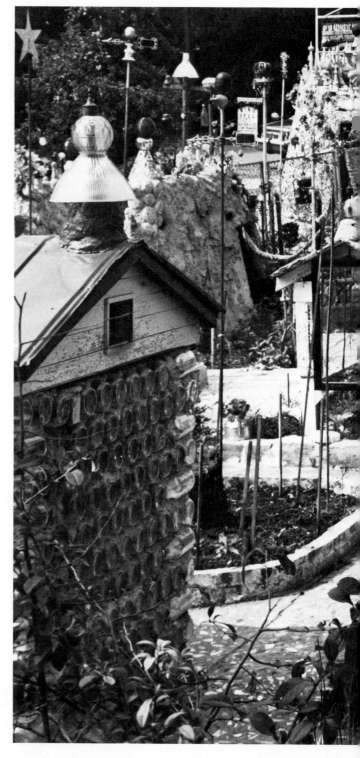

Untitled self-portrait, 1978. Enamel on cement.
Right: Howard Finster's garden *Courtesy of Victor Faccinto*

present-day people and by famous figures and personal acquaintances, Finster's painted visions convey a timeless and placeless sense. As is characteristic of the obsessiveness that pervades all his pursuits, Finster has numbered each of his paintings, constructions, and painted cutouts. To date he has made over three thousand works.

It is not unusual for Finster to view his life in statistical terms. By his own count he has delivered 4,625 sermons for a total of thirty-six million words. He has presided over four hundred funerals and two hundred weddings. He has taken only eight vacations and spent two-and-a-half days on activities he labels "sports." Finster's computations extend to the meticulous, almost graffiti-like records he has kept for all the purchases and income from his various repair businesses and to the exhaustive listings of the weddings, baptisms, and funerals he has performed in his position as pastor of various congregations.

However hyperbolic such statistical claims may be, they are indications of Finster's seemingly unceasing and compulsive energy, even at the age of sixty-nine. Indeed, Finster's entire life, from his earliest years until the present, has been motivated by a spiritual, if not economic, drive to work hard and productively and an unfailing belief in his inner resources. In the way Finster writes and talks about his past—which he does prolifically and in sentences that move from one to the

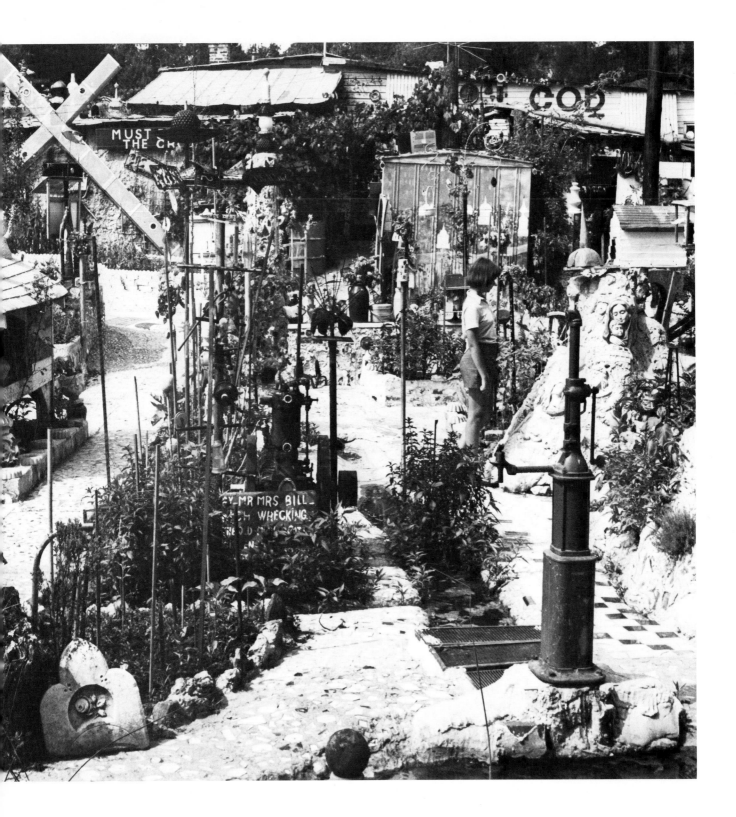

next without punctuation—his life seems to be governed by an urge to accomplish. "No doubt in my mind," he once wrote, "I have had the greatest working strength of any man who has been on this planet earth—except Jesus Christ and my father only."

Finster's father was a lumberjack and, by his reverend son's definition and description, "a sinner." Neither his father nor his mother had strong religious inclinations or, for that mat-

ter, an interest in art. Perhaps they were too busy raising thirteen children and tending their forty-two-acre farm in rural Valley Head, Alabama. Not surprisingly, many of Finster's memories of childhood are of the various jobs he had around the farm: making slop for the hogs, gathering and cutting wood, clearing the fields after the corn was harvested, loading lumber with his father. The older Finster grew, the more enterprising his jobs became. Using materials available

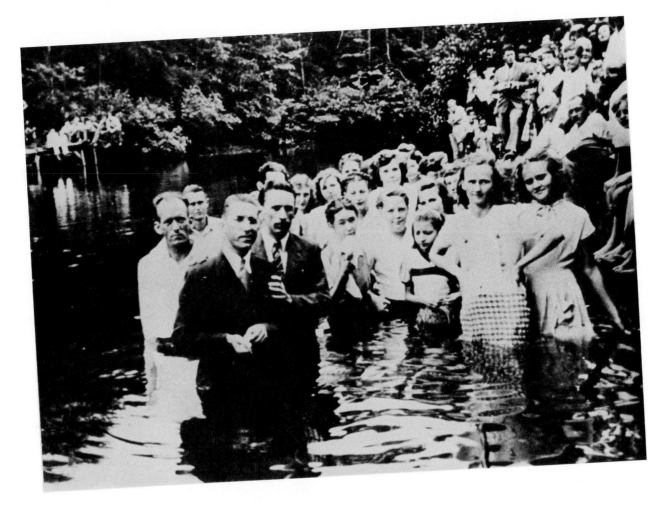

on the farm, he began to make small, eight-inch wooden oil lamps as well as salt and pepper shakers and talcum powder containers, which he sold by going house to house on his bicycle. To support himself and his family when he became a minister, at various times he worked in textile factory, labored in a sawmill, built houses, and in later years ran a lawnmower and bicycle repair shop. His prevailing skill was his ability to find a way to use simple materials or common objects to advantage.

Religion, perhaps the most powerful force in Finster's life, had an unlikely beginning in the form of Santa Claus, who was his first "deity" and who, he said, led him ultimately to God. Finster moved closer to religious convention when he was saved at the age of thirteen at a revival meeting and when, three years later, he was called by the voice of God to preach the Gospel. That same year he gave his first sermon at Lee's Chapel in Valley Head, and at age sixteen, with only a sixth-grade education, he began to preach the Lord's word.

Visions have determined many of the choices in Finster's life, from becoming a minister to building Paradise Garden and taking up brush and paint. But it took decades before Finster felt he could understand his first vision—which he experienced at age three—of his dead sister Abby:

> She appeared to me coming down from heaven on a set
> of steps made of clouds. She was covered with a long,
> white robe. I went back to the house and spread the

news. My mother was surprised, she thought it was a warning, fearing that I would die, but I am still living today. . . . Mother for years wondered about the vision and never knew what it meant. She finally died and I also wondered for years, so in 1976, when God called me, Howard, into sacred folk art, I began to understand Abby was saying, "Howard, you will be a man of visions," after which I began having more visions of other worlds and space things began to come to me.

Howard Finster, man of visions as he calls himself, was ordained at Violet Hill Baptist Church in Valley Head, Alabama, and was baptized in spring water at a nearby cow pasture. Accompanied by his wife Pauline and their first child, he moved across the border into Georgia to become pastor of the Rock Bridge Baptist Church. Over the next thirty years he went from church to church, from Mt. Carmel Baptist Church in Fort Payne, Alabama, to Chelsea Baptist Church in Menlo, Georgia, and from job to job, from grocery store proprietor to TV repairman. At Chelsea Baptist Church, where he had been preaching for fifteen years, he decided to realize a long-standing idea to build a garden planted, in part, with the message of the Lord. The church congregation, uninterested in such a creative digression from conventional religious practice, forbade the project, and, finding motivation in their disapproval, Finster began to build a garden behind his home in the Pennville community of Summerville.

Finster at a baptism (opposite, fourth from left) and preaching the word (below)

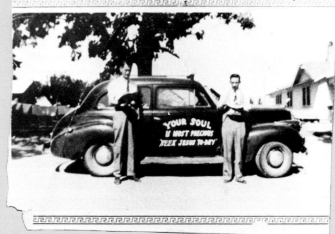

Tent Revival

HOWARD PUTS ON BIBLE SHOWS **AT BERRYTON**

BEGINS MONDAY NIGHT, MAY 30, 7:30

BIBLE PICTURES WILL BE SHOWN EACH EVENING—FROM THE BIRTH OF CHRIST TO THE RESURRECTION.

ALL DENOMINATIONS ARE WELCOME

Conducted by Rev. Howard Finister and Rev. Fred Tucker.

Rev. L. H. Newson, of Attalla, Ala. will do the Preaching.

COME HEAR THE MAN OF GOD PREACH

The Pastor of the Shady Grove Baptist Church in Attalla, Ala.

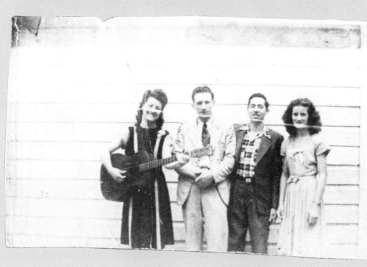

HEAR

REV. HOWARD FINSTER
Over WGWD

Gadsden's powerful station, each Saturday morning, 10:00. Pastor Mt. Carmel Baptist church.

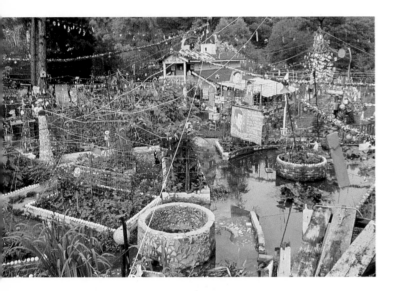

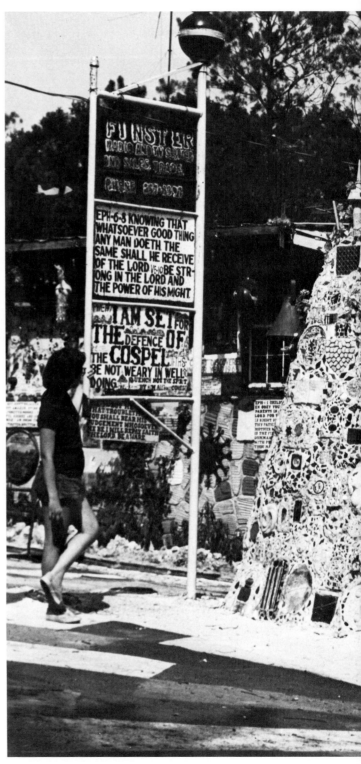

The yard, originally a hunting preserve, was overgrown three to four feet deep in areas. During the seven years Finster spent clearing and filling the land, he says he killed one hundred snakes. But in deference to the other creatures that inhabited the area, he left small niches and tunnels among the paths, towers, and other formations that gradually transformed the garden into a manifestation of his creativity as well as a translation of the Bible. As in the evolution of other rural folk-art environments, Finster's garden became increasingly elaborate as he began to build sculptural constructions from his immense collection of materials. He even foraged at the city dump: "I asked God, 'Why is it I'm a garbage collector? Everything I have is junk.' He said, 'You don't have anything. I want the world to understand that you can make something out of what other people throw away.' "

If Finster specializes in any particular material in his garden, it is cement. He has used it to mold mountains, towers, and castles, many inlaid with broken glass and with mirror, another favorite material. According to his estimation, there are twenty-five thousand pieces of mirror on one cement castle. A formation called Honeycomb Mountain is embellished with jars containing pictures of people, both famous and unknown. There is also a two-ton cement shoe that bears a Biblical quotation, "And your feet shod with the preparation of the gospel." Hands are made by casting cement in gloves reinforced with wire, then painting the hardened surface. The garden pump house is constructed of Coca Cola bottles embedded in cement, and a chapel is similarly built of half-gallon soft drink bottles.

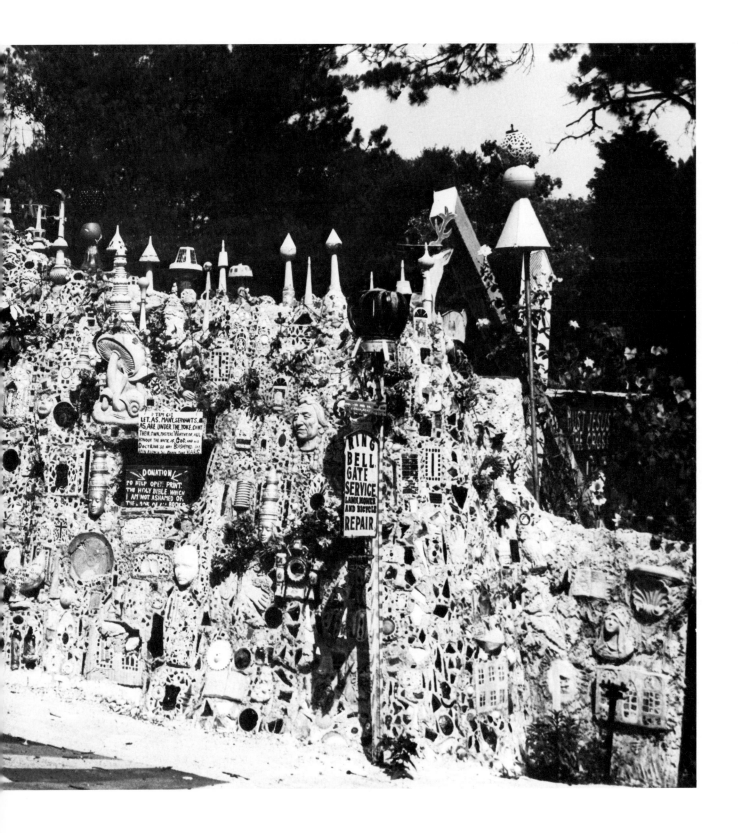

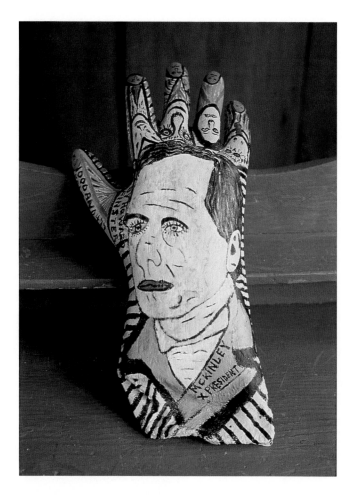

Record of Howard Begin with Scraps and Wound up with Profit

I bought a junk bicycle from Mr. Gowers for three dollars and added my skill and a few new parts to it and it became a nice bike worth fifteen dollars. So I sold it for fifteen dollars. From a wholesale catalogue I bought seven wall clocks. By adding seventy-five cents and my skill, I designed a mantle clock case with a few pieces of wood. I built seven beautiful mantle clocks that wholesaled at ten dollars each, which totaled seventy dollars. I sent one hundred dollars to the World's Mission Rice Fund for the hungry, I sent another hundred to A-A-Tanner, the radio pastor and twenty-five cents to Flower Fund, ten dollars to my pastor, ten dollars to my church, one hundred to a sick patient in Trion Hospital, one hundred to Frank Rosser, my favorite missionary, which left me a balance of forty-five seventy-five, which would buy 456 scrap pieces of plywood from Bryce Evins wood shop and from these scrap pieces I could build two hundred fifty clock cabinets at four-fifty each, which amounted to eleven hundred twenty-five dollars, which I did, taking three seventy-five and turning it over four times and coming out with eleven hundred twenty-five. How did this happen? By using my gift of talent and tools and labor. 1949

Throughout the garden Finster has turned his collection of mechanical and electronic parts into ingenious structures. One tower is made of hub caps and bicycle frames—"I've fixed and rebuilt and repaired enough bicycles to load a cargo ship or a freight train from deck to deck or car to car"—which can be ascended nearly thirty feet to the top for a panoramic view of the entire garden. A windmill that reaches sixteen feet is built of mower parts and wagon rims. Old television tubes are painted with portraits, then used to make large circular flower planters. Other objects found in the garden have been donated by friends and visitors. One boy brought his tonsils in a jar, and other admirers have given Finster jewelry and small trinkets which he has incorporated into the cement walks. Finster ultimately hopes to collect at least one of each of mankind's inventions. To house this accumulation as well as his own art, he recently purchased an abandoned church adjacent to his garden which he has renamed the Folk Art Church.

In 1976, years after Finster began to conceive of his garden as a work of art, or as he says, "the folk art of God," he had another vision:

One day I was using my finger to patch little spots on different things I painted, lawn mowers, bicycles, anything I was painting. I dipped my finger in white paint and started to patch something, and I looked at the end of my right finger, and on the round ball of my finger was a white face with eyes, nose, just a human face on the end of my finger. And it was so amazing to me I just stood there lookin' at my finger with that human face on it where I dipped it in paint. There are different kinds of feelings but this was a divine feeling. I can always tell a

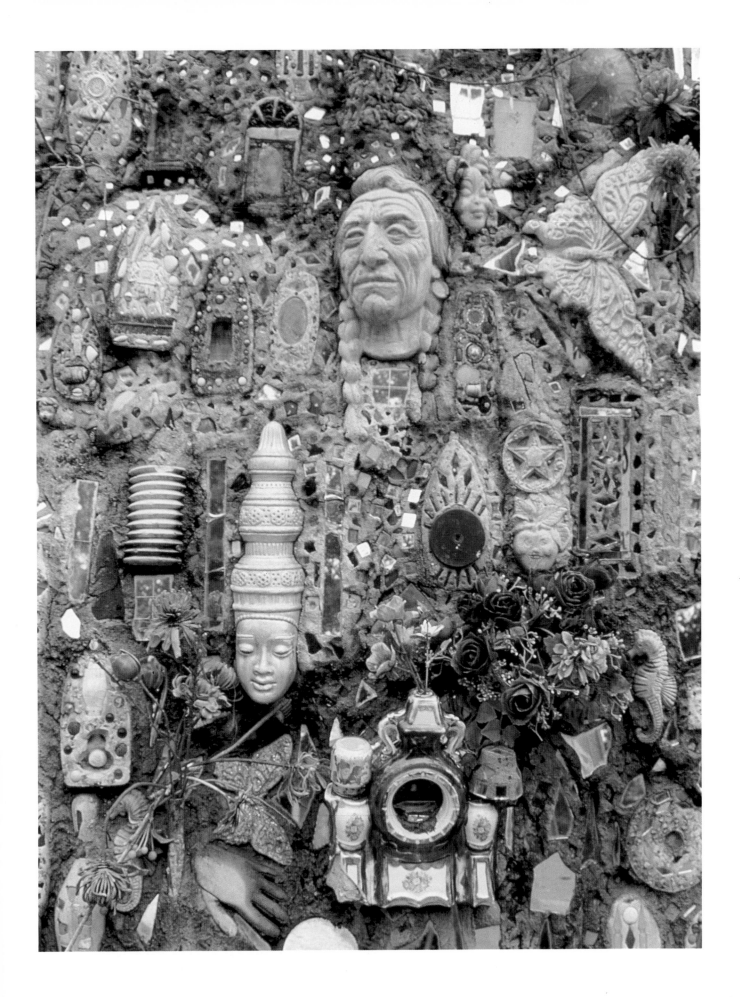

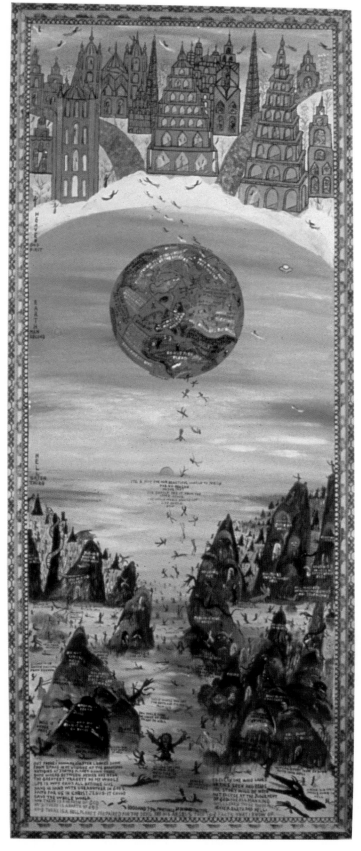

Finster's paintings often represent hierarchies of good and evil, like this one of heaven, earth, and hell. *Phyllis Kind Gallery*

Howard Goes to Heaven

One beautiful morning I arose from sleep and all my work was caught up. I had all the riches that I would ever need. I looked at the clock and pitched it in the waste can. I took the calendar from the wall and tore it in half. I took my insurance policy and pitched it into the waste. I took my all my business books and papers, tax return forms, and threw them away. I went to my workshop and cut off the power and locked the doors. Every failing member of my body became strong and my young feeling returned to me.

I took my medicine cabinet and threw it away. I took my electric razor and pitched it out. I left my home without a suitcase or a change of clothes. I began to walk away without looking back.

I took my billfold and pitched it in the gutter. I took a road that led upwardly. I met a great company of people. Thousands and thousands of them, they were all smiling. I could see peace and love shining in their faces. Little children playing all along the streets. I reached down and raked my hand across the street and it was smooth as polished marble.

I looked up to see the sun but it was gone. The lamb of God was the light. The light was so equal, every corner and turn shined. There was no such thing as darkness. I could see the most beautiful domes and structures near and far of pure gold. They didn't have a sun glitter, they shined on all sides, the grass an even color by miles and miles. The top of the grass was level as mohair. After time had passed and passed and passed, I never grew tired. No such thing as thirst or hunger. The mansions were vacant of beds. There were no railroad lines or planes overhead. The only sounds were beautiful singing, and the music beyond describing and groups of people talking and meeting one another. God himself in person. People bowing by thousands at the presence of Jesus, who they had always wanted to see face to face. Everyone who had believed in Christ was present. Bible debates were unknown. Everyone lived with a shout in his soul. Praise to God. The joy and peace and luxury were so great that the former things were forgotten. You could pass one object a thousand times and it was just as new as ever. Nothing could be improved. It was so perfect. 1968

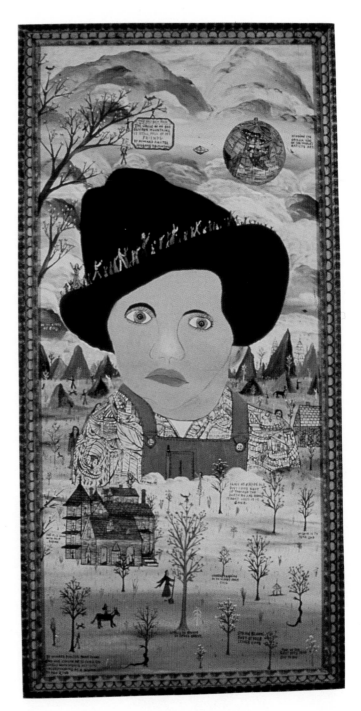

divine feeling, so I tried the spirit to see whether it was God or not, and a warm feeling come over me to paint sacred art, and I thought to myself, "Well, I can't do it but I'm goin' to try," and I started painting.

Finster still sometimes paints with his fingers, but paint is not the only medium he uses. People and patterns are occasionally "etched" on metal with ballpoint pen, and several works have incorporated posters or magazine cutouts around which he creates his imaginative visions. While most of the works are made simply of paint on rectangular sheets of metal or wood, others are not so simple at all: portraits shaped like their subjects, pictures executed on trellises of wood, and a long, thin, overgrown gourd painted with "visions of strangers from other worlds." His ingenuity extends to the wood frames around his paintings, which are imprinted with designs generated by a machine of his own invention.

Almost all of Finster's paintings, which he calls "telegrams to the world," include Biblical quotations, reference to God, or religious overtones of some kind. A number of the works are apocalyptic visions in which the pictures are divided into paths, buildings, strata, or planets representing hierarchies of good and evil. There are also smatterings of homespun sayings such as those in painting No. 1000, a shoe inhabited by the Reverend himself: "If you happen to get stepped on, just up and keep walking" and "If a man's home is his castle, he should wear shoes there and rule his house."

Like the paintings of other untrained artists, Finster's do not follow the laws of perspective, nor are they drawn with consistent scale relationships. Unlikely combinations of subjects and techniques are the hallmarks of Finster's style. Elvis Presley, one of his revered heroes, is the main character in several paintings, one of which (No. 1781) shows a line of tiny figures parading around his hat brim. Also among the roster of subjects are former presidents Jimmy Carter, John F. Kennedy, and Franklin Roosevelt, Gen. Robert E. Lee, Albert Einstein, Queen Elizabeth and Queen Henrietta, the Mona Lisa, Leonardo da Vinci, Daniel Boone, the Ayatollah Khomeini, and Santa Claus—as well as countless self-images. Henry Ford's Model T appears in painting No. 644, with Finster himself standing behind it and a text that refers to the Bible's prophecy of the coming of the horseless chariot.

In addition to such juxtapositions of subjects and epochs, it is not uncommon to find spaceships, flying saucers, and unfamiliar planets among the more earthbound imagery. Hovering in the sky behind one picture of Queen Henrietta is a spacecraft that Finster insists is outfitted for solar power. For him the afterlife is not so much in heaven as it is in space:

I, Howard Finster, was lying on my bed one day and looking out over my garden. A feeling come over me that I had lived and had a job on another planet before I come to earth. But the former things of my first planet had passed away so that they would not confuse me about my work on earth's planet, and now I desperately try to draw paintings to remind me of the work that I did on my first planet. I have visions of worlds beyond the light of the sun, unbelievable domes and mansions and trees that go up out of sight in the sky. I am a stranger from another world, and when my work is finished I will go back to other worlds.

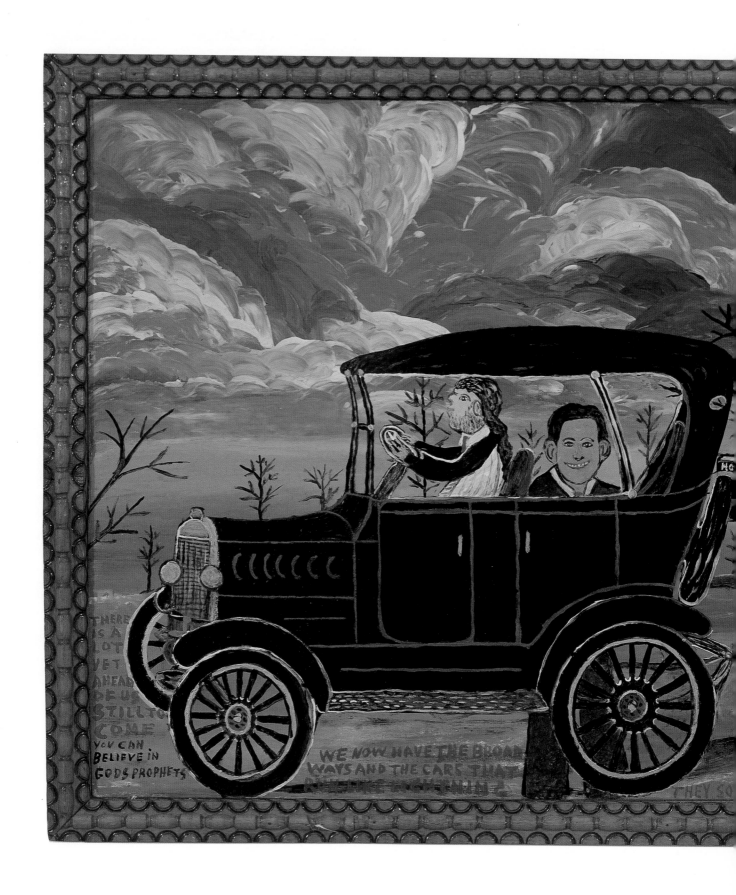

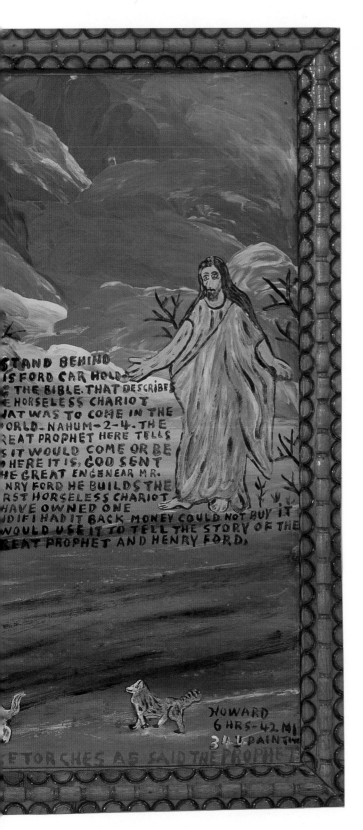

STAND BEHIND
IS FORD CAR HOLD—
E THE BIBLE. THAT DESCRIBES
E HORSELESS CHARIOT
IAT WAS TO COME IN THE
ORLD- NAHUM-2-4- THE
REAT PROPHET HERE TELLS
S IT WOULD COME OR BE
HERE IT IS, GOD SENT
HE GREAT ENGENEAR MR.
NRY FORD HE BUILDS THE
RST HORSELESS CHARIOT
HAVE OWNED ONE
JD IF I HAD IT BACK MONEY COULD NOT BUY IT
WOULD USE IT TO TELL THE STORY OF THE
REAT PROPHET AND HENRY FORD,

HOWARD
6 HRS-42 MI
341 PAINTW

E TORCHES AS SAID THE PROPHET

The Truth of the Trade

I was a farmer. I could plow, cultivate, plant, sow, gather, and preserve, all it took to be a farmer. But I finally quit. I don hammer out blacksmith irons with white heat and shoed mules, but I finally quit. I begin preaching as a pastor and pastored churches for many years, but finally quit. I mounted animals, stuffed them, treated them with formality-hide, and even skinned a chicken so small its skin was almost thin as tissue paper. I stuffed him, sew him up and mounted him on a board, standing up and eating corn from a little pan, and had corn in the pan. But I finally quit. I told a few fortunes as a mind reader but I finally quit. I begin woodcraft and could do top work as a finisher and was finally employed at a furniture factory, but quit. I became textile employee and learned to wind thread and work with cotton fabrics, but quit. I became a machine fixer in a glove mill and could fix machines, but I quit. I worked in a dye house dyeing cloth, became a cloth inspector and quit. I started out as an evangelist preaching with large truck, portable instruments, and speaking equipment, but I quit after wearing out two or three tents. I took up carpenter work, built houses, remodeled flooring, tiling, plumbing, and pipe work, but I quit. I begin plumbing and pipe cutting but I quit. I even made bricks and blocks with my own mold and build my first home, but I quit. I begin lawn mower and bicycle repair for years but I quit. I begin making clocks by the hundreds and hundreds but I quit. I begin machine work on cars and could rebuild a motor but I quit. I used to contract cutting logs from the forest but I quit. I owned and operated a grocery store for years but I quit. I begin marrying people and preaching funerals for years and still do. In 1976 I begin folk art painting and I don't think I will ever quit because I can do all these things together in folk art painting. I find no end to folk art painting and I don't think no artist on earth found the end of art.

1976

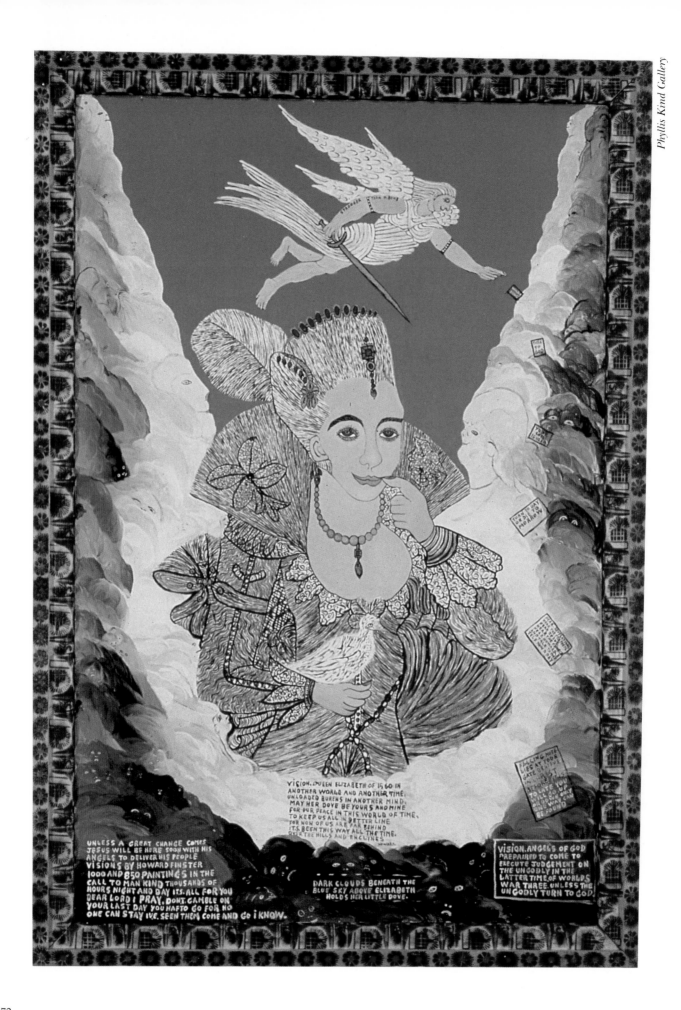

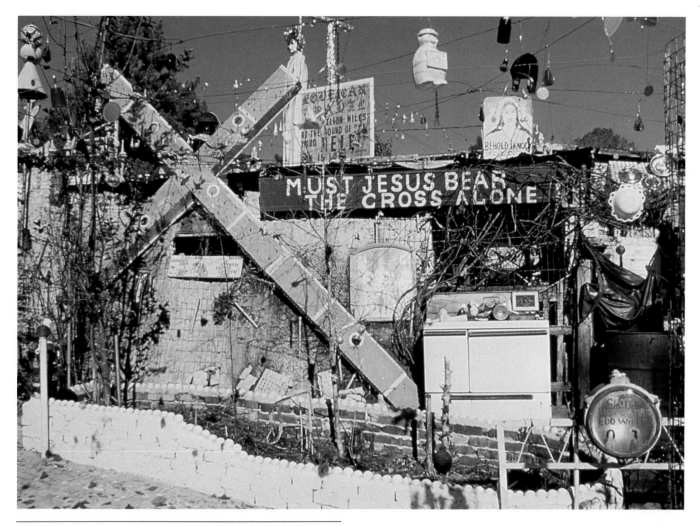

Queen Elizabeth (opposite), and Howard Finster's garden (above)

Considering Finster's abundant imagination and his tireless constitution, his work will probably never be finished. He continues to expand his garden and to paint his way to picture No. 4000. In recent years he has received recognition from the art-world establishment—reviews in art periodicals, exhibits in galleries and museums, and guest appearances at colleges and universities. He also finds time to write songs and poetry and to play the guitar, harmonica, and banjo and has recently produced a record of his music. To fit in all these pursuits, he follows an idiosyncratic schedule, eating and sleeping—what little sleeping he does—when the impulse strikes. Howard Finster surely speaks the truth when he says, "I won't live long enough to draw all my visions."

Just a Little Tack in the Shangle of the Roof

Oh why in the world did you leave your home
Why in the world have you stayed so long
Want you come on back and stay with me

Make your little house what it ought to be
Oh make your little house what it ought to be.

Oh I'm just a little tack in the shangle of your roof
Oh I'm just a little tack in the shangle of your roof
Oh I'm just a little tack in the shangle of your roof
To hold your house together, to hold your house together.

Oh come on back and live with me
Oh come on back and let me see
Oh come on back and live with me
Make your little house what it ought to be
Oh make your little house what it ought to be.

Oh I'm just a little nail in the plank on your wall
Oh I'm just a little nail in the plank on your wall
Oh I'm just a little nail in the plank on your wall
To hold your house together, to hold your house together.

Oh I'm just a little stone in the pillow of your house
Oh I'm just a little stone in the pillow of your house
I'm just a little stone in the pillow of your house
To hold your house together, to hold your house together
Don't let it fall on me, don't let it fall on me.

CONTRIBUTORS

John Bennett is a professor of anthropology and former chairman of the Anthropology Department at Washington University, St. Louis. He is also an associate of the Land Tenure Center of the University of Wisconsin, Madison, and the author of many books and papers dealing with agriculture, human settlement, and international development. His essay for *Folklife Annual* is based on a twenty-year study of social and economic development in Western Canada, which has also resulted in the book *Northern Plainsmen: Adaptive Strategy and Agrarian Life.*

David S. Cohen is coordinator of the Folklife and Ethnic History programs for the New Jersey Historical Commission. He is the author of *The Ramapo Mountain People* (1974) and *The Folklore and Folklife of New Jersey* (1983).

Judith Dunham is a freelance editor who specializes in the arts and humanities.

John Erickson is a working cowboy who lives in Perryton, Texas. He is the author of a number of books, including *Through Time and the Valley, Panhandle Cowboy, The Modern Cowboy,* and *The Hunter.*

Archie Green retired in 1982 from teaching at the University of Texas, Austin. During the decade 1967–76, he campaigned for the passage of the American Folklife Preservation Act. For many years, he has commented in the *JEMF Quarterly* on graphic depictions of folk music. Currently, he is writing a book on labor lore in the United States.

Mary Hufford is a folklife specialist at the American Folklife Center. She was project director for the center's Pinelands Folklife Project.

Marjorie Hunt is a staff folklorist for the Office of Folklife Programs at the Smithsonian Institution. She is a doctoral candidate in the Department of Folklore and Folklife at the University of Pennsylvania. Her documentary film about the stone carvers previewed at the Smithsonian on May 19, 1984.

Edward D. (Sandy) Ives is professor of folklore, chairman of the Anthropology Department, and director of the Northeast Archives of Folklore and Oral History at the University of Maine, Orono. He is the author of *Larry Gorman: The Man Who Made the Songs* (1964), *Lawrence Doyle: The Farmer-Poet of Prince Edward Island* (1971), *Joe Scott: The Woodsman-Songmaker* (1978), and *The Tape-Recorded Interview* (1980). He is president and cofounder of the Northeast Folklore Society and editor of its annual, *Northeast Folklore.*

I. Sheldon Posen is an applied folklife researcher and consultant based in the Northeast. Posen has done folklife research in both rural and urban settings in Newfoundland, Ontario, the Ottawa Valley in Quebec, New York's Lake Champlain district, and all five boroughs of New York City. His publications include *Tradition and Community in the Urban Neighborhood: Making Brooklyn Home* (1983, with Maxine Miska).

John F. Turner has been documenting folk artists and their environments through photography, oral history, and videotape for the past fifteen years. He works for ABC TV and is the curator of twentieth-century American folk art for the San Francisco Crafts and Folk Art Museum.

Daniel Franklin Ward is a doctoral candidate in the American Culture Program at Bowling Green State University, where he is completing a dissertation on Watts Towers. During 1983 and 1984 he served as coordinator of the Committee for Simon Rodia's Towers in Watts, and his book, *Personal Places* (1984), provides perspectives on informal art environments throughout the United States.

PUBLICATIONS
of the American Folklife Center

BLUE RIDGE HARVEST: A REGION'S FOLKLIFE IN PHOTOGRAPHS
By Lyntha Scott Eiler, Terry Eiler, and Carl Fleischhauer. 115 pp. (S/N 030-000-00127-3) $6. Available from the Superintendent of Documents, U. S. Government Printing Office, Washington, D. C. 20402. Check or money order payable to the Superintendent of Documents must accompany order.
A look at the landscape, communities, and religion of the men and women who live along the Blue Ridge Parkway.

BUCKAROOS IN PARADISE: COWBOY LIFE IN NORTHERN NEVADA
By Howard W. Marshall and Richard E. Ahlborn. 120 pp. (reprint) $15.95. Available from the University of Nebraska Press, Sales Department, 901 North 17th Street, Lincoln, Nebraska 68588.
A publication to accompany the Smithsonian exhibit "Buckaroos in Paradise," including an essay on buckaroo life, a catalog of exhibit artifacts, and numerous photographs.

CHILDREN OF THE HEAV'NLY KING:
RELIGIOUS EXPRESSION IN THE CENTRAL BLUE RIDGE
Edited and annotated by Charles K. Wolfe. Two discs and a 48-page illustrated booklet (AFC L69/70). $14. Available from the Library of Congress, Recording Laboratory, Motion Picture, Broadcasting, and Recorded Sound Division, Washington, D. C. 20540. Checks payable to the Library of Congress must accompany orders.

CRANBERRIES
32 pp. $5. Available from the Library of Congress, American Folklife Center, Washington, D. C. 20540. Checks payable to the Library of Congress must accompany orders.
Cranberry recipes collected during the American Folklife Center's 1983 Pinelands Folklife Project in New Jersey, illustrated with full-color photographs.

CULTURAL CONSERVATION: THE PROTECTION OF CULTURAL HERITAGE IN THE UNITED STATES
By Ormond Loomis. 123 pp. (S/N 030-000-00148-6) $4.50. Available from the Superintendent of Documents, U. S. Government Printing Office, Washington, D. C. 20402. Check or money order payable to the Superintendent of Documents must accompany order.
A report on the means of preserving intangible features of the nation's cultural heritage, with an appendix that traces the history of relevant legislation and a bibliography.

ETHNIC RECORDINGS IN AMERICA: A NEGLECTED HERITAGE
Edited by Judith McCulloh. 269 pp. (S/N 030-001-00098-2) $13. Available from the Superintendent of Documents, U. S. Government Printing Office, Washington, D. C. 20402. Check or money order payable to the Superintendent of Documents must accompany order.
A collection of essays on the history and current status of the ethnic recording industry, with numerous illustrations and an index.

THE FEDERAL CYLINDER PROJECT: A GUIDE TO FIELD CYLINDER RECORDINGS IN FEDERAL AGENCIES

Available from the Superintendent of Documents, U. S. Government Printing Office, Washington, D. C. 20402. Check or money order payable to the Superintendent of Documents must accompany order.
Volume 1, Introduction and Inventory, by Erika Brady, Maria La Vigna, Dorothy Sara Lee, and Thomas Vennum, Jr. 110 pp. (S/N 030-000-00153-2) $8.50
Introductory essay that describes the project and an indexed listing by collection of more than ten thousand field-recorded wax cylinders for which preservation tape copies exist at the Library of Congress.
Volume 8, Early Anthologies, edited by Dorothy Sara Lee, with a foreword by Sue Carole De Vale. 96 pp. (S/N 030-000-154-1) $8.
Describes Benjamin Ives Gilman's cylinder recordings from the 1893 World's Columbian Exposition and the "Demonstration Collection" edited by Erich Moritz von Hornbostel and issued by the Berlin Phonogramm Archiv shortly after World War I.

WATERMELON
By Ellen Ficklen. 64 pp. $10. Available from the Library of Congress, American Folklife Center, Washington, D. C. 20540. Checks payable to the Library of Congress must accompany orders.
History, facts, and lore of the watermelon, along with numerous recipes. Illustrated in color and black and white.

The following publications are available free of charge from the Library of Congress, American Folklife Center, Washington, D. C. 20540.

AMERICAN FOLK ARCHITECTURE: A SELECTED BIBLIOGRAPHY
By Howard W. Marshall, with the assistance of Cheryl Gorn and Marsha Maguire. 79 pp.
Articles and books on theory and general topics, antecedent references from the British Isles, and resources dealing with specific regions of the country.

AMERICAN FOLK MUSIC AND FOLKLORE RECORDINGS 1983:
A SELECTED LIST
An annotated list of thirty-one 1983 recordings selected because they include excellent examples of traditional folk music.

FOLKLIFE CENTER NEWS
A quarterly newsletter reporting on the activities and programs of the center.

FOLKLIFE AND FIELDWORK: A LAYMAN'S INTRODUCTION TO FIELD TECHNIQUES
By Peter Bartis. 28 pp.
An introduction to the methods and techniques of fieldwork.

TRADITIONAL CRAFTS AND CRAFTSMANSHIP IN AMERICA:
A SELECTED BIBLIOGRAPHY
By Susan Sink. 84 pp.
An indexed bibliography citing Library of Congress call numbers, produced in cooperation with the National Council for the Traditional Arts.